The Stones of Florence

Books by Mary McCarthy

The Company She Keeps

The Oasis

Cast a Cold Eye

The Groves of Academe

A Charmed Life

Sights and Spectacles

Venice Observed

Memories of a Catholic Girlhood

The Stones of Florence

On the Contrary

The Group

Mary McCarthy's Theatre Chronicles

Vietnam

Hanoi

The Writing on the Wall and Other Literary Essays

Birds of America

Medina

The Seventh Degree

The Mask of State: Watergate Portraits

Cannibals and Missionaries

Ideas and the Novel

The Hounds of Summer and Other Stories

Occasional Prose

How I Grew

Intellectual Memoirs: New York 1936-1938

Hannah Arendt and Mary McCarthy

Between Friends: The Correspondence of Hannah Arendt and Mary McCarthy, 1949–1975

Mary McCarthy

The Stones of Florence

A Harvest Book • Harcourt, Inc.

San Diego New York London

This edition, 1963, is published by arrangement with the author and with rights reserved by the author and comprises the text of an edition published in 1956 that included both text and illustrations. Some of the text in this book originally appeared, in different form, in the *New Yorker*.

All rights reserved. No part of this publication may be reproduced or transmitted in any form or by any means, electronic or mechanical, including photocopy, recording, or any information storage and retrieval system, without permission in writing from the publisher.

Requests for permission to make copies of any part of the work should be mailed to the following address:

Permissions Department, Harcourt, Inc.,
6277 Sea Harbor Drive, Orlando, Florida 32887-6777.

ISBN 0-15-602763-1 (Harvest: pbk.)

Printed in the United States of America

BDFHJIGECA

To Roberto Papi

AUTHOR'S NOTE

Florentines assure me that the Florentines are stingy and inhospitable; in the text I have taken their word for it and cited examples they have given. If they are right, then all the Florentines, born and naturalized, whom I came to know well are exceptions. The list of these exceptions and an account of my indebtedness would make a short chapter in itself, and I name only those who were of direct help in the work of this book. First of all, Roberti Papi and his wife, Vittorina; their quick kindness and perceptive generosity would stand out even in Heaven, among the angels. Also my affection and thanks go to Aldo Bruzzichelli, Miss Nicky Mariano, Dr Hanne Khiel, Signora Titina Sartori, Countess Cristina Rucellai, Professor Ulrich Middeldorf, Bernard Berenson, the Reverend Mr Victor Stanley, and Sabatina Geppi.

My thanks finally go to the city of Florence and to all the Florentines, past and present. I agree with that pope who called them the fifth element.

The reader, I hope, will overlook a few inaccuracies in the description of present-day Florence. The incessant changes of modern Florence keep it always ahead of the author.

MARY McCARTHY

Chapter One

'How can you stand it?' This is the first thing the transient visitor to Florence, in summer, wants to know, and the last thing too - the eschatological question he leaves echoing in the air as he speeds on to Venice. He means the noise. the traffic, and the heat, and something else besides, something he hesitates to mention, in view of former raptures: the fact that Florence seems to him dull, drab, provincial. Those who know Florence a little often compare it to Boston. It is full of banks, loan agencies, and insurance companies, of shops selling place mats and doilies and tooled-leather desk sets. The Raphaels and Botticellis in the museums have been copied a thousand times; the architecture and sculpture are associated with the schoolroom. For the contemporary taste, there is too much Renaissance in Florence: too much 'David' (copies of Michelangelo's gigantic white nude stand on the Piazza della Signoria and the Piazzale Michelangelo; the original is in the Academy), too much rusticated stone, too much glazed terracotta, too many Madonnas with Bambinos. In the lacklustre cafés of the dreary main piazza (which has a parking lot in the middle), stout women in sensible clothing sit drinking tea, and old gentlemen with canes are reading newspapers. Sensible, stout, countrified flowers

like zinnias and dahlias are being sold in the Mercato Nuovo, along with straw carryalls, pocketbooks, and marketing baskets. Along the Arno, near Ponte Vecchio, ugly new buildings show where the German bombs fell.

Naples is a taste the contemporary traveller can understand, even if he does not share it. Venice he can understand ... Rome ... Siena. But Florence? 'Nobody comes here any more,' says the old Berenson, wryly, in his villa at Settignano, and the echoing sculpture gallery of the Bargello bears him out; almost nobody comes here. The big vaulted main hall seems full of marble wraiths: San Giorgio, San Giovanni, San Giovannino, the dead gods and guardians of the city. The uniformed modern guards standing sentinel over the creations of Donatello, Desiderio, Michelozzo, Luca della Robbia, Agostino di Duccio have grown garrulous from solitude, like people confined in prison: they fall on the rare visitor (usually an art historian) and will scarcely let him go. The Uffizi, on the contrary, is invaded by barbarian hordes from the North, squadrons of tourists in shorts, wearing sandals or hiking shoes, carrying metal canteens and cameras, smelling of sweat and sun-tan oil, who have been hustled in here by their guides to contemplate 'Venus on the Half-Shell'.

'Il Diluvio Universale,' observes a Florentine, sadly, punning on the title of Paolo Uccello's fresco (now in the Belvedere). There is no contradiction. 'Nobody comes here any more' is simply the other side, the corollary, of the phenomenon of mass tourism – the universal deluge. The masses rush in where the selective tourist has fled.

Almost nobody comes to see Donatello's 'David' in the Bargello, the first nude statue of the Renaissance, or San Giorgio or San Giovannino, Donatello's also, or the cantorias of dancing children in the Museum of the Works of the Duomo, but Michelangelo and Cellini, partly, no doubt, because of vaguely sensed 'off-colour' associations, draw crowds of curiosity-seekers. Florence is scraping the bottom of the tourist barrel. And the stolid presence of these masses with their polyglot guides in the Uffizi, in the Pitti, around the Baptistery doors and the Medici Tombs, in the cell of Savonarola and the courtyard of Palazzo Vecchio is another of the 'disagreeables', as the Victorians used to call them, that have made Florence intolerable and, more than that, inexplicable to the kind of person for whom it was formerly a passion. 'How can you stand it?'

Florence is a manly town, and the cities of art that appeal to the current sensibility are feminine, like Venice and Siena. What irritates the modern tourist about Florence is that it makes no concession to the pleasure principle. It stands four-square and direct, with no air of mystery, no blandishments, no furbelows – almost no Gothic lace or baroque swirls. Against the green Arno, the ochre-and-dun file of hotels and palazzi has the spruce, spare look of a regiment drawn up in drill order. The deep shades of melon and of tangerine that you see in Rome, the pinks of Venice, the rose of Siena, the red of Bologna have been ruled out of Florence as if by municipal decree. The eye turns from mustard, buff, écru, pale yellow, cream to

of Santa Maria Novella's façade or the dark-green and white and flashing gold of San Miniato. On the Duomo and Giotto's bell tower and the Victorian façade of Santa Croce, there are touches of pink, which give these buildings a curious festive air, as though they alone were dressed up for a party. The general severity is even echoed by the Florentine bird, which is black and white – the swallow, a bachelor, as the Florentines say, wearing a tail coat.

The great sculptors and architects who stamped the outward city with its permanent image or style - Brunelleschi, Donatello, Michelangelo - were all bachelors. Monks, soldier-saints, prophets, hermits were the city's heroes. Saint John the Baptist, in his shaggy skins, feeding on locusts and honey, is the patron, and, except for the Madonna with her boy-baby, women saints count for little in the Florentine iconography. Santa Reparata, a little Syrian saint, who once was patron of the Cathedral, was replaced by the Madonna (Santa Maria del Fiore) early in the fifteenth century. The Magdalen as a penitent and desert-wanderer was one of the few female images, outside of the Madonna, to strike the Florentine imagination; Donatello's gaunt sculpture of her stands in the Baptistery: a fearsome brown figure, in wood, clad in a shirt of flowing hair that surrounds her like a beard, so that at first glance she appears to be a man and at second glance almost a beast. Another of these hairy wooden Magdalens, by Desiderio, is in the church of Santa Trinita.

Like these wild creatures of the desert, many of the Florentine artists were known for their strange ascetic habits: Paolo Uccello, Donatello, Piero di Cosimo, Michelangelo, Pontormo. When he was doing a statue of Pope Julius II in Bologna, Michelangelo, though an unsociable person, slept four to a bed with his workmen, and in Rome, so he wrote his relations, his quarters were

too squalid to receive company.

Many Florentine palaces today are quite comfortable inside and possess pleasant gardens, but outside they bristle like fortresses or dungeons, and, to the passing tourist, their thick walls and bossy surfaces seem to repel the very notion of hospitality. From the Grand Canal. the Venetian palaces, with their windows open to the sun, offer glimpses of sparkling chandeliers and painted ceilings, and it is not hard for the most insensitive tourist to summon up visions of great balls, gaming, love-making in those brilliant rooms. The Florentine palaces, on the contrary, hide their private life like misers, which in fact the Florentines are reputed to be. Consumption is not conspicuous here; an unwritten sumptuary law seems to govern outward display. The famous Florentine elegance, which attracts tourists to the shops on Via Tornabuoni and Via della Vigna Nuova, is characterized by austerity of line, simplicity, economy of effect. In this spare city, the rule of nihil nimis prevails. A beggar woman who stands soliciting in front of Palazzo Strozzi, when offered alms a second time in the same day, absently, by another Florentine, refuses: 'No. You gave me before.' Poverty

has its own decorum; waste is frowned on. This is a city of endurance, a city of stone. A thing often noticed, with surprise, by foreigners is that the Florentines love their poor, for the poor are the quintessence of Florence – dry in speech, frugal, pessimistic, 'queer', disabused. 'Pazienza!' is their perpetual, shrugging counsel, and if you ask them how they are, the answer is 'Non c'è male.' 'Not so bad.' The answer to a favourable piece of tidings is 'Meno male', literally, 'less bad'. These people are used to hardship, which begins with a severe climate and over-

crowding.

The summers are the worst. The valley of the Arno is a natural oven, in which the city bakes, almost without relief, throughout July and August. Venice has the sea: Rome has a breeze and fountains; Bologna has arcades; Siena is high. But the stony heat of Florence has no extenuation. Some people pretend that it is cooler in Fiesole or near the Boboli Garden, but this is not true, or at least not true enough. For the populace and the tourists, the churches are the only refuge, except for UPIM, the local five-and-ten (a Milanese firm), which is air-cooled, and for an icy swimming pool, surrounded by a flower garden, in the Tennis Club of the Cascine that few tourists hear about and that the native population, on the whole, cannot afford. The Boboli Garden is too hot to walk in until sunset, which is the time it closes. In some Italian cities, the art galleries are cool, but the Uffizi, with its small rooms and long glassed-in corridors, is stifling, and the Pitti stands with wings extended in a glaring gravel courtyard, like a great brown flying lizard, basking in the terrible sun. Closed off, behind blinds and shutters, the city's inhabitants live a nocturnal life by day, like bats, in darkened rooms, wanly lit for the noon meal by electricity. At seven o'clock in the evening, throughout the city, there is a prolonged rumble that sounds as if it were thunder; the blinds are being rolled up to let in the exhausted day. Then the mosquitoes come.

For the tourist, it is too hot, after ten o'clock in the morning, to sight-see, too close, with the windows shut and the wooden blinds lowered, to sleep after lunch, too dark to read, for electricity is expensive, and the single bulb provided for reading in most Florentine hotels and households is no brighter than a votive candle. Those who try to sight-see discover the traffic hazard. The sidewalks are mere tilted rims skirting the building fronts; if you meet a person coming towards you, you must swerve into the street; if you step backward onto the pavement to look up at a palace, you will probably be run over. 'Rambles' through Florence, such as the old guidebooks talk of, are a funny idea under present conditions. Many of the famous monuments have become, quite literally, invisible, for lack of a spot from which they can be viewed with safety. Standing (or trying to stand) opposite Palazzo Rucellai, for example, or Orsanmichele, you constitute a traffic obstruction, to be bumped by pedestrians, honked at by cars, rammed by baby carriages and delivery carts. Driving a car, you are in danger of killing; walking or standing, of being killed. If you walk, you curse the automobiles and

motor-scooters; if you drive, you curse the pedestrians – above all, old women, children, and tourists with their noses in maps or guidebooks.

A 'characteristic' Florentine street - that is, a street which contains points of touristic interest (old palaces, a Michelozzo portal, the room where Dostoievski finished The Idiot, et cetera) - is not only extremely narrow, poor, and heavily populated, lined with florists and greengrocers who display their wares on the strip of sidewalk, but it is also likely to be one of the principal traffic arteries. The main route today from Siena and Rome, for example, is still the old Roman 'way', the Via Romana, which starts at the old arched gate, the Porta Romana (1326; Franciabigio fresco in the archway), bends northeast, passing the gardens of the Annalena (suppressed convent) on the left and the second gate of the Boboli on the right, the church of San Felice (Michelozzo façade) on the left again, to the Pitti Palace, after which it changes its name to Via Guicciardini, passes Palazzo Guicciardini (birthplace of the historian), the ancient church of Santa Felicita ('Deposition' by Pontormo inside, in a Brunelleschi chapel), and continues to Ponte Vecchio, which it crosses, changing its name again to Por Santa Maria and again to Calimala before reaching the city centre. The traffic on Via Romana is highly 'characteristic'. Along the narrow sidewalk, single file, walks a party of Swiss or German tourists, barelegged, with cameras and other equipment hanging bandoleerstyle from various leather straps on their persons; clinging to the buildings, in their cleated shoes, they give the effect

of a scaling party in the Alps. They are the only walkers, however, who are not in danger of death. Past them flows a confused stream of human beings and vehicles: baby carriages wheeling in and out of the Boboli Garden, old women hobbling in and out of church, grocery carts, bicycles, Vespas, Lambrettas, motorcycles, topolinos, Fiat seicentos, a trailer, a donkey cart from the country delivering sacks of laundry that has been washed with ashes, in the old-fashioned way, Cadillacs, Alfa-Romeos, millecentos, Chevrolets, a Jaguar, a Rolls-Royce with a chauffeur and a Florence licence plate, bands of brawny workmen carrying bureaus, mirrors, and credenzas (for this is the neighbourhood of the artisans), plumbers tearing up the sidewalk, pairs of American tourists with guidebooks and maps, children, artists from the Pensione Annalena, clerks, priests, housemaids with shopping baskets stopping to finger the furred rabbits hanging upside down outside the poultry shops, the sanitation brigade (a line of blueuniformed men riding bicycles that propel wheeled platforms holding two or three garbage cans and a broom made of twigs), a pair of boys transporting a funeral wreath in the shape of a giant horseshoe, big tourist buses from abroad with guides talking into microphones, trucks full of wine flasks from the Chianti, trucks of crated lettuces, trucks of live chickens, trucks of olive oil, the mail truck, the telegraph boy on a bicycle, which he parks in the street, a tripe-vendor, with a glassed-in cart full of smoking-hot entrails, outsize Volkswagen station wagons marked 'U.S. Forces in Germany', a man on a motorcycle with an overstuffed armchair strapped to the front of it, an organgrinder, horse-drawn fiacres from the Pitti Palace. It is as though the whole history of Western locomotion were being recapitulated on a single street; an airplane hums above; missing only is the Roman litter.

But it is a pageant no one can stop to watch, except the gatekeeper at the Boboli, who sits calmly in his chair at the portal, passing the time of day. In his safe harbour, he appears indifferent to the din, which is truly infernal, demonic. Horns howl, blare, shriek; gears rasp; brakes squeal; Vespassputter and fart; tyres sing. No human voice, not even the voice of a radio, can be distinguished in this mechanical babel, which is magnified as it rings against the rough stone of the palaces. If the Arno valley is a natural oven, the palaces are natural amplifiers. The noise is ubiquitous and goes on all day and night. Far out, in the suburbs, the explosive chatter of a Vespa mingles with the cock's crow at four in the morning; in the city an early worker, warming up his scooter, awakens a whole street.

Everyone complains of the noise; with the windows open, no one can sleep. The morning paper reports the protests of hotel-owners, who say that their rooms are empty: foreigners are leaving the city; something must be done; a law must be passed. And within the hotels, there is a continual shuffling of rooms. Number 13 moves to 22, and 22 moves to 33, and 33 to 13 or to Fiesole. In fact, all the rooms are noisy and all are hot, even if an electric fan is provided. The hotel-managers know this, but what can they do? To satisfy the client, they co-operate

with polite alacrity in the make-believe of room-shuffling. If the client imagines that he will be cooler or quieter in another part of the hotel, why destroy his illusions? In truth, short of leaving Florence, there is nothing to be done until fall comes and the windows can be shut again. A law already exists forbidding the honking of horns within city limits, but it is impossible to drive in a city like Florence without using your horn to scatter the foot traffic.

As for the Vespas and the Lambrettas, which are the plague of the early hours of the morning, how can a law be framed that will keep their motors quiet? Readers of the morning newspaper write in with suggestions; a meeting is held in Palazzo Vecchio, where more suggestions are aired: merit badges to be distributed to noiseless drivers; state action against the manufacturers; a special police night squad, equipped with radios, empowered to arrest noisemakers of every description; an ordinance that would make a certain type of muffler mandatory, that would make it illegal to race a motor 'excessively', that would prohibit motor-scooters from entering the city centre. This last suggestion meets with immense approval; it is the only one Draconian enough to offer hope. But the motor-scooterists' organization at once enters a strong protest ('undemocratic', 'discriminatory', it calls the proposal), and the newspaper, which has been leading the antinoise movement, hurriedly backs water, since Florence is a democratic society, and the scooterists are the popolo minuto - small clerks and artisans and factory workers. It

would be wrong, the paper concedes, to penalize the many well-behaved scooterists for the sins of a few 'savages', and unfair, too, to consider only the city centre and the tourist trade; residents on the periphery should have the right to sleep also. The idea of the police squad with summary powers and wide discretion is once again brought forward, though the city's finances will hardly afford it. Meanwhile, the newspaper sees no recourse but to appeal to the *gentilezza* of the driving public.

This, however, is utopian: Italians are not civic-minded. 'What if you were waked up at four in the morning?' – this plea, so typically Anglo-Saxon, for the other fellow as an imagined self, elicits from an Italian the realistic answer: 'But I am up.' A young Italian, out early on a Vespa, does not project himself into the person of a young Italian office worker in bed, trying to sleep, still less into the person of a foreign tourist or a hotel-owner. As well ask the wasp, after which the Vespa is named, to think of itself as the creature it is about to sting. The popolo minuto, moreover, likes noise, as everyone knows. 'Non fa rumore,' objected a young Florentine workman, on being shown an English scooter. 'It doesn't make any noise.'*

All ideas advanced to deal with the Florentine noise problem, the Florentine traffic problem, are utopian, and nobody believes in them, just as nobody believed in Machiavelli's Prince, a utopian image of the ideally self-

^{*} Nevertheless, finally an ordinance was passed by the municipality, setting a curfew of 11 p.m. to 6 a.m. on the use of motor scooters in the city's centre.

interested despot. They are dreams, to toy with: the dream of prohibiting all motor traffic in the city centre (on the pattern of Venice) and going back to the horse and the donkey; the dream that someone (perhaps the Rockefellers?) would like to build a subway system for the city.... Professor La Pira, Florence's Christian Democratic mayor, had a dream of solving the housing problem, another of the city's difficulties: he invited the homeless poor to move into the empty palaces and villas of the rich. This Christian fantasy collided with the laws of property, and the poor were turned out of the palaces. Another dream succeeded it, a dream in the modern idiom of a 'satellite' city that would arise southeast of Florence, in a forest of parasol pines, to house the city's workers, who would be conveyed back and forth to their jobs by special buses that would pick them up in the morning, bring them home for lunch, then back to work, and so on. This plan, which had something of science fiction about it, was blocked also; another set of dreamers - professors, architects, and art historians - rose in protest against the defacement of the Tuscan countryside, pointing to the impracticalities of the scheme, the burdening of the already overtaxed roads and bridges. A meeting was held, attended by other professors and city-planners from Rome and Venice; fiery speeches were made; pamphlets distributed; the preservers won. La Pira, under various pressures (he had also had a dream of eliminating stray cats from the city), had resigned as mayor meanwhile.

But the defeat of Sorgane, as the satellite city was to

be called, is only an episode in the factional war being fought in the city, street by street, building by building, bridge by bridge, like the old wars of the Blacks and Whites, Guelphs and Ghibellines, Cerchi and Donati. It is an uncertain, fluctuating war, with idealists on both sides, which began in the nineteenth century, when a façade in the then-current taste was put on the Duomo, the centre of the city was modernized, and the old walls along the Arno were torn down. This first victory, of the forces of progress over old Florence, is commemorated by a triumphal arch in the present Piazza della Repubblica with an inscription to the effect that new order and beauty have been brought out of ancient squalor. Today the inscription makes Florentines smile, bitterly, for it is an example of unconscious irony: the present Piazza, with its neon signs advertising a specific against uric acid, is, as everyone agrees, the ugliest in Italy-a folly of nationalist grandeur committed at a time when Florence was, briefly, the capital of the new Italy. Those who oppose change have only to point to it, as an argument for their side, and because of it the preservers have won several victories. Nevertheless, the parasol pines on the hill of Sorgane may yet fall, like the trees in the last act of The Cherry Orchard, unless some other solution is found for the housing problem, for Florence is a modern, expanding city - that is partly why the selective tourist dislikes it.

A false idea of Florence grew up in the nineteenth century, thanks in great part to the Brownings and their readers – a tooled-leather idea of Florence as a dear bit of

the old world. Old maids of both sexes - retired librarians, governesses, ladies with reduced incomes, gentlemen painters, gentlemen sculptors, gentlemen poets, anaemic amateurs and dabblers of every kind - 'fell in love' with Florence and settled down to make it home. Queen Victoria did water colours in the hills at Vincigliata; Florence Nightingale's parents named her after the city. where she was born in 1820 - a sugary statue of her stands holding a lamp in the first cloister of Santa Croce. Early in the present century, a retired colonel, G. F. Young of the Indian Service, who, it is said, was unable to read Italian, appointed himself defender of the Medicis and turned out a spluttering 'classic' that went through many editions, arguing that the Medicis had been misrepresented by democratic historians. (There is a story in Turgenev of a retired major who used to practice doctoring on the peasants. 'Has he studied medicine?' someone asks. 'No. he hasn't studied' is the answer. 'He does it more from philanthropy.' This was evidently the case with Colonel Young.) Colonel Young was typical of the Anglo-American visitors who, as it were, expropriated Florence, occupying villas in Fiesole or Bellosguardo, studying Tuscan wild flowers, collecting ghost stories, collecting triptychs and diptychs, burying their dogs in the churchyard of the Protestant Episcopal church, knowing (for the most part) no Florentines but their servants. The Brownings, in Casa Guidi, opposite the Pitti Palace, revelled in Florentine history and hated the Austrian usurper, who lived across the street, but they did not

mingle socially with the natives; they kept themselves to themselves. George Eliot spent fifteen days in a Swiss pensione on Via Tornabuoni, conscientiously working up the background for Romola, a sentimental pastiche of Florentine history that was a great success in its period and is the least read of her novels today. It smelled of libraries, Henry James complained, and the foreign colony's notion of Florence, like Romola, was bookish, synthetic, gushing, insular, genteel, and, above all, proprietary. This sickly love ('our Florence,' 'my Florence') on the part of the foreign residents implied, like all such loves, a tyrannous resistance to change. The rest of the world might alter, but, in the jealous eyes of its foreign owners, Florence was supposed to stay exactly as it was when they found it – a dear bit of the Old World.

Florence can never have been that, at any time in its existence. It is not a shrine of the past, and it rebuffs all attempts to make it into one, just as it rebuffs tourists. Tourism, in a certain sense, is an accidental by-product of the city—at once profitable and a nuisance, adding to the noise and congestion, raising prices for the population. Florence is a working city, a market centre, a railway junction; it manufactures furniture (including antiques), shoes, gloves, handbags, textiles, fine underwear, nightgowns, and table linens, picture frames, luggage, chemicals, optical equipment, machinery, wrought iron, various novelties in straw. Much of this work is done in small shops on the Oltrarno, the Florentine Left Bank, or on the farms of the contado; there is not much big industry but there is a

multitude of small crafts and trades. Every Friday is market day on the Piazza della Signoria, and the peasants come with pockets full of samples from the farms in the Valdarno and the Chianti: grain, oil, wine, seeds. The small hotels and cheap restaurants are full of commercial travellers, wine salesmen from Certaldo or Siena, textile representatives from Prato, dealers in marble from the Carrara mountains, where Michelangelo quarried. Everyone is on the move, buying, selling, delivering, and tourists get in the way of this diversified commerce. The Florentines, on the whole, would be happy to be rid of them. The shopkeepers on the Lungarno and on Ponte Vecchio, the owners of hotels and restaurants, the thieves, and the widows who run pensiones might regret their departure, but the tourist is seldom led to suspect this. There is no city in Italy that treats its tourists so summarily, that caters so little to their comfort.

There are no gay bars or smart outdoor cafés; there is very little night life, very little vice. The food in the restaurants is bad, for the most part, monotonous, and rather expensive. Many of the Florentine specialties—tripe, paunch, rabbit, and a mixture of the combs, livers, hearts, and testicles of roosters—do not appeal to the foreign palate. The wine can be good but is not so necessarily. The waiters are slapdash and hurried; like many Florentines, they give the impression of being preoccupied with something else, something more important—a knotty thought, a problem. At one of the 'typical' restaurants, recommended by the big hotels, the waiters, who are a family, treat the clients

like interlopers, feigning not to notice their presence, bawling orders sarcastically to the kitchen, banging down the dishes, spitting on the floor. 'Take it or leave it' is the attitude of the pensione-keeper of the better sort when showing a room; the inferior pensiones have a practice of shanghaiing tourists. Runners from these establishments lie in wait on the road, just outside the city limits, for cars with foreign licence plates; they halt them, leap aboard, and order the driver to proceed to a certain address. Strangely enough, the tourists often comply, and report to the police only later, when they have been cheated in the pensiones. These shades of Dante's highwaymen are not the only ones who lie in wait for travellers. One of the best Florentine restaurants was closed by the police a few years ago - for cheating a tourist. Complaints of foreign tourists pour every day into the questura and are recorded in the morning newspaper: they have been robbed and victimized everywhere; their cars, parked on the Piazza della Signoria or along the Arno, have been rifled in broad daylight or spirited away. The northern races - Germans and Swedes appear to be the chief prey, and the commonest complaint is of the theft of a camera. Other foreigners are the victims of accidents; one old American lady, the motherin-law of an author, walking on Via Guicciardini, had the distinction of being hit by two bicycles, from the front and rear simultaneously (she was thrown high into the air and suffered a broken arm); some British tourists were injured a few years ago by a piece falling off Palazzo Bartolini Salimbeni (1517-20) in Piazza Santa Trinita. Finally the sidewalk in front of that crumbling building was closed off and a red lantern posted: beware of falling masonry.* Recently, during the summer, a piece weighing 132 pounds fell off the cornice of the National Library; a bus-conductor, though, rather than a tourist or foreign student, just missed getting killed and, instead, had his picture in the paper.

All summer long, or as long as the tourist season lasts, the 'Cronaca di Firenze' or city news of the Nazione, that excellent morning newspaper, is a daily chronicle of disaster to foreigners, mixed in with a few purely local thefts, frauds, automobile accidents, marital quarrels, and appeals for the preservation of monuments. The newspaper deplores the Florentine thieves, who are giving the city a bad name, like the noisemakers (i selvaggi). It seeks to promote in its readers a greater understanding of the foreigner, a greater sympathy with his eating habits, his manner of dress, and so on. Yet an undertone of irony, typically Florentine, accompanies this official effort; it is the foreigners with their cameras and wads of currency who appear to be the 'savages', and the thieves who are behaving naturally. A series of 'sympathetic' articles on tourism was illustrated with decidedly unsympathetic photographs, showing touristic groups masticating spaghetti, tourists entering the Uffizi naked to the waist.

On the street, the Florentines do not like to give directions; if you are lost, you had better ask a policeman. Unlike the Venetians, the Florentines will never volunteer

^{*} The palace has since been restored.

to show a sight to a passing stranger. They do not care to exhibit their city; the monuments are there - let the foreigners find them. Nor is this a sign of indifference, but of a peculiar pride and dignity. Florentine sacristans can never be found to turn on the lights to illuminate a fresco or an altar painting; they do not seem to take an interest in the tip. Around the Masolino-Masaccio-Filippino Lippi frescoes in the Brancacci Chapel of the Carmine, small groups of tourists wait, uneasily whispering; they try to find the lights for themselves; they try looking for someone in the sacristy. Finally a passing priest flicks on the electricity and hurries off, his robes flying. The same thing happens with the Ghirlandaio frescoes in Santa Trinita. Far from hovering, as the normal sacristan does, in ambush, waiting to expound the paintings, the Florentine sacristan does not make himself manifest until just before closing time, at midday, when he becomes very active, shooing people out of the church with shrill whistles and threatening gestures of his broom. If there are postcards for sale in a church, there is usually nobody to sell them.

This lack of co-operative spirit, this absence, this pre-occupation, comes, after a time, and if you are not in a hurry, to seem one of the blessings of Florence, to make it, even, a hallowed place. This is one of the few cities where it is possible to loiter, undisturbed, in the churches, looking at the works of art. After the din outside, the churches are extraordinarily peaceful, so that you walk about on tiptoe, fearful of breaking the silence, of distracting the few old

women, dimly seen, from their prayers. You can pass an hour, two hours, in the great churches of Brunelleschi -Santo Spirito and San Lorenzo - and no one will speak to you or pay you any heed. Touristic parties with guides do not penetrate here; they go instead to the Medici Chapels, to see the Michelangelos. The smaller churches-Santa Trinita, Santa Felicita, Ognissanti, Santissima Annunziata, Santa Maria Maddalena dei Pazzi, San Giovannino dei Cavalieri - are rarely visited; neither is the Pazzi Chapel in the court of Santa Croce, and the wonderful Giottos, freshly restored, in the Bardi Chapel of Santa Croce, still surrounded by a shaky scaffold, are seen only by art critics, their families and friends. San Miniato, on its hill, is too far away for most tourists; it is the church that, as they say, they missed. And the big churches of the preaching orders, Santa Maria Novella and Santa Croce, and the still bigger Duomo, where Savonarola delivered sermons to audiences of ten thousand swallow up touristic parties, leaving hardly a trace. The tourists then complain of feeling 'dwarfed' by this architecture. They find it 'cold', unwelcoming.

As for the museums, they are the worst-organized, the worst-hung in Italy – a scandal, as the Florentines say themselves, with a certain civic pride. The exception, the new museum that has been opened in the old Fort of the Belvedere, with pale walls, wide views, cool rooms, sparsely hung, immediately became a subject of controversy, as did the new rooms of the Uffizi, which were held to be too white and uncluttered.

In the streets, the famous parti-coloured monuments in geometric designs - the Baptistery, Giotto's bell tower, the Duomo, the façade of Santa Maria Novella - are covered with grime and weather stains. The Duomo and the Bell Tower are finally getting a bath, but this is a tedious process that has been going on for years; by the time the Duomo's front is washed, the back will be dirty again. Meanwhile, the green, white, and pink marbles stand in scaffolding, while the traffic whizzes around them. The Badia, the old Benedictine abbey, where the Good Margrave, Ugo of Tuscany (Dante's 'gran barone') lies buried and which has now been partly incorporated into the police station, is leaking so badly that on a rainy Sunday parishioners of the Badia church have had to hear mass with their umbrellas up; it was here that Dante used to see Beatrice at mass. Among the historic palaces that remain in private hands, many, like Palazzo Bartolini Salimbeni, are literally falling to pieces. The city has no money to undertake repairs; the Soprintendenza delle Belle Arti has no money; private owners say they have no money.

Historic Florence is an incubus on its present population. It is like a vast piece of family property whose upkeep is too much for the heirs, who nevertheless find themselves criticized by strangers for letting the old place go to rack and ruin. History, in Venice, has been transmuted into legend; in Rome, the Eternal City, history is an everlasting present, an orderly perspective of arches receding from popes to Caesars with the papacy guaranteeing perman-

ence and framing the vista of the future - decay being but an aspect of time's grandeur. If St Peter's were permitted to fall to pieces, it would still inspire awe, as the Forum does, while the dilapidation of Venetian palaces, reflected in lapping waters, is part of the Venetian myth, celebrated already by Guardi and Bellotto in the eighteenth century. Rome had Piranesi; Naples had Salvatore Rosa; but Florentine decay, in the Mercato Vecchio and the crooked byways of the Ghetto (now all destroyed and replaced by the Piazza della Repubblica), inspired only bad nineteenthcentury water-colourists, whose work is preserved, not in art galleries, but in the topographical museum under the title of 'Firenze Come Era' ('Florence as It Was'). History, for Florence, is neither a legend nor eternity, but a massive weight of rough building stone demanding continual repairs, pressing on the modern city like a debt, blocking progress.

This was a city of progress. Nothing could be more un-Florentine, indeed more anti-Florentine, than the protective custody exercised by its foreign residents, most of whom have abandoned the city today, offended by the Vespas, the automobile horns, the Communists, and the rise in the cost of living. Milanese businessmen are moving into their villas and installing new tiled bathrooms with coloured bathtubs and toilet seats, linoleum and plastics in the kitchen, television sets and bars. These Milanesi are not popular; they too are 'selvaggi', like their Lombard predecessors who descended on Tuscany in the sixth century to brutalize and despoil it. Yet these periodic

invasions belong to Florentine life, which is penetrated by the new and transforms it into something newer. Florence has always been a city of extremes, hot in the summer, cold in the winter, traditionally committed to advance, to modernism, yet containing backward elements narrow as its streets, cramped, stony, recalcitrant. It was the city where during the last war individual Fascists still held out fanatically after the city was taken by the Allies, and kept shooting as if for sport from the roof tops and loggias at citizens in the streets below. Throughout the Mussolini period, the Fascists in Florence had been the most violent and dangerous in Italy; at the same time, Florence had been the intellectual centre of anti-Fascism, and during the Resistance, the city as a whole 'redeemed itself' by a series of heroic exploits. The peasants of the contado showed a fantastic bravery in hiding enemies of the regime, and in the city many intellectuals and a few aristocrats risked their lives with great hardihood for the Resistance network. Florence, in short, was split, as it had always been, between the best and the worst. Even the Germans here were divided into two kinds. While the S.S. was torturing victims in a house on Via Bolognese (a nineteenth-century upper-middle-class 'residential' district), across the city, on the old Piazza Santo Spirito, near Brunelleschi's church, the German Institute was hiding anti-Nazis in its library of reference works on Florentine art and culture. The chief arm of the S.S. was a Florentine devil strangely named 'Carità', who acted as both informer and torturer; against the S.S., the chief defence was the German consul, who

used his official position to save people who had been denounced. After the Liberation, the consul was given the freedom of the city, in recognition of the risky work he had done. Such divisions, such extremism, such contrasts are *Firenze Come Era* – a terrible city, in many ways, uncomfortable and dangerous to live in, a city of drama, argument, and struggle.

Chapter Two

Catiline, fleeing from Rome, came to Etruria, to the ancient hill town of Fiesole, where he and his fellowconspirators found a ready welcome among the dissatisfied townspeople. In the old Etruscan stronghold, he proclaimed himself consul and assumed the consular dress. A Roman expedition was sent against him and the people of Fiesole. It was a noble Roman warrior called Fiorino who led the attack against Fiesole, which was too well defended, however, to be taken by assault. Fiorino, perceiving this, built a camp at the ford on the Arno where Florence now is and where the Fiesole people used to come every week to market. Fiorino was killed during a surprise night sortie from Fiesole. Caesar arrived with reinforcements and started to build a city. Fiesole was taken and destroyed. Catiline and his partisans escaped into the Pistoiese hills, where they were hunted down by the legions and slain in the great battle of Pistoria.

This account of the founding of the city, given by the old chroniclers, is a curious mixture of myths and actual history. Caesar never fought in Tuscany, but Catiline was in Fiesole, and there was a famous battle of Pistoria in which he perished. Fiorino, the eponymous hero, was a literary invention, on the pattern of Romulus, but there

was an Etruscan ford and market on the Arno, near Ponte Vecchio, at the narrowest point of the river, and Caesar, in a sense, was the founder of the city, which was resettled by his veterans, on the site of an Italic town, under the agrarian laws he sponsored. Even the date is not far off; the battle of Pistoria, which gives the time of the legendary foundation, took place in 62 B.C.; the agrarian laws were put into effect in 59 B.C.

Roman Florence had baths, temples, a forum, where the Piazza della Repubblica is now, a Capitol or a great temple to Jupiter with a marble staircase leading up to it, an aqueduct, and a theatre, all of which have vanished, leaving a few street names as markers: Via delle Terme or Street of the Baths, Via del Campidoglio or Street of the Capitol. Outside the city walls, there was an amphitheatre, seating fifteen thousand people; its outlines can still be seen on curving Via Torta, Via dei Bentaccordi, and Piazza dei Perruzzi, which transcribe half an oval near the church of Santa Croce. The back of Palazzo Vecchio occupies the site of the theatre, and the Baptistery, that of the praetorium or residence of the Roman governor. In the Baptistery, in the crypt of San Miniato (the first local Christian martyr; decapitated in the arena, he carried his head across the river and up the hill to what is now his church), there are Roman columns and frilled capitals which were put to use by Romanesque builders. The tradition of Rome is palpable in Florence to those who know that it is there, just as, to those who know of it, the plan of the Roman colony, laid out like a camp

or castrum, becomes visible in the city's old streets. Florence was the 'daughter', Rome, the 'mother' – this was the medieval notion. The Florentines of the Middle Ages boasted of the tradition, claiming descent from noble Roman families. The Uberti, for example, purported to descend from a supposed son of Catiline, pardoned by Caesar and adopted by him under the name of Uberto Cesare. In Dante's day, it was believed that two races had settled Florence: the nobles or Blacks, who were descended from the soldiers of the Roman army; and the common people or Whites, who were descended from the primitive

inhabitants of Fiesole. The incompatibility of these two stocks was held to be the explanation of the perpetual strife in the city. Another story told how Florence, destroyed by Totila, was rebuilt by Charlemagne, who restored it 'come era', with its antique form of government –

Roman law, consuls, and senators.

These legends and genealogical fantasies struck a core of truth. The sobriety and decorum of Florence is the gravitas of Rome – a pioneer, frontier Rome, set in the wild mountains, on a rushing river. This sense of an outpost, of a camp pitched in a military rectangle hard by the mountain of Fiesole, is still perceptible in the streets around the Duomo – Via Ricasoli, Via dei Servi, which run straight out towards the mountain barrier like streets in the raw towns of the old American Far West.

Beneath the surface of Florence lies a sunken Rome. In the dim light, the crypt of San Miniato, with its pillars of odd sizes and shapes, resembles a petrified forest. Tradition

used to say that the Baptistery was the old temple of Mars, the war god of Caesar's veterans, who was the patron of the city. There is a modern theory that the Marzocco or Florentine heraldic lion was really the Martocus or a mutilated equestrian statue of Mars that was left on guard, superstitiously, at Ponte Vecchio, until 1333, when it was carried away by a flood. This statue played an ominous part in Florentine history. In the year 1215, on Easter Sunday, young Buondelmonte de' Buondelmonti, riding his milk-white palfrey, in his wedding garment, with his marriage wreath on his head, was struck down at the north end of Ponte Vecchio, at the statue's base, by the Amidei, because he had broken his marriage pledge to a member of their family. This was the fuse that set off the Guelph-Ghibelline chain reaction that continued for a century and a half and nearly consumed the city. In 1300, when the headless and ravaged torso of the god was replaced at its post on Ponte Vecchio, after some building improvements, it was set up facing north instead of east, as it had done in the past; this was considered to be a sinister portent for Florence, and, in fact, that year the Black and White division began. Dante, a White Guelph, who was driven into exile by that feud, identified the angry war god, who had been displaced as the city's guardian by the Baptist, with the spirit of restless faction in Florence. Much earlier, according to the story, the statue, having been removed from its former temple, was stowed away in a tower near the Arno and fell into the river at the time of the mythical destruction by Totila; if it had not finally been retrieved

and set up on Ponte Vecchio, Florence could not have been rebuilt. The flood of 1333, which swept away the bridges together with the statue, was an apocalyptic event. A strange storm began it, lasting ninety-six hours, as described by an eyewitness, the chronicler Villani. There were sheets of fire, thunder, and a continuous stream of water; men and women, crying for mercy, moved from roof to roof on slender planks; tiles fell, towers crashed, the walls gave way; the red columns of San Giovanni were half buried in water. Church and convent bells tolled to exorcise the spirit of the storm. It was not long after this fearful flood and the loss of the guardian statue that another great calamity befell Florence: in 1339, Edward III of England went bankrupt, toppling the two Florentine banking houses of the Bardi and the Peruzzi, which had backed him in his continental wars; this was the ruin of Florence as world banking power.

The war god on the bridge was replaced as the city's portafortuna by the lion on the shield. The Florentine Marzocco, unlike the Venetian Lion of Saint Mark, had no church affiliations; it was a strictly political beast, repulsive to look at, even in Donatello's stone carving. The pious emblem of Florence was the lily, and some writers who do not hold the Martocus theory believe that the Marzocco was the relic of a different superstition: during the Middle Ages, the signory used to keep lions in the dungeons of the city palace, and their behaviour was carefully watched throughout times of crisis for its bearing on the fortunes or the state. The ancient art or science of

augury had been a specialty of the region long before Caesar or Catiline. Etruscan priests, renowned for their skill, practised divination on the mountain top of Fiesole, scanning the skies and the storms for portents, just as Galileo, later, condemned by the church, observed the heavenly bodies on the hills of Bellosguardo and Arcetri, under the protection of Cosimo II. In this river settlement, surrounded by natural observatories, science and prophecy flourished, together with odd religions. On the Piazza San Firenze, not far from the Bargello, there was a temple to Isis, the Egyptian goddess of floods and rivers, whose cult may have been brought home by Roman veterans; at Fiesole, there was a college of lay priests devoted to the Magna Mater, an Eastern importation. Isis weeping for Osiris, the Magna Mater weeping for Attis, who castrated himself under a pine tree - these sad cults from faraway places found votaries here in Tuscany, where they were purified of their licentious elements, so characteristic of them elsewhere in the Empire; they foreshadowed, says the historian Davidsohn, the special Florentine devotion to the Madonna. The Mourning Mother was, of course, linked to the calendar and to the seasons. Until the middle of the eighteenth century, the Florentines dated the beginning of the year ab incarnazione, that is, from the conception or incarnation of Christ, which meant that the new year started nine months before Christmas, on the twenty-fifth of March. This is the Day of the Annunciation - one of the most popular subjects of Tuscan painting. The angel of the new year, with his lily, announcing

the planting of a Sacred Seed to a peasant maiden, is evidently spring. The old Roman calendar had started the new year with the spring equinox – the twenty-first of March.

The forum or market place, later the Mercato Vecchio, had been framed by a triumphal arch (still remembered in the Middle Ages) and adorned with statues of emperors and magistrates. Those who complain of an absence of religious feeling in Florentine churches, finding them too plain, too sober, too, as it were, 'Protestant', will discover that feeling in the Bargello and in the Museum of the Works of the Duomo, which are dedicated to sculpture, like temples. These all-but-deserted sanctuaries are the holy places of the city. Much of the statuary in these two museums has been brought indoors, to protect it from the elements. Old Testament prophets from their high lookout posts on the Bell Tower; tall, ox-eyed Virgins from above the doorways of the Duomo; a group of three monumental figures - Saint Peter, Saint Paul, and the Virgin - from the Porta Romana; Saint George, lightly clad, with his shield, from Orsanmichele, that peculiar church that was half a grain depot to be used in case of emergency, siege or famine-they stood at key posts, coigns of vantage, in the city, like watchmen of the public weal. Battered by the weather, they have taken on some of the primordial character of the elements they endured as protectors of the people. In their bunched or draped garments, with wide-open, deep-socketed stone eyes, they have a curious look of pilgrims or wayfarers who

are gathered together in these shelters to await the next stage on the journey; other figures, from inside the churches, have joined them: several Baptists; a mitred pope, blessing; the singing, dancing children of Luca della Robbia and Donatello. Some, like the Doctors of the Church from the Poggio Imperiale avenue who were transformed into poets by the addition of laurel wreaths, are in a pitiable condition, resembling Immortals in a drunken disguise. They are a strange mixed crew, these holy persons, but this attests their holiness and the fact that they are pilgrims. Saint George, in his commanding niche at the Bargello, is a Spartan athlete or young Roman Empire-builder, swordless, in a light cloak, tied in a becoming bow around his handsome neck, intrepid eyes forward to the future; near him stands a starveling San Giovannino, the boy Baptist, daunted by his mission, gasping, with parted lips and staring eyes. Queer companions, as far apart as Achilles and the tortoise, yet both are by Donatello; both are profoundly moving and beautiful; both are patterns of courage. The resolute Saint George, mailed at arms, legs, and feet, wears no halo on his short manly locks; San Giovannino, irresolute, in his ragged hair shirt, with his thin arms, bumpy shoulders, and shrunken legs, has an emaciated gold cross and a thin gold plate of a halo, like feeble sun glints, to accompany him in the scary desert. Behind San Giovannino is a bust in painted terracotta of Nicolò da Uzzano, leader of the Aristocratic party, looking like a Roman magistrate. Further down the room is the Marzocco.

The statuary of Florence is its genius or attendant spirit, compelling awe not only because it is better than any other statuary done since ancient Greece, a categorical statement, but because, good and bad alike, it is part of the very fabric of the city - the respublica or public thing. It belongs to a citizenry, stubborn and independent, and to a geography, like that of Athens, of towering rock and stone. The Florentine sculptors of the quattrocento sprang from the quarries of the neighbouring hills, where the macigno or grey pietra serena was cut. Desiderio da Settignano, Benedetto da Maiano, Mino da Fiesole, Benedetto da Rovezzano - these were village boys brought up among stone-cutters. Michelangelo was put out to nurse in Settignano, and he used to say that he imbibed his genius from his wet nurse's limy milk. Green marble, used chiefly for facing churches in geometric designs, came from the hills near Prato; the famed white marble of Florentine sculpture came from Carrara, in that eerie mountain range, the Apuan Alps, that runs above the coast north of Pisa, near where Shelley drowned, at Viareggio, and where there is now an ugly string of beach resorts. Michelangelo, like some strange Ibsen hero, spent years in the Carrara mountains, quarrying marble for his statuary amid peaks that appear snow-streaked because of their gleaming white fissures. The great white blocks, 'free from cracks and veins', as the contracts promised, were loaded onto barges and floated, along green waterways, to Florence or Rome. This marble was already known in the days of Augustus, and the art of carving beautiful marbles was first mastered by the Pisans, as early as the *duecento*, three centuries before Michelangelo, in sculptures that were already Renaissance or still classical. Workmen from Pisa brought the art to Florence; the Florentine habit of casting in bronze is

thought to go back to the Etruscans.

White, black, grey, dun, and bronze are the colours of Florence – the colours of stone and metal, the primitive elements of Nature out of which the first civilizations were hammered – the Stone Age, the Bronze Age, the Iron Age. The hammer and the chisel strike the sombre music of Florentine art and architecture, of the Florentine character. Those huge iron gratings on the windows of Florentine palaces, the iron rings and the clamps for torches that are driven into the rough bosses of stone came from the gloomy iron mines of Elba, a Tuscan possession. You can still hear the sound of the forge in the workshops of the Oltrarno, and the biggest industry of modern Florence is a metallurgical works.

The Florentines of the Middle Ages and the Renaissance, when they went into battle, carried statuary with them. Savonarola, though he was supposedly an enemy of art, had a Donatello Infant Jesus borne in procession on the day of the Bonfire of Vanities, when so many secular paintings were burnt, including the studies from life of Fra Bartolomeo. Among the people, it was believed, as late as the present century, that spirits were imprisoned in statues. The statue of Neptune by Ammannati in the fountain of the Piazza della Signoria is called 'Il Biancone' or 'The Great White Man' by the poor people, who used

to say that he was the mighty river god of the Arno turned into a statue because, like Michelangelo, he spurned the love of women. When the full moon shines on him, so the story goes, at midnight, he comes to life and walks about the Piazza conversing with the other statues. Michelangelo's 'David', before it became a statue, used to be known as 'The Giant'. It was a great block of marble eighteen feet high that had been spoiled by Agostino di Duccio; personified by popular fancy, it lay for forty years in the workshops of the Cathedral, until Michelangelo made the Giant into the Giant-Killer, that is, into a patriotic image of the small country defeating its larger foes. Giants, it was related, had built the great Etruscan stone wall of Fiesole, and many stories were told in Florence of beautiful maidens being turned into pure white marble statues.

More than any other piazza in Italy, the Piazza della Signoria evokes the antique world, not only in the colossal deified statues, the 'David', the 'Neptune' (of which Michelangelo said, 'Ammannato, Ammannato, che bel marmo hai rovinato,' thinking, that is, of the damage to the marble wrought by the inept sculptor), the hideous 'Hercules and Cacus', but in the sober Loggia dei Lanzi, with its three lovely full arches and its serried statuary groups in bronze and marble. Some are antique Greek and Roman; some are Renaissance; some belong to the Mannerist epoch; one to the nineteenth century. Yet there is no disharmony among them; they seem all of a piece, one continuous experience, a coin periodically reminted. It

is a sanguinary world they evoke. Nearly all these groups are fighting. The helmeted bronze Perseus, by Cellini, is holding up the dripping head of Medusa, while her revolting trunk lies at his feet; Hercules, by Giambologna, is battling with Nessus the Centaur; Ajax (after a Greek original of the fourth century B.C.) is supporting the corpse of Patroclus. There are also the Rape of the Sabine Women, by Giambologna, the Rape of Polixena, by Pio Fedi (1866), and 'Germany Conquered', a Roman female statue, one of a long line of Roman matronly figures that stand against the rear wall, like a chorus of mourners. Two lions - one Greek, one a sixteenth-century copy - flank these statuary groups, which are writhing, twisting, stabbing, falling, dying, on their stately pedestals. Nearby, at the entrance to Palazzo Vecchio, Judith, by Donatello, displays the head of Holofernes, and in the courtyard, Samson struggles with a Philistine. Down the square, Cosimo I rides a bronze horse.

This square, dominated by Palazzo Vecchio, which was the seat of government, has an austere virile beauty, from which the grossness of some of the large marble groups does not at all detract. The cruel tower of Palazzo Vecchio pierces the sky like a stone hypodermic needle; in the statuary below, the passions are represented in their extremity, as if strife and discord could be brought to no further pitch. In any other piazza, in any other city, the line-up of murderous scenes in the Loggia dei Lanzi (named for Cosimo I's Swiss lancers, who stood on guard there, to frighten the citizenry) would create an effect of

terribilità or of voluptuous horror, but the Florentine classical spirit has ranged them under a porch of pure and refined arches (1376–81), which appear to set a ceiling or limit on woe.

This was the civic centre, distinct from the religious centre in the Piazza of the Duomo and the Baptistery and from the two market places. Donatello's 'Judith and Holofernes' was brought here from Palazzo Medici, where it had been part of a fountain, and set up on the aringhiera or balustraded low terrace of Palazzo Vecchio as an emblem of public safety; an inscription on the base declares that this was done by the people in 1495 - when the Medici had just been chased out and their treasures dispersed. The aringhiera was the platform from which political orations were delivered and decrees read by the signory to the people (this is the derivation of the word 'harangue'), and the statue of Judith cutting off the tyrant's head was intended to symbolize, more succinctly than words, popular liberty triumphing over despotism. The Medici were repeatedly chased out of Florence and always returned. When Cosimo I installed himself as dictator, he ordered from Cellini the 'Perseus and Medusa', to commemorate the triumph of a restored despotism over democracy. Meanwhile, Michelangelo's 'Brutus' (now in the Bargello) had been commissioned, it is thought, by a private citizen, to honour the deed of Lorenzino de' Medici, who had earned the name Brutus by assassinating his distant cousin, the repugnant tyrant Alessandro. This same Lorenzino was infatuated with the antique and had been blamed by his relation Pope Clement VII for knocking the heads off the statues in the Arch of Constantine in Rome – the meaning of this action remains mysterious. Another republican, Filippo Strozzi, of the great banking family, when imprisoned by Cosimo I, summoned up the resolution to kill himself by calling to mind the example of Cato at Utica.

The statues in the square were admonitory lessons or 'examples' in civics, and the durability of the material, marble or bronze, implied the conviction or the hope that the lesson would be permanent. The indestructibility of marble, stone, and bronze associates the arts of sculpture with governments, whose ideal is always stability and permanence. The statue, in Greek religion, is thought to have been originally a simple column, in which the trunk of a man or, rather, a god was eventually descried. Florentine sculpture, whether secular or religious, retained this classic and elemental notion of a pillar or support of the social edifice. Other Italians of the Renaissance, particularly the Lombards, were sometimes gifted in sculpture, but the Florentines were almost always called upon by other cities when it was a question of a public, that is, of a civic, work. The great equestrian statue of the condottiere Gattamelata that stands in the square at Padua was commissioned from Donatello: when the Venetians wanted to put up a statue along the same lines (the Colleone monument), they sent for Verrocchio. The state sculptor of the Venetian Republic was the Florentine, Sansovino.

The idea of infamy, curiously enough, was conveyed by the Florentines through painting. Important public malefactors had their likenesses painted on the outside walls of the Bargello, which was then the prison and place of execution, where they were left to fade and blister with time, like the rogues' gallery in an American post office, though in the case of Florence the criminals were not 'wanted' but already in the grasp of the authorities. The flimsiness and destructibility of a painted image, corresponding to a tattered reputation, was also emphasized in the Bonfire of Vanities, when the Florentines, disapproving of the attitude of a Venetian merchant who was present, had his portrait painted and burned it with the rest of the pyre.

The sculpture galleries of the Bargello and of the Works of the Duomo create a somewhat mournful and eerie effect because a civic spirit, the ghost of the Republic, is imprisoned, like a living person, in the marble, bronze, and stone figures, which appear like isolated, lonely columns, props and pillars of a society whose roof has fallen in. As in the ancient city-states, the religious and the civic were identical or nearly so in republican Florence; the saints were the civic champions, under whose protection and example the city fought. This was general among the city-states of the Middle Ages, each of which had its own special protectors (i.e., its own religion). The Venetians rallied to the yell of 'San Marco', and the Luccans to 'San Martino', as the Florentines did to 'San Giovanni'. Having their own religion, their own patriotic

saints, the Florentines, like the Venetians, had small fear of the pope and were repeatedly subjected to interdict and excommunication; at one point, Florence, acting through the bishops of Tuscany, turned around and excommunicated the pope. The inscription, put up on Palazzo Vecchio during the siege of Florence in 1529, 'Jesus Christus, Rex Florentini Popoli S.P. Decreto electus' ('Jesus Christ, King of the Florentine People, elected by Popular Decree') asserted an absolute independence, not only of worldly rulers, but of any other spiritual power but Christ's. This claim to be the city of God, the new Jerusalem, had already been implicit in the multiplicity of durable patriotic images, telamons, caryatids, hammered out by Florentine sculptors. Florentine sculpture has a local character, the spirit of a small place and province, unknown elsewhere in the West after Attica and Ionia. 'The small state,' says Jacob Burckhardt, 'exists so that there may be a spot on earth where the largest possible proportion of the inhabitants are citizens in the fullest sense of the word.' He was thinking of the Greek polis or city-state, but he might also have been describing the Florentine Republic; in both cases, citizenship and sculpture, together, were developed to the highest point.

Florentine sculpture, like Greek, was capable of intimacy and of the delicate shades of private feeling, but this, for the most part, as in Greece, was expressed on tombs and in the form of bas-relief, which is between statuary and drawing. The exquisite tombs of Desiderio

and of Mino da Fiesole and their many charming heads of children are full of a private and therefore half-fugitive emotion; the discreet grief of a mourning family has the finest veil drawn across it, like the transparent marble veils of the Madonna and the drapery of angels in which these refined sculptors excelled. The restraint and control of Florentine low relief is very close to the Greek stele, which was originally a simple tablet with an inscription; the evanescent is inscribed or imprinted on stone, and the modulations in depth, with a narrow compass, imply

reserve and tact, as in Greek elegiac poetry.

What makes this art appear 'classical' has nothing to do with the imitation of classical models. The Greek work that is closest to Mino, to Desiderio, to some of Donatello. and to Agostino di Duccio was hardly known in Italy in their time. The affinity with fifth-century Athens may be due partly to geography, partly to political structure to the clear outlines of landscape and to a tradition of sharp, clear thought. Distinction and definition reduce forms and ideas to their essentials - that is, to bedrock. 'By sculpture,' said Michelangelo, 'I understand an art that takes away superfluous material; by painting, one that attains its result by laying on.' The art that takes away superfluous material, to lay bare an innate form or idea, was the art practised by Socrates in eliciting a truth from his interlocutor, who 'knew' the truth already but could not perceive it until the surrounding rubbish was cut away. The Florentines 'knew' that a statue was, in essence, a pillar, a column, and that a funerary monument

was, in essence, a tablet with writing on it. This knowing is the classic temper.

The line between public and private was strictly drawn in the days of the Republic. The Florentines were known for their extreme individuality, yet no statue of a condottiere was permitted in a public square or, for that matter, in a private chapel. Grandiose tombs were unheard of in Florence before Michelangelo. Mourning remained a family matter, as it had been with the Etruscans, who represented husband and wife sitting at ease on their tombs, as if at a last domestic feast. Florentine decorum did not permit apotheoses of dead persons, such as were common in Venice.

The glorification of the individual was frowned on by the Republic; it was against public policy to encourage private show. Bifore windows, for example, so familiar in Sienese Gothic palaces, were allowed only in religious buildings in medieval Florence; the householder had to be content with a monofore. The severity of Florentine architecture owes a good deal to this prohibition. Cosimo il Vecchio, the founder of the Medici dynasty, was too cautious a politician to endanger his power by a pompous style of living; in his later days, he rejected titles and honours and declined the luxurious palace, in full Renaissance style, that Brunelleschi proposed to build him, commissioning Michelozzo instead to do him a plain, solid dwelling with a heavy cornice, in rusticated stone, where, dissimulating his real sovereignty, he played the part of a retiring private citizen. 'Too big a house for such

a little family,' he used to sigh, nevertheless, when he was a lonely pantaloon in the big silent rooms, and his children had disappointed him. He buried his parents in a plain marble box in the Old Sacristy of San Lorenzo.

It was a bastard Medici - Pope Clement VII, illegitimate son of that Giuliano who was killed by the Pazzi Conspirators while hearing mass at the Duomo - who breached the tradition, ordering the New Sacristy in San Lorenzo from Michelangelo to glorify two members of his family who would better have been forgotten. These celebrated Medici Tombs have a curious theatrical quality, as of a stage production in Caesarean costumes, complete with helmets, armour, plumes; the chapel that contains this brilliant rodomontade is more like a stage set than like architecture - a travesty or cynical exaggeration of the Brunelleschi sacristy, which it copies, just as the two dukes, posed like actors in a tableau, are a travesty of Renaissance virtù. Michelangelo, who, in any case, as Vasari says, 'detested to imitate the living person unless it were one of incomparable beauty,' made no attempt at portraiture, such as was customary in funerary statues; his two dukes are two handsome leading men, type-cast in Renaissance parts. The statue had become the statuesque - no longer a pillar of the community, but a form of marble flattery.

Michelangelo's sculpture projects were expensive, and, as he grew older, only popes and tyrants could afford to patronize him. The gigantism of his later conceptions was out of scale, too, with the strict notions of measure and

limit that governed his native city - notions peculiar to small, armed republics of the antique stamp. He himself lived in Rome, under the patronage of a series of papal princes, and even Cosimo I, the new Medici despot, could not entice him back to what then became the Grand Duchy of Tuscany. During the Siege of Florence, he had run away, briefly, to Venice, quitting his job as supervisor of the city's fortifications in an access of panic, which he tried to justify afterward, when he wanted to return. He was no Cato or Brutus, yet in his way, like the embittered Dante in exile, he was a sour patriot. The four famous, somewhat rubbery symbolic figures of Night and Day, Twilight and Dawn, on the Medici Tombs are believed to express, in hidden language, his despair over the fall of the Republic and the triumph of the Medici dynasty. And in the statuary group called 'Victory' in Palazzo Vecchio, which shows an inane-looking young man crushing the back of an old man, who is bent double beneath him, the victim is supposed to have the features of Michelangelo. It is hard, however, to attribute Michelangelo's personal sense of persecution (the other side of his megalomania) to patriotic motives. 'I never had to do with a more ungrateful and arrogant people than the Florentines,' he wrote in a letter.

In other respects, he himself was a true Florentine – dry, proud, terse, thrifty. The correspondence of his later years is almost wholly concerned with money matters. Miserly with himself, he was buying up Tuscan real estate for his brothers and his nephew. One by one,

through his agents, he picked up farms at good prices, and he finally achieved his ambition of establishing the Buonarroti family in a solid, unostentatious dwelling, now the Casa Buonarroti or Michelangelo museum, on Via Ghibellina, in the Santa Croce quarter. All his private incentives, his planning for the future, centred on Florence. Though he refused to come himself, he advised Cosimo through Vasari about his building projects for the city, and he tried to accumulate merit in the next world by providing dowries for poor Florentine girls of good family, to permit them to marry or buy their entry into convents.

In his own day, he was often likened to the sculptors of antiquity, and a 'Sleeping Cupid' he had done as a young man actually passed for an antique. This was an early case of art forgery, whose victim was a Roman cardinal. Acting on the advice of a dealer, the young Michelangelo scarred his Cupid and stained it with earth, to make it look as if it had been dug up. The cardinal discovered the fraud and demanded his money back; eventually the statue, which belonged briefly to Cesare Borgia, who had looted it in Urbino, passed into the hands of Isabella d'Este, the Marchioness of Mantua, the greediest collector of her day. But the faking or imitation of antiquity (chiefly based on Hellenistic models) to suit a collector's taste, like the flattering of tyrants and popes, had little in common with the natural and inbred classicism of Florence, whose sculpture died a painful and indeed a gruesome death with the extinction of the Republic.

Cosimo I, like so many absolute sovereigns, had a neoclassic or pseudo-classic taste; he had himself sculptured in the costume of a Roman emperor and commissioned various Ledas and Ganymedes and other mythological subjects from the Mannerist and neo-classic sculptors who worked for him, the best of whom were Cellini and Giambologna, a Frenchman. Much of this sculpture was private in the worst sense, like the 'Hermaphroditus', a poem done much earlier for Cosimo il Vecchio and inscribed to him by the writer Beccadelli - a work so crudely indecent that even the most ribald humanists attacked it and the author was burned in effigy in Ferrara and Milan. While licentious marbles and bronzes were being sought by the private collector, the noble nudity of public sculpture grew, as it were, embarrassed before the general gaze. The people of Florence put a gilded fig leaf on Michelangelo's 'David'; later, in Cosimo I's time, Ammannati violently attacked the nude in a letter to the Florentine Academy of Design and publicly 'repented' his 'Neptune' (not because it was ugly but because it was naked).

Actually, Florentine humanism, which had been preying on the antique from the days of the old Cosimo, the passion of book collecting, art collecting, the appearance of the connoisseur, the whole notion, indeed, of 'taste', spelled the end of the heroic age of sculpture. The craze for the antique originated in Florence, under the patronage of the old Cosimo, who died while listening to a dialogue of Plato. It was, to start with, chiefly a literary movement,

but the humanists quickly moved into the sphere of collecting art objects, trophies from the ancient world, competing with millionaires for these items, many of which were doubtless fakes. Poggio Bracciolini, the Florentine humanist, whose speciality was the recovery of classical manuscripts (Lucretius, Quintilian, Cicero, Manilius), which he gave to the world, collected for himself an array of marble busts - only one, he wrote, was 'whole and elegant'; the rest were noseless. He sent a monk from Pistoia to Greece, antiquity-hunting for him, but this monk later cheated him and sold the items he had collected to Cosimo il Vecchio. Another Pistoiese delighted Lorenzo de' Medici with a marble figure of Plato, said to have been found at Athens in the ruins of the Academy. Lorenzo accepted it, like any credulous American millionaire; he had been longing for a likeness of his 'favourite philosopher'.

Even in Poggio's time, there were not enough real antiques to supply the demand; only six antique statues, he reported, five marble and one of brass, were left in Rome. Later, the excavation of the 'Laocoön' in Rome, which was witnessed by Michelangelo, excited great wonder throughout the cultivated world. The vogue for antiquity and for imitations of antiquity made Baccio Bandinelli the most popular sculptor in Florence, rivalling even Michelangelo, who at once despised him and was jealous of him. Bandinelli turned out a mass of degraded statuary, including the 'Hercules and Cacus' in the Piazza, that frankly exploited the greed for 'classic-

type'sculpture on the part of the new rulers and collectors.

Naturally, in none of this statuary, which was once à la mode (nor in the graceful Cellini either), is there a grain of that local tender piety, religious or civic, that appears in its purest, most intense concentration in Donatello's figures. Donatello ('little Donato') was the most numinous of all the Florentine sculptors, and Michelangelo, though bigger, was not as fine. In the wiry tension of Pollaiuolo, working in bronze, the barbaric grace and luxury of the Etruscans reappears for a final time, as sheer fluid energy, but these works, even when they take the form of a papal tomb, like that of Innocent VIII in St Peter's, have something of the private fetish about them, beautiful, strange, and secret. Michelangelo was the last truly public sculptor, and his works, so full of travail and labour, of knotted muscles and strained, suffering forms, are like a public death agony, prolonged and terrible to watch, of the art or craft of stonecutting. He anticipated the baroque, a style utterly un-Florentine, whose power centre was papal Rome. The Medici Tombs, in fact, make the impression of a papal enclave, an extraterritorial concession, within the Florentine city-state.

These tombs, nevertheless, recently re-entered Florentine public life in an unexpected way. One of Cosimo I's building projects was the Santa Trinita bridge, which was rebuilt, after a flood, by Ammannati, who also extended the Pitti Palace for Cosimo, botching, in the enlargement, Brunelleschi's original design. Ammannati's bridge, the most beautiful in Florence, the most beautiful perhaps in

the world, was destroyed by the Germans during the last war and has been rebuilt, as it was. The rebuilders, working from photographs and from Ammannati's plans, became conscious of a mystery attaching to the full, swelling, looping curve of the three arches - the slender bridge's most exquisite feature - which conforms to no line or figure in geometry and seems to have been drawn, free hand, by a linear genius, which Ammannati was not. Speculation spread, throughout the city, among professors and art critics, on the enigma of the curve. Some said it was a catenary curve, drawn, that is, from the looping or suspension of a chain; some guessed that it might have been modelled on the curve of a violin body. Just before the bridge's opening, however, a new theory was offered and demonstrated, very convincingly, with photographs in the newspaper; this theory assigns the design of the bridge to Michelangelo, whom Cosimo I was consulting, through Vasari, at this period. The original of the curve was found, where no one had thought of looking for it, in the Medici Tombs, on the sarcophagi that support the figures of Night and Day, Twilight and Dawn. Thus, if this argument is correct (and it has been widely accepted), a detail of a work of sculpture, done for the glorification of a despotic line in their private chapel, was translated outdoors and became the property of the whole Florentine people. Sculpture returned to architecture, like a plant reverting to type, and a curve of beauty, thrice repeated, which was as mysterious in its final origin as though it came from a god and not from

an architect's drawing board, upholds the traffic of the city.

Every time, no doubt, a bridge has been rebuilt in Florence, from the day the statue of Mars was put back 'the wrong way' on Ponte Vecchio, dispute must have clouded the process. The dispute over Ponte Santa Trinita has lasted ever since the war's end and is not finished yet. First came the question of whether the old bridge should be rebuilt at all. Why not a modern one? When this was settled, the old quarries in the Boboli Garden from which the golden stone had been cut were reopened; one-sixth of the original stone was retrieved from the Arno. Difficulties then followed with the masons, who had to be restrained from cutting the new stone 'better' (i.e., with the clean edges made possible by modern machinery). Patience began to run out, as Michelangelo's had when he wrote: 'I have undertaken to raise the dead, to try and harness these mountains, and to introduce the art of quarrying into this neighbourhood.' Once the stone had been cut, the matching of the colour was criticized; the flooring in the Arno was criticized. A sluice was opened up the river, inadvertently, and endangered the bridge's underpinnings when it was almost finished, and had already been opened to foot traffic. The fall rains would do the rest, said the pessimists, scanning the sky, and indeed, for a few anxious days, it appeared that they might be right, that the whole frail lovely structure might be swept away if the sluice were not closed in time. Rebuilding the bridge as it was, was really a case of

'undertaking to raise the dead', and pride in this Florentine feat, unique in the modern world, made everyone apprehensive of a fall. And the more beautiful the resurrected bridge appeared, rising like an apparition from the green river, the more the population squabbled, warned, cavilled, lest it not be perfect.

The final and most acute disagreement, curiously enough, concerned a question of statuary. Four late sixteenth-century statues by the Frenchman Pietro Francavilla, representing the seasons, had stood at the four corners of the bridge. They were of no great value artistically, but they had 'always' been there, like the old sentry-statue of Mars on Ponte Vecchio. Three had been rescued intact - one, according to the story, by a local sculptor (others say a foreign sculptor) who had dived into the Arno to save it - but the fourth, 'Primavera', had lost her head. Report circulated that an American Negro soldier had been seen carrying it away during the fighting and confusion; other testimony declared that it was a New Zealand soldier or an Australian. Advertisements were put in the New Zealand papers, asking for the return of the head, but nothing resulted from this. Meanwhile, all sorts of queer rumours persisted: the head had been seen in Harlem; it was buried in the Boboli Garden. The Florentine fantasy would not consent to the idea that it had simply been blown to pieces.

When any realistic hope of finding it again was finally given up, the authorities of the Belle Arti decided not to replace the statues. This produced an angry outcry; the

people wanted the statues back. When the Belle Arti insisted, an opinion poll was taken, and the popular will said, overwhelmingly, that the statues must return. Then the Belle Arti yielded, or seemed to yield, and dispute moved on to the question of whether 'Primavera' should be set up in its mutilated state as a sort of war memorial or whether a new head should be made for her. Again the city was divided, almost irreconcilably this time, and the Belle Arti used this as a pretext for delaying the entire operation. Not seeing the pedestals put back in their former places, the people suddenly grew suspicious; the newspaper, demanding action, hinted that the head-orno-head issue had been introduced by the Belle Arti itself disingenuously, as a dividing tactic, to avoid complying with the popular will. It wanted the pedestals produced at once, as evidence of good faith.

In no other city in the world could a controversy of this kind have embroiled all classes and generated such heat and bitterness. The fact is all the queerer because the Florentines, as has been said, are not sentimental about their past. There are no ruins in Florence, and the temperament that muses over ruins, the romantic (or Roman-ish) temperament, is inconceivable in this city. In the story of the statues, there is something deeper, more elemental, more obstinate, more, even, superstitious than aesthetic disagreement, than a 'question of taste'. Machiavelli, writing of the love of liberty characteristic of small independent republics of the classic stamp (and in the back of his Florentine mind there is always the Roman Republic)

associates it with 'the public buildings, the halls of the magistracy, and the insignia of free institutions', which remind the citizens of their liberty, even after they have lost it for generations. To eradicate this sentiment, you would have to destroy the city and all its emblems, stone by stone. This was exactly what the Ghibellines wanted to do after their decisive victory over the Florentine Guelphs at Montaperti in 1260 and what the great Ghibelline lord, Farinata degli Uberti, who traced his descent from Catiline, opposed 'a viso aperto' in the war council of Ghibelline chiefs. Catiline, driven from Rome, left, threatening to return and burn it, but Farinata, an authentic Florentine, would not consent to see his native city razed. He declared boldly and proudly - he was one of the proudest spirits that Dante met in hell, where he found him, not among the traitors, but among the heretics and Epicureans - that he had not taken up arms against Florence to see it destroyed but in order to come back to it. This plain-spoken and inalterable refusal was ill rewarded, typically, by the ungrateful Guelph city, which tore down the towers of his descendants in the old centre of the town, near where Palazzo Vecchio now stands. The reason, it is said, Palazzo Vecchio has such a peculiar shape is that the signory would not permit a stone of it to be built on land that had once belonged to the Uberti - Ghibelline-tainted soil.

In Florence, so concretely visual, even the shape of a building is a reminder and a political lesson, and the story of the statues is simply another example. 'Spring' didnot get a new head, and she now stands on her pedestal, headless, like the old wasted statue of Mars – a reminder of the Nazi occupation. It was not the Belle Arti but the people who wanted her, the Tuscan goddess, back.*

^{*}The head was found, after all, in the Arno, during some work on Ponte Vecchio. After its authenticity was thoroughly tested, it was carried in procession and put back on *Primavera*.

Chapter Three

The discontented shade of Catiline, dressed in the consular toga, haunts Florentine history. It is not hard to imagine some of his cohorts surviving in the Pistoiese hills, fathering children from whose seed would spring the fierce factions of medieval Tuscany. Ancient Pistoria became Pistoia, a fitting den, said Dante, for the bestial church-robber, Vanni Fucci, who 'rained from Tuscany' into a gullet of hell, where Dante found him, in a coil of serpents, still unrepentant, cursing, and making an obscene gesture called 'the figs' at God. The poet invokes Pistoia and advises it to turn to ashes for having surpassed its seed (meaning Catiline and his conspirators) in evil-doing.

Pistoia, now a nursery-garden centre, half an hour up the austostrada from Florence, was in fact a veritable lair of strife and dissension; it was the breeding ground of the Black and White division, which proved so ruinous for Florence, as though the witches' brood of Catiline took an ancestral revenge on the city that arose from the Roman camp on the river. The division, they say, originated in a quarrel between two Pistoiese families that started with a children's game. One child slightly wounded another while playing at swords; his father sent him to apologize, and the second father, in reply, had his servants

chop the boy's hand off on a meat block and sent him back with a message: 'Tell your father that iron, not words, is the remedy for sword wounds.' As if at a signal, the city split into factions, calling themselves Bianchi and Neri because the ancestress of one family had been named Bianca. The cancer quickly spread to Florence, where the two leading families, the Donati and Cerchi, using the Pistoiese names, leapt to arms against each other. Corso Donati, the leader of the Florentine Blacks, was described by Dino Compagni in his early fourteenth-century 'Chronicle' as a man who resembled Catiline except that he was more cruel. Like Catiline, he was 'gentle in blood, polished in manners, beautiful in person, of pleasing intellect, and a mind ever intent on evil'. The people called him 'the Baron' because of his excessive pride.

The word 'pistol' means literally 'Pistoian'; before the days of firearms, a pistole was a dagger, called after Pistoia, either, says one authority, because daggers were made there or because they were used there so commonly. The first pistols were made there in the sixteenth century. There are still many forges in Pistoia which give off a smell of hot iron. Of all the towns in Tuscany, it is Pistoia that most recalls the dark passages in medieval history. The old civic buildings are made of an iron-grey stone – pietra bigia pistoiese. Fastened to the front of Palazzo del Comune or Town Hall, in the main square, is an ominous head in black marble, with an iron mace or club above it, which the Pistoians say is the head of a traitor

who betrayed the town to the Luccans. Scholars think that it is really a likeness of Musetto, the Moorish king of Majorca, who was conquered by a Pistoiese captain in the expedition against the Balearic Islands, led by the Pisans during the twelfth century. Some keys on the building are the papal emblem, put up to honour Leo X (Giovanni de' Medici, the son of Lorenzo), but the local people say that these are the keys of the city that the traitor gave away.

Across the square is the Palace of the Podestà or foreign governor, an office once held by Giano della Bella, the Florentine Gracchus; in its lofty grey porticoed court are a long stone table of justice, a long stone judges' bench, and, opposite, the bench of the accused. The court that sat here, half in the open air, judging and receiving denunciations, was noted, even in Tuscany, for its iron severity, particularly during the period of the democracy, towards the beginning of the fourteenth century. The democrats, true Catilinarians, detested the nobility, who were deprived of all civic rights and reduced to a state worse than that of felons; if a commoner committed a crime in Pistoia, he was punished by being ennobled. Even in the full Renaissance, Pistoia was regarded by its neighbours as a fated and fateful place. Michelangelo wrote a sonnet against it; Machiavelli described a family called the Palandra, 'which, though rustic, was very numerous, and like the rest of the Pistolesi, brought up to slaughter and war'. It was even believed that the Guelph-Ghibelline factions took their names from two rival brothers of Pistoia, called Guelph and Gibel.

To those who know its history, however, the most striking fact about Pistoia is that so much of it is, literally, black and white. The wealth of Pistoia was lavished on a series of Romanesque churches and a tall octagonal Baptistery which are faced in horizontal courses of black-and-white marble; the profusion of these churches, the black Moors' heads (there is another mortised into the striped façade of Sant'Andrea), the iron club, the dread grey of the civic halls, give the city a strange formidable

appearance, at once luxurious and sectarian.

The style of dressing sacred buildings in horizontal stripes of alternating black and white came from Pisa, the mariner-city on the coast, whose sailors had fought the Saracens in Spain, defeated the Emir of Egypt, and gone on crusades; wherever the Pisan influence reached in Tuscany, the black-and-white stripes appear and, with them, a suggestion of the Orient, like the markings of an exotic beast. You find the gleaming stripes in rosy Siena, on the ferocious, tense Cathedral that sits in the Piazza exactly like a tiger poised to spring; you find them in Lucca, the silk town, where the Pisan style was enriched with decorative reliefs, polychrome marble inserts, stone lions on supporting columns, writhing stone serpents. The Pisan style, sometimes fusing with the Luccan, and rich itself in sculptures and tiers on tiers of graceful loggias, made its way into the remote parishes of rural Tuscany, like the spices from the East - to steep Volterra and Carrara, far south to the ancient mining town of Massa Maríttima, inland to Arezzo and the wool town of Prato,

across the water to the islands of Corsica and Sardinia.

This trail of tigerish architecture stopped short of Florence, where the classic tradition was proof against the exotic. The black-and-white (sometimes, as elsewhere, dark-green-and-white) marbles of the Baptistery and San Miniato and the Badia at San Domenico di Fiesole are not striped or banded but arranged in charming geometric patterns - in lozenges or diamonds, long wavy lines like the water pattern in hieroglyphics, squares, boxes, rosettes, suns and stars, wheels, semi-circles, semiellipses, tongues of flame. These delightful designs, fresh and gay, are associated with classic architectural elements: pure Corinthian columns, entablature, and pediments. Unlike the burly Lombard churches of their period, the Florentine Romanesque churches, though simple, are never rough; and unlike the Pisan Romanesque, which dealt in marvels and monsters (the leaning of the Tower of Pisa appears an ordained accident) and combined many foreign styles and influences, as Pisa mingled traffic in its port, the Florentine retained its own local innocence and ordered clarity. No column ever grossly twisted in medieval Florence; nor did stone snakes glide through the Eden into which Giotto was born, a shepherd boy. As early as the thirteenth century, the Florentines were straightening their streets and piazzas. Decrees were promulgated that new streets must be 'pulchrae, amplae, et rectae', for the sake of the city's decorum. A street that was not beautiful, straight, and broad, it was said, would be 'turpis et inhonesta'.

There is something of the simple chapel in all the Florentine Romanesque churches - a chapel in the woods or at a crossing of roads. The Baptistery, dressed outside in black-and-white marble and inside in black-and-white marble and mosaics, a pure octagon topped by a pyramidal roof, with a dome inside and below it, formerly, a pool in which every year a communal baptism was performed on all the children born that year in Florence, was originally the Cathedral. San Miniato keeps the pure early-Christian basilica form, with the choir, however, raised very high, like an anthem, over the crypt and flanked by elegant flights of marble stairs. In the pavement is a remarkably beautiful mosaic design, in black on white, showing the signs of the zodiac, doves, and lions; at the end of the nave is a great triumphal arch, in black-andwhite marble inlaid with doves and candelabra. San Miniato stands on what was once the cemetery in which the early Christians were buried; the simplicity of interment marks it, just as the simplicity of baptism marks the Baptistery. The Badia at San Domenico di Fiesole, which has a diminutive geometric dark-greenand-white marble façade set in its stone body like a jewel, was dictated by a vision accorded to a saintly hermit; redone by Brunelleschi in the Renaissance for Cosimo il Vecchio, it still has the air of a hermitage perched in the hills.

Innocent legends cling to these candid temples, with their black-and-white sign language of diamonds, circles, water, and fire. An elm outside the Baptistery is supposed to have burst into leaf in midwinter when the corpse of Saint Zenobius was carried past it; a pillar commemorates the flowering tree. Two porphyry columns on either side of the east Baptistery doors have a story of Pisan perfidy attached to them: they were magic columns, in whose polished surfaces treasons and machinations against the state could be seen; the Florentines had won them, as trophy, from the Saracens in the expedition against the Balearic Islands, but the Pisans, before turning them over to the Florentines, had passed them through a furnace which destroyed their lustre and their enchantment. Over the door of Santi Apostoli, the church of the Apostles, in the tiny Piazza del Limbo, where unbaptized infants were buried, there is a Latin inscription saying that the church was built by Charlemagne and consecrated by Archbishop Turpin, with Roland and Oliver as witnesses. This little church, where La Pira distributes bread to the poor on Sundays, possesses some chips of stone believed to have been brought back from the Holy Sepulchre by a certain Pazzino de' Pazzi, who was the first to scale the wall of Jerusalem on the First Crusade; on Holy Saturday, the chips are carried to the Baptistery, where a spark struck from them lights the Easter Fire, which is carried in procession to the Duomo. At the intoning of the 'Gloria' at high mass in the Duomo, a mechanical dove with a fuse in it is lit in the apse with the sacred fire and sent out on an iron wire to the Carro, or Florentine war chariot, loaded with fireworks outside: if the dove makes a safe journey and explodes the fireworks, the harvest that year will be good. In such legends and rituals, the Florentine country heritage is evident. The archetypal model of the early Florentine churches, contrasting with the luxury of Pisa, Lucca, Venice, Siena, was perhaps the stable of Bethlehem – before the coming of the Kings. A still more rustic version of the Easter dove ceremony used to take place at Empoli, where the women today sit in their doorways weaving straw novelties for the Florentine Mercato Nuovo; out of the window of the principal church (which is faced with green-and-white marbles in the Florentine geometric patterns), a life-size mechanical donkey was sent shuttling down to the square; the last of these animals is preserved in the little Empoli museum.

In general, the towns with the striped Pisan architecture were Ghibelline, like Pisa itself, which enjoyed the special favour of the Emperor on account of its navy, and the towns with the geometric patterns were Guelph, like Florence, Fiesole, and Empoli. An exception must be made for Lucca and another for Prato, a Guelph town long under Ghibelline domination. But whatever the style, Florentine or Pisan or Pisan-Lucchese, bichromatism was prevalent throughout Tuscany in the Romanesque period, and the blacks and whites, sun and shadow, sharps and flats, recurring on the old church fronts, evoke what has been called the checkerboard of Tuscan medieval politics, the alternation of Guelph and Ghibelline, Pope and Emperor, Black and White. These were the terms, the severe basic antinomies, in which the

Tuscans thought and saw. The last of the geometric church façades, and one of the most beautiful, was completed by Leon Battista Alberti, the exponent of classicism in the Renaissance: this was for Santa Maria Novella, the Dominican preaching church of Florence.

Lucca was predominantly a Guelph city; Pisa, its natural enemy, was Ghibelline. Prato was Guelph; Pistoia, a few miles off, was Ghibelline. Florence was Guelph; Siena, Ghibelline. Each black square on the board had a white square adjoining it in sharp political contrast. The colours sometimes changed; if Pisa briefly became Guelph, Lucca briefly became Ghibelline. The nearest and most powerful neighbour was the 'natural' enemy. Each city, moreover, had within it a faction of the other side. The Florentine Ghibellines, led by the old noble families, supporters of the Emperor, were allied with Siena, and the Sienese Guelphs, merchants and citizens, with Florence.

The policy of the victorious faction, once it had seized the government of a city, was to burn the houses and towers of the defeated faction and drive their owners into exile, and Italy was full of these *fuorusciti*, scheming and planning, as exiles do, to come home. The *fuorusciti*, ready to foment war and to cement any alliance as the price of their return, represented a permanent external danger, while those who had been left behind, their friends and relations (since all could not be banished), represented a permanent internal danger, which grew more acute, naturally, in time of war.

Not only Pistoia, but nearly every Tuscan town has its story of a corrupted garrison or commander ready to open the gates to the besieging foe: il traditore. Life in these thriving commercial towns was fearfully insecure; betrayal was normal. Anyone - any discontented citizen, noble, or prelate - was a potential traitor, and, for this very reason, the traitor, the man of two faces, was held in horror and repulsion inconceivable to a non-Italian. The fact that treason was commonplace made it appear more terrible, a trap in the midst of the everyday, like those mines left by the Nazis during the last war in the country houses of Fiesole they had occupied - mines that were concealed in an armchair or a lemon tree in the garden or a book on the library shelf, to explode, often, months afterward, when life had returned to normal. The road to treason, moreover, was paved with good intentions, and the doubleness of treachery was made easier by a double standard. Dante, for example, put the traitors in the lowest circle of hell, yet he himself, an exiled White Guelph, living at the court of Can Grande in Verona, in a nest of Ghibelline fuorusciti, invited the Emperor to redeem fallen Italy and would have been glad, no doubt, to turn his native city over to the Imperial forces if he had been in a position to do so.

This curious double standard reappears in a new form in Machiavelli, that other Florentine genius, also condemned to exile, whose works have troubled the world like a tantalizing enigma; his advice to Lorenzo de' Medici as the potential princely despot (not the great Lorenzo, but

the contemptible Duke of Urbino, who sits in his helmet, thinking, on one of Michelangelo's Medici Tombs) seems now straightforward cynical counsel and now a kind of double talk, to be understood almost in a reverse sense, as a masked and bitter criticism of politics as they are. As Pistoia became 'pistol', 'Old Nick' (Niccolò Machiavelli) became in English a synonym for the devil, that is, for the original traitor and fuoruscito from Heaven; yet it is hard to read Machiavelli himself without feeling that in his dry recipes for tyranny there is a hidden ingredient working, a passion for liberty, which comes out, like one of the slow-acting poisons of the period, in the History of Florence and the Discorsi. But if Machiavelli's work is 'suspicious', not to be taken by a tyrant altogether at its smiling face-value, it is all the more a product of its treacherous place and time.

The swift changes of Italian politics in the Middle Ages and Renaissance make any general distinctions false at almost any particular moment of the period in question. The Guelph party, generally speaking, was the party of the pope and Italian business interests; the Ghibellines were attached to the Holy Roman Emperor, across the Alps in Germany, and represented the old feudal nobility. When the emperor crossed the Alps, the Ghibelline power became dominant and many towns changed colour, driving their Guelphs into exile; when he went home, it was the Ghibellines' turn to go. A strong pope meant a strong Guelph party and vice versa. But these distinctions were blurred by local rivalries, by the inter-

vention of the Normans or the Angevins, by religious issues, by the hatred felt for some particular tyrant or condottiere, by the buying and selling of conquered towns. And the crooked policies pursued by both pope and emperor, plus the creation of a throng of anti-popes and anti-emperors, confused the situation still further.

The distinction between Guelph (commercial) and Ghibelline (feudal) is still clear, however, to the eye if Florence is contrasted with Siena: Florence, low and solid on its river, with its (relatively) straight spokes of streets, its ochres and duns, its noble civic sculpture and stalwart plain architecture; Siena, like a vision of chivalry, flaming brick on its hilltops, girdled by walls, with flowering Gothic palaces and streets spiralling upward, as in a maze, to the fierce rich Cathedral at the centre, its mystic painting, gold and pink and black and red, and its painted wooden figures of announcing angels and Virgins. 'We peasants could not have done that,' said a Florentine at the opening of the Belvedere, pointing regretfully to an exquisite fresco of the Virgin in the Sienese Gothic manner. 'We peasants,' on the other hand, discovered volume, with Giotto, and planted painting, four-square and massive, on the earth. Between the two cities an opposition is still felt; tourists who 'love' Siena dislike Florence, and Siena's leading aristocrat will not set foot in Florence. When he wants intellectual conversation, he invites professors from Florence up for an evening in his palace. The Palio of Siena, with its heraldry and costumes, is a race run round the principal square on horses; Florence

has a game of football, or, rather, soccer, played in medieval costumes, on the Piazza della Signoria. It is the difference between the knight and the commoner.

Most of the Tuscan towns, like the Tuscan men and women of the Middle Ages and Renaissance, have a strongly marked individuality, as though the principle of individuation, of which the schoolmen talked, had asserted itself here with a mysterious force and every town and person had been bent on achieving its own entelectly. This is a process that has continued almost to the present day, with Siena becoming more 'Sienese' and Florence more 'Florentine'. In the Middle Ages the two towns must have seemed more alike than they do today, since both were mercantile and banking centres with a strong civic life, a large class of highly skilled artisans, and a feudal nobility that had been constrained to live within the town walls.

It was these nobles who introduced the habit of faction, so especially disastrous for Florence, into the life of the towns. The insupportable pride of the nobility is mentioned by every historian of Florence. From their mountain castles in the Mugello and the Casentino, they had regularly laid waste the countryside, like fairy-tale ogres; a typical member of this caste was a man named Guido Bevisangue (Blood-drinker); another was Guido Guerra (War). When the merchants of Florence defeated such a noble in battle, they set fire to his castle and compelled him, by treaty, to live in the city for a part of every year. The same practice was followed by Lucca and Siena. The

strange stillness of the Tuscan countryside, the almost Chinese loneliness and bareness of the hills between Florence and Siena are a product of these wars of pacification, which go back to the eleventh century, on the part of the towns against the nobles or magnates, as they were called in Florence. As the towns grew stronger, castle after castle, fortification after fortification, was dismantled, leaving the area, as it were, deforested and void of habitation. The towers of San Gimignano, silhouetted against the sky, like a mirage of skyscrapers, are all that remain to tell the modern traveller what this region looked like when every hill was crowned by a feudal castle, a village, and a thicket of towers, which belonged to a feudal lord who was really a sort of highwayman, levying customs duties or simply plundering the merchant caravans that passed through his territory. The crumpled grey-and-brown paper landscapes of trecento painting, the gaunt precipices and peaks and slabs of naked stone, though a stylistic convention, give a sense of medieval Tuscany as a wasteland or mountainous rocky desert, fit only for a hermit or a beggar saint in his brown robe and rope cincture to kneel down and pray to God.

At a later period, the hills were planted over with olive trees, grapes, cypresses, parasol pines; near the cities, handsome villas were built, with gardens, terraces, lemon trees growing in tubs. Yet the peculiar beauty of the Tuscan landscape is in the combination of husbandry with an awesome, elemental majesty and silence; the olives' silver and the varied greens of the growing crops appear

an embroidered veil on a wilderness of bare geology, of cones and cups and solid triangles cut out by a retreating glacier. The knightly era, which turned the landscape of the Veneto into a magic story, with every distant hill topped by a pink castle, was wiped off the map of Tuscany by the wars of the burgher towns. Except for an occasional ruin, the remnants of a grey wall or a tower, rural Tuscany has only convents and abbeys as ricordi of the medieval days, for it was a great place for holy persons; hermits and saints flocked here to live in caves or grottoes, preach. see visions, and found monasteries. The Irish and Scottish saints felt a special call to Tuscany; many were buried here and left their names to churches or villages, like San Frediano in Lucca, and San Pellegrino (which means simply 'pilgrim') delle Alpi. Saint Bridget's brother, Blessed Andrew, founded the monastery of San Martino on the river Mensola, just outside Florence, and she herself was flown by an angel from Ireland to Tuscany to join him, in answer to his dying wish. She then built a church, on her own, and retired to live in a cave in the hills.

The nobles of the *contado*, who were unable, in their original savage state, as the documents testify, to write their own names, were also scarcely Christianized, being fond of pillaging convents and monasteries and playing crude jokes on the monks and lay brothers whom they captured in their raids. 'Pacified', they brought down into the town of Florence from their feudal mountain lairs the tower-building habit, like animals – moles or beavers –

conforming to the instinct of their species. They also brought with them the blood feud and the vendetta. The first towers were built in Florence in the eleventh century; by the twelfth, there were well over a hundred, concentrated in the old quarter around the Mercato Vecchio and what is now the Piazza della Signoria. These rough towers, bearing names like the Lion Tower, the Flea Tower, the Snake Tower, became symbols of insolent prepotency, of that harsh and overbearing character which was forever after attributed to the Florentines by their neighbours: 'Gent' è avara, invidiosa, e superba'. That, Dante said, was the reputation of the Florentines from olden time, and, in another place, he said that the Pisans looked on them as a wild pack of mountaineers.

'Stingy, envious, and proud,' the Florentines were possessed by a ferocious independence and rivalry, a determination to be outdone by no one. This, all the old chroniclers agree, was the cause of their civic turmoils: a boundless ambition and its corollary, an overweening envy. Every man wished to be first, and no man could tolerate that anyone should be ahead of him. The towers grew steadily taller as the burghers copied the nobles, and the city became a sort of multiple Babel, with many towers two hundred feet high and some even higher. In 1250, the year of the first democracy (called the *Primo Popolo*), the height of the towers was ordered to be reduced by two thirds, and enough material is supposed to have been left from this to build the city walls beyond the Arno. A democratic tendency, among the poorer

artisans, appeared very early in Florence, to match the pride of the nobles and the greed of the burghers. The reduction of the towers to an equal height (none was to exceed ninety-six feet) was a symbol of the levelling process. Today, they are nearly all gone; viewed from across the river, at Piazzale Michelangelo, where a copy of 'David', the Giant-Killer, stands, Florence appears a level city, whose uniform low sky line is only broken by the civic tower of Palazzo Vecchio, by the Bargello, by the three great domes of Brunelleschi - the Duomo, San Lorenzo, and Santo Spirito - and by the bell towers of the Duomo, the Badia, and of the two churches of the preaching orders - Santa Maria Novella and Santa Croce. From the time of Arnolfo di Cambio, who began work on the Duomo in 1296, just after the fall of the second democracy, a characteristic trait of Florentine building has been the heavy stressing of horizontals.

In early times, however, the towers had a function which was not one of mere ostentation or the vaunting of family greatness. They were used to withstand a siege, just as they had been in the mountain passes, but now within the city, in the feuds that began to break out, between one family or clan and another, or between one family and the rest of the *comune*. Each family or group of families had a tower adjoining the house of its chief, with a little bridge connecting the tower to the house's upper storey. The more powerful families had a whole series of towers, clustered together, or dispersed throughout the city. After some deed of vengeance had been committed,

the clan would take refuge in its tower or towers, hurling stones and burning pitch down into the street at its opponents. The houses adjoining a belligerent tower, when not burned to the ground, were often destroyed by the heavy scaling engines used in the attack. Barricades were thrown up in the streets, and it was unsafe for an ordinary citizen to go out during a feud. Men sent to repair Ponte Vecchio after one of the great floods appeared in chain mail, with axes, and the unfurled banner of their parish, to protect them while they worked against the fighting magnates. This happened in 1178, on one of the occasions when the statue of Mars had been swept into the river; the year before, the first civil war had been started in Florence, by the Uberti, ancestors of Farinata. The war, between the Uberti and the ruling oligarchy, lasted two years and burned down half the old city. During this time, says Davidsohn, citing a fourteenthcentury tradition, the tormented citizens, meeting together, debated leaving Florence and starting a new city somewhere else.

Earlier, in the eleventh century, a passionate and illiterate young noble, on his way up to San Miniato one Good Friday, met the man who had killed his brother; on an impulse, perhaps because it was Good Friday and the man threw out his hands to him for mercy, in the gesture of Christ on the cross, he spared his life and, coming into the church, knelt down to pray before a painted Crucifix, which gravely bowed its head to him, commending his restraint. This was Saint Giovanni Gualberto, the founder

of the Vallombrosan order, an extraordinary figure whose fight against simony was of crucial importance for the eleventh-century religious revival but who is remembered in story less as a pioneer church reformer than as the man who renounced a blood feud. In fact, he was a typical Florentine extremist who kept the city in uproar for the next forty years with his brawling monks and their partisans, causing great scandal and embarrassing the pope, himself a religious reformer and firebrand - Urban II. Giovanni made Florence the headquarters of the reform movement, carrying the fight into the piazza, where monks of his party appeared armed with swords to meet the bishop's faction. Blood shed by the truculent monks was sopped up, on one occasion, by pious women, with cloths, which were then preserved in reliquary vessels. The saint, meanwhile, remained in his convent in the Vallombrosan forest, directing operations, struggling against sins of the flesh, to which his manly nature was prone, and learning to write his name.

Religious sects of various kinds flourished in medieval Florence, which oscillated between an extreme fanaticism and an equable, enlightened tolerance. On the one hand, it was a centre of Epicureanism, as it was then understood (Farinata degli Uberti was supposed to have been an Epicurean, that is, a pagan sceptic and materialist given over to bodily pleasure); on the other, it was a hotbed of puritan theory and practice. The Patarene heresy, which resembled the Albigensian, made thousands of converts here during the twelfth and early thirteenth centuries.

Florence, in fact, was the seat of a Patarene 'diocese', the most powerful in Italy, with its own bishops and clergy. This puritan sect believed that this world was wholly ruled by the devil; they were vegetarians and pacifists who refused to marry or take oaths; they did not believe in baptism or the Eucharist or in prayers and alms for the dead or in the veneration of relics, pictures, or images, and they thought that all the popes from Saint Sylvester on (he was responsible for the so-called 'Donation of Constantine', that is, for the temporal power of the Church) were condemned to eternal damnation. Such uncompromising doctrines had a profound attraction for the Florentines, who thirsted periodically for religious reform as they thirsted for an ideal state. In Saint Giovanni Gualberto and the early Tuscan hermits can be seen the precursors, like so many shaggy Baptists, of the great Franciscan religious revivalist movement and, finally, of Savonarola. This strain of zealotry in the Florentine temperament is no doubt the reason the Florentine churches today strike the eye as 'protestant' or 'reformed', in comparison with the churches of Lucca, Siena, Venice, Rome. The Florentines have, in both senses, an iconoclastic, image-breaking nature. If Savonarola had prevailed, Luther would not have been needed.

The Reformation was anticipated in Florence in the eleventh century. The fight against simony or the trafficking in religious offices was the same, essentially, as the fight against indulgences. But it is characteristic, also, of the city, so changeable in its passions, so black and white,

so either-or, that something like the Counter Reformation took place here in the thirteenth century, when the Inquisition, under Saint Peter Martyr, organized two lay groups, the Crocesegnati and the Compagnia della Fede, to exterminate the Patarene movement. And this battle, too, was fought in the streets and the piazzas. Peter, wearing his Dominican habit and grasping a red-cross banner, led his sodalities, which were really military bands, into action. Near Santa Maria Novella, where he used to fulminate from the pulpit, occurred the horrible massacre of the Patarenes; the spot is marked by a cross called the Croce al Trebbio and a peculiar lone column. Another column, near the church of Santa Felicita, on the other side of the Arno, not far from Ponte Vecchio, marks the site of another holy massacre. In the Spanish Chapel in the cloister of Santa Maria Novella, the Inquisitor-Saint is shown, in his black-and-white Dominican habit, accompanied by a pack of black-and-white dogs (the Hounds of the Inquisition), who are helping him snuffle out heresy. This saint was subsequently stabbed to death (i.e., 'martyred') by a heretic on his way from Como to Milan. In north Italian painting, he is usually represented with a knife through his head; the Florentines sometimes showed him with his finger to his lips, which is thought to be a symbol of the Inquisition. The Spanish Chapel is called that because the Spanish suite of Eleanor of Toledo, wife of Cosimo I, were accustomed to hear mass here; the trecento frescoes on the walls, depicting the triumph of orthodoxy over heresy, which seem to us today somewhat quaint in their subject matter, must have formed for them, early in the Counter Reformation, a congenial picture of the world – only the rack and the faggots were lacking. Meanwhile, Peter Martyr's armed columns, having disposed of the Patarenes, devoted themselves to good works, founding hospitals and tending the sick. Their brotherhood, which was now known as the Brotherhood of Mercy and had its centre in the Bigallo, opposite the Duomo, became the original Red Cross. These brethren, masked, in their black hoods (their identities are officially kept secret for humility's sake), can still be seen sometimes alighting from an automobile with a stretcher late in the afternoon outside a tenement in one of the poorer quarters – Santo Spirito, Santa Croce, or San Frediano – to take a sick person to the hospital.

Such shifts in public attitude were as characteristic of Florentine medieval politics as they were of Florentine medieval religion, and in politics, too, they were attended by terrible outbreaks of cruelty. An alternating current, reversing itself at very short intervals, seemed to run through this people like a dangerous electrical fluid. No one could hold public office with safety, and charges of heresy mingled with charges of treason. The Guelphs were called 'traditori', and the Ghibellines were called Patarenes. 'In ancient and modern times,' wrote the chronicler Giovanni Villani, 'it has always happened in Florence that anyone who made himself head of the people has always been humbled by that same people, who are never inclined to give due praise or acknowledge merit.'

He was speaking of the fall of Giano della Bella, his contemporary, a puritan in politics, the first tragic figure, after Brutus, in political history. A completely disinterested man, an aristocrat who made himself a commoner out of love of justice, he was accepted by the people as their leader in the fight for 'full democracy' late in the thirteenth century, which meant widening the base of the electorate by increasing the number of the minor 'Arts' or guilds to include small merchants and craftsmen –oil merchants, innkeepers, cutlers, woodworkers, bakers, and so on.

In his zeal against the lawless nobles of his own class and the greedy 'special interests' of the great wool and banking guilds (represented at this period by the Guelph party), Giano inspired the fearful 'Ordinances of Justice' (1292-94), which were a genuine instrument of terror and which gave the political informer, for the first time in democratic history, a regular status in society. Under the Ordinances of Justice, the greatest injustices were perpetrated: offenders (i.e., anti-democrats or nondemocrats) could be convicted on rumour and public opinion only, without the presentation of evidence; the nobles were excluded from every honour and office, and every individual was made liable for the crimes committed by his relations. Boxes called 'Tamburi' were set up outside the Podestà's palace (the Bargello) and the house of the captain of the people to receive secret denunciations. Seventy-three families were deprived of their civic rights, and families at this time were veritable

tribes; one man, for example, had thirty cousins and nephews under arms. It was during this period, of the *Secondo Popolo*, that many aristocratic families changed their names and became plebeians to blend with the environment as the Jews in Spain and Portugal used to have themselves baptized during the Inquisition: the Tornaquinci turned into the Tornabuoni, the Calvacanti into the Clampoli, and the Marabottini into the Malatesti.

Giano himself became a victim of this atmosphere of suspicion and fear. Stories of a 'Ghibelline danger' were put into circulation by the Guelphs, and Giano was soon denounced as a 'subverter' through a subtle ruse of Corso Donati's. Idealistically, he volunteered to go into exile for the sake of the public peace, but this did not prevent him from being condemned, in absentia, together (on his own principle) with all his family. His houses were wrecked, and he ended his life abroad, a fuoruscito, running a branch in France of the Pazzi family's bank. 'Giano was a wise man,' says Villani, 'albeit somewhat presumptuous.'

In another popular uprising, shortly after the fall of Giano, the nobles were forced to sell their great crossbows to the Republic, and in 1298 Palazzo Vecchio was started, to protect the signory from the attacks of the nobles. But the power of the magnates and the new-rich burghers (called the 'fat' popolani) could not be curbed. Soon – in June, 1304 – the Donati, Tosinghi, and Medici were throwing fire into each other's palaces, and the heart of the city was again burned. The poor in the East End quarter, which became known as the Red City, repeatedly saw

their wooden houses destroyed in these contests of the great. The strike was tried out, abortively, as a weapon of protest. Then, in 1378, came the revolt of the Ciompi, or wool-carders, in which a remarkable red-haired proletarian, Michele di Lando, a wool-carder whose wife sold vegetables, rose to power as gonfalonier of justice. He, too, though a man of sense and moderation, finished in exile. Donatello's father, a wool-carder, figured in the Ciompi Revolt and, having been designated as a 'ringleader', fled to Lucca, where he stayed some time before he found it safe to return. The popolo minuto or working class of Florence, excluded from representation in the big middle-class guilds, was nevertheless highly developed politically. The people of Florence were, in fact, too articulate, politically, for government to be possible at all: the threat of direct democracy or piazza rule was always present, and no matter how short the period of elective office (sometimes six months), it generally seemed too long. Nearly every form of government was tried out in Florence. This makes Florentine history 'transparent and typical', as Burckhardt said of Athens. If the incorruptible Giano della Bella seems to prefigure the French Revolution and Saint-Just, Michele di Lando and his organized textile workers loom out of the fourteenth century, nearly a hundred years after Giano, as premonitory of the Lancashire spinners and weavers in the England of the Industrial Revolution, lit by a Dickensian chiaroscuro of black factory smoke, the torches of marching men, and the fire of oratory.

The Florentines were fond of listening to speeches. At the sound of the great bell, they congregated in the piazza to hear what was to be said. The 'arringa' or harangue was originally a special discourse prepared by the consuls and delivered to the people in assembly. An early account. set down at the beginning of the thirteenth century, describes the methods used by an orator of the day in working up the people to war or a vendetta. He would strike a tremendously bellicose attitude, make hideous faces, knit his brows, raise his arms in threatening gestures: these pantomimes, resembling the war dances of savages, were judged, apparently, as performances. The vividness of the mime's acting determined the policy to be pursued by the state. Political meetings are still held in the Piazza della Signoria, and the public goes to measure them as performances: at night, a Communist orator stands thundering at a podium under the full arches of the Loggia, while hundreds of red flags wave and giant shadows of the 'David', the 'Perseus', and the 'Hercules' fall on him and the assembled, curious Florentines. This piazza seems made for politics, and its shape is only fully defined when it swells with a 'sea' of electors, washing up against the sides of the buildings and lapping against the tall statues' bases. On such nights, oratory and statuary seem inseparably joined, and, indeed, it is possible that something of the realism of Florentine sculpture, particularly noticeable in Donatello's wild Baptists, goes back to the early pantomimes or orations, so to speak, in the round. One of the treasures of the Archaeological Museum is a statue in

the Etruscan style called the 'Arringatore' (third century B.C.), which is supposed to represent a certain Aulus Metellus in the act of speaking.

Before a war, the people listened to a warlike harangue. and it was the Florentine custom, after a victory, to circulate insulting verses about the enemy. This practice, very ancient in Florence, going back to the subjugation of Fiesole, was later copied by the other Tuscan towns. The insult was often acted out as well. After the battle of Campaldino, in which Dante fought, the Florentines came to the defeated town of Arezzo, which was ruled by a fighting bishop, and threw thirty dead asses with mitres on their heads over the walls. Such uncouth jests, regarded as typically Florentine, continued late into the Renaissance and were sometimes very barbarous. Savonarola's mockers, the juvenile delinquents known as the 'Bad Companions', smeared the pulpit in the Duomo from which he preached with filth, hung it with a stinking ass's skin, and drove great spikes in along the rim where he would hammer his hands for emphasis. Four or five centuries earlier, the statue of Mars on the Ponte Vecchio had been crowned with flowers every March if the season was good and daubed with mud if not. This 'revenge' on the god (who, Davidsohn thinks, was actually an equestrian statue of the Emperor Theodoric, though the Florentines did not know it) was again typical of Florentine extremism, of the attitude of either-or.

The orations on the piazza often ended in horrible tumults, in which people were torn to pieces. In 1343, after

the fall of the Duke of Athens, a man was eaten on the Piazza della Signoria. Much later, after the thwarting of the Pazzi Conspiracy, portions of dead bodies, according to Machiavelli, were seen borne on spears and scattered throughout the streets, and the roads around Florence were covered with fragments of human flesh. The cruelties committed in Pistoia, during the struggles of the factions, are said to have surpassed those committed in Florence, and the practice of 'planting' traitors, that is, of burying them alive, upside down, in the soil, was general in medieval Tuscany.

The wars and insurrections and factional frays that occasioned these barbarities were often marked, too, by touches of poetic beauty and by a sense of fair play. Count Ugolino della Gherardesca, captain of Pisa, while besieging Genoa, the hereditary enemy, shot silver arrows over the walls of the city as a sign of contempt. (This man, nevertheless, was a traitor, whom Dante found freezing in ice in the lowest circle of hell: for his double-dealing, he and his sons and his young grandsons had been starved to death by the Pisans in the tower called, after their fate, the Tower of Hunger.) Arezzo, mourning for the Ghibellines, after the defeat of Henry VII, changed the horse on its shield from white to black. The Florentine carroccio, or war chariot, was drawn by four pairs of beautiful white oxen covered with scarlet cloth; it was ornamented with wood carvings of lions and painted vermilion; the driver was dressed in crimson. A red-and-white silk banner waved from the flagstaff, which was topped by a golden apple

and decorated with branches of palm and olive. A bell and a priest went with the *carroccio* into battle; the tinkling of the bell, as the heavy car moved, told the combatants where the priest was, so that the dying could receive absolution and the last sacraments. The army was also accompanied by a great bell called the Martinella or the Campana degli Asini (Donkey's Bell); for thirty days before fighting began, the Martinella tolled from the great arch of Por Santa Maria, to let the enemy have fair warning.

Castruccio Castracane, lord of Lucca, celebrated his victory over the Florentines at Altopascio (1325) with a triumphal return to Lucca in the style of a Roman general. Wearing a laurel wreath and dressed in purple and gold, he stood in a chariot drawn by four white horses, while captives in chains were driven ahead of him, as in a Caesarean triumph, and the carrocci of Florence and her ally, Naples, were drawn backward, to signify humiliation. This medieval condottiere, the military genius of his place and day, who cultivated a Roman appearance, in robes of crimson silk, was greatly admired by Machiavelli, two centuries later. He appears on the Tuscan scene, during the lifetime of Giotto, like some vision or tableau vivant of the full Renaissance; Piero della Francesca, more than a century later, might have painted him in an exquisite Triumph with allegorical figures, like the one he did of Frederick of Montefeltro, Duke of Urbino, which is now in the Uffizi. Fortunately for Florence, which could not have borne Castruccio's thirst for glory and personal

pageantry, he died of a common cold, after one of his victories, just as he was planning to attack the city.

Many witty sayings and cruel jests are attributed to Castruccio by Machiavelli in the fanciful life he wrote of him, after the manner of Plutarch. For example: Castruccio was invited to dinner by a wealthy Luccan, who had just had his house redone in the most showy and sumptuous manner, with rich hangings and a tessellated floor, varicoloured, having a flower-and-leaf motif; looking about him, Castruccio suddenly spat in his host's face and explained himself by saying that he did not know where else to spit without damaging something. This blunt and malicious tale is full of Florentine pungency; it is a story that might be told today at the Bar Giacosa on Via Tornabuoni or at Gilli's in the Piazza della Repubblica.

The harsh humour and realism of the Florentines have a long history. They are fond today of pinning names on each other ('The Unmade Bed', of a blowsy lady; 'The Tired Horse', of an ageing cavalier; 'The Miracle of St Januarius', of an old lady whose make-up runs); in the Middle Ages, such names stuck and became surnames. Davidsohn gives a list of nicknames that had been accepted as surnames in the twelfth century; among them: Deaf, Blind, Scabby, Stumpfoot, Monkeymouth, Beautiful (Bella), Horse, Cow, Mule, Liar, Sinner, Blockhead, Shit, Drunkard, Pharisee, Highway Robber, Evil Counsellor. And the streets around the Duomo, up to the present century, when many of the names were changed, were called Death, Hell, Purgatory, Crucifixion, Our Lady of

Coughs, the Rest of Old Age, Gallows Lane, the Tombs, the Way of the Discontented, Dire Need, Small Rags, Skeleton Street.

According to Dante and Villani, Florence in the Middle Ages enjoyed only ten years of civil peace - the ten blessed years of the Primo Popolo. The same impression is left by later historians. Dante saw a fatal likeness between Florence and Thebes, that other city of the war god, whose founders were the crop of warriors sprung from the dragon's teeth that Cadmus sowed. The chroniclers, indeed, appear to be surprised that Florence did not perish, like Thebes, as a result of her internal dissensions, which also weakened her to outward attack. Unlike the Venetians, the Pisans, the Genoese, the Milanese, the Florentine Republic, after its early successes in subjugating the nobles of the contado and the smaller towns roundabout, was not a military nation; the Florentines' gift was for fighting with each other. In the field, they lost more battles than they won. Nor were they gifted in diplomacy. Time and again, Florence, weak and disunited, was saved from annihilation by a sheer accident, like the death of Castruccio Castracane or the death of Henry VII or of Manfred or of Giangalleazo Visconti or of Ladislaw, King of Naples, all of which happened providentially and just in the nick of time. Intellect and energy explain the pre-eminence of the Florentines and their wealth, which was reputed to be fabulous. But this wealth only offered another temptation to an enemy eager for plunder. The survival of the state under these circumstances has never been explained by an historian.

Chapter Four

'How fair a thing is this perspective!' Paolo Uccello's wife used to say that he would stay all night at his writing desk, worrying some perspective problem, and when she would call him to come to bed, he would tell her: 'O che dolce cosa è questa prospettival' A groan of admiration, one would think, for perspective was a hard mistress for the artist. The principles of an ordered recession to create an illusion of deep space had been discovered in Florence by the architect Brunelleschi while Uccello was still a boy in the workshop of the sculptor Ghiberti. These principles were based on geometry; Brunelleschi had studied under the great Florentine mathematician Toscanelli, and had even taken a 'brevetto' in mathematics. To demonstrate the laws of his discovery to the curious, he painted a little peepshow panel of the Baptistery as seen from the door of the Duomo; the spectator looked through a hole into a mirror and found the vanishing point. This was the precursor of the camera obscura, which was not invented till the sixteenth century.

Florence, in those early days of the Renaissance, was full of scientific excitement. Donatello had been in Rome taking measurements of Greek statues, while Brunelleschi, his friend, measured Roman temples. The 'art' of making something and the 'science' of making something were regarded as the same thing. Laws of measurement were sought everywhere, and statistics of every kind were collected. Toscanelli, in 1460, constructed a great gnomon in the cupola of the Duomo to determine the summer solstice, the movable feasts of the Church being reckoned by the sun's path, according to the Golden Number. The sun rays, let into Santa Maria del Fiore by this prodigious calculator, called 'the noblest astronomical instrument in the world', fell 277 feet, onto a dial made of marble flags in the floor of the tribune. This gnomon, with its finger of shadow, was looked on as both a thing of wonder and an object of beauty, like the dome itself, which was considered the greatest engineering feat since antiquity.

The marble gnomon and the bronze armillary sphere or astrolabe that are fixed, like ornaments, at either end of the black-and-white voluted central façade of Santa Maria Novella belong to a later period; they were ordered by Cosimo I from his court astronomer, Ignazio Danti, a Dominican friar. Lorenzo de' Medici had a clock that told the hours of the day, the motions of the sun and the planets, the eclipses, and the signs of the zodiac. The Florentines have a twin predilection for astronomy and the science of optics. The lantern of a dome, on which so much care was expended by the Florentine Renaissance architects, was known as the 'oculus', or eye of the church. Legend says that eyeglasses were invented by a Florentine, Salvino degli Armati, and Florence is still a world centre of optical instruments. Armillary spheres, showing the rings

of the planets, were very popular in Renaissance Florence, being valued both for beauty and usefulness. The Museum of the History of Science has a remarkable collection of them, as well as a fine collection of optical instruments. There are still three observatories in Florence, and the first solar tower in the world was built here in the nineteenth century.

In the early Renaissance, astronomical science, the observation of the heavenly bodies, linked this farsighted mountain people with the great navigators. Toscanelli, who taught Brunelleschi, also advised Columbus and the king of Portugal. For the Florentine artist in his studio, the charting of the rules of linear perspective made possible voyages of exploration in a fictive space that were not less marvellous than those voyages of discovery just being undertaken by navigators of real geography. Many of the landscapes of the quattrocento, especially Baldovinetti's, have the character of aerial maps; the bare Tuscan hills once depicted by Giotto and his followers are now shown furrowed by husbandry. This maplike quality is what distinguishes Florentine landscape (Fra Angelico, Benozzo Gozzoli, Piero della Francesca) from the idealized Venetian work that followed it. The Florentine school was equipped, as it were, with a surveyor's rod. These cartographers of the studio showed the same scientific bent, the same concern for accuracy in their conquest of space as the actual mapmakers of the age. Later, Leonardo worked as a chief engineer for Cesare Borgia, and his maps are famous. The New World took its name, though somewhat fortuitously,

from a Florentine traveller, Amerigo Vespucci, who was an agent of the Medici Bank.

Handy helps to the painter for achieving correctness were offered by Leon Battista Alberti, the quattrocento architect, in his little treatise Della Pittura. He recommended the use of a thin veil or net, to section the object to be painted, like transparent ruled paper. Leonardo used the net and so did Dürér. The invention of the camera obscura or a device resembling it is given by some writers to Alberti. Besides these scientific aids, Alberti also furnished prescriptions for subject matter, to be drawn from the antique: the Death of Meleager, for example, the Immolation of Iphigenia, the Calumny of Apelles. And he advised the use of a 'commentator' or chorus figure in a painting: 'someone who admonishes and points out to us what is happening there or beckons with his hand for us to see'. A painting should have 'copiousness and variety', that is, it should contain 'old, young, maidens, women, youths, young boys, fowls, small dogs, birds, horses, sheep, buildings, provinces.... There ought to be some nude and others part nude and part clothed in the painting. But always make use of shame and modesty. The parts of the body that are ugly to see and, in the same way, others that give little pleasure should be covered with draperies, a few fronds, or the hand.'

Alberti was a gentleman, descended from a powerful noble family of imperialists and enemies of Florence whose stronghold had been Prato, many centuries before his time. As a gentleman, he was a spokesman for 'correctness' and a well-bred neo-classicism which was incongruous, on the whole, with the place-spirit and genius of his native city. He tried, unsuccessfully, to introduce the classic orders into Florentine architecture, which resisted subjugation to a book of rules. The tyranny of form he sought to impose was more attractive to the rulers of Mantua and Rimini – the Gonzaga and the Malatesta – for whom he did his best architectural work, in a rich neo-classical style. As a literary man, he perpetrated a fraud – a Latin comedy called *Philodoxius*, which he passed off as the work of 'Lepidus', an ancient Roman poet.

For the pioneer artists, his contemporaries, the new spatial science was something more than a device for attaining academic propriety or correct proportions in a painting. It was an eerie marvel, a mystery, partaking of the uncanny; to a nature like Uccello's, it had all the charm of magic. The vanishing point, towards which all the lines of a painting race to converge, as if bent on their own annihilation, exercised a spell like that of the ever-disappearing horizon towards which Columbus sailed with his mutinous crew - the brink of the world, as it was then thought to be. The vanishing point, if contemplated steadily, can induce a feeling of metaphysical giddiness, for this point is precisely the centre at which the picture ought to disappear, a zero exerting on the 'solid' realities of the canvas a potent attraction, as though it would suck the whole - old, young, maidens, women, small dogs, sheep, buildings, provinces - down the funnel of its own nothingness. That is, the very fulcrum on which the picture rests,

the organizing principle of its apparent stability, is at the same time the site at which the picture dissolves. Uccello, fascinated by perspective, was the first 'cracked' artist of modern times.

He was born Paolo di Dono, and his people came from Pratovecchio, the seat of the fierce Guidi family high in the Casentino, and was called Uccello, Vasari says, which means 'bird', because of the birds and beasts that abounded in his paintings. Vasari describes him as 'a shy man . . . solitary, strange, melancholy, and poor'. His house was 'always full of painted representations of birds, cats, dogs, and every sort of strange animal of which he could get drawings, as he was too poor to have the living creatures themselves'. His scientific studies, it was thought, had unhinged him. When he was engrossed in some difficult or impossible question of perspective, he would shut himself up for weeks and months in his house, not letting himself be seen. One of his few friends was the mathematician Manetti. with whom he liked to discuss Euclid. His other friend, Donatello, told him he was wasting his time making drawings of mazzocchi (tyres made of wood or straw, worn by men of the quattrocento as a sort of scaffolding for a cloth head-dress) with projecting points and bosses, and spheres with seventy-two facets, all shown in perspective, from different angles. 'Such things,' said Donatello, 'are only useful for workers in intarsia.' In his old age, Uccello, too crankish to get commissions, became utterly destitute and had to apply to the state for tax relief. 'I am old and without means of livelihood,' he

wrote on his tax return. 'My wife is sick and I am unable

to work any more.'

The perspective lessons of Brunelleschi, which had inspired Masaccio to create figures and scenes of monumental majesty, larger than life and stiller, were taken to heart by Uccello in a quite different way. For him, perspective opened up vistas of haunted fantasy, and the vanishing point figured as the 'eye' of a storm or the centre of a whirlpool, in which forms were tossed about, pulled by hidden currents obeying mathematical laws. Two scientific strains oddly combine in Uccello, one mathematical, the other descriptive and classificatory. He was one of those solitary artists who delight in the minute particulars of botany and zoology, and for him the human parade appeared, as if under a magnifying glass, as a collection of specimens, comparable to the specimens of botany - leaves and flowers and grasses - or to those zoological curiosities that were collected in Books of Beasts.

A freak of Nature or 'rare bird' himself, he was drawn to the whimsicalities and aberrations of the natural world, which comprised man in its scope; the armour of a mounted knight appeared to him in the same light as the hard shell of an insect, and the plumes of a helmet like the waving tail or combed forelock of a horse. He seems to have been hypnotized by headgear, particularly by the mazzocchi. Curious shapes and outlines caught his attention, and he was fond of showing the human face in profile, with a hard bright eye like the alert eye of a bird.

He was 'simple', says Vasari, and tells the story of how he produced a camel when a chameleon had been ordered, having been misled by the similarity of names. Bright ribbon attracted him, like a magpie, and one of his most charming works is simply a rosette of pleated ribbon in clear green, blue, and white, done in mosaic on a vault of St Mark's atrium in Venice. The marvellous precision with which it is made, in perspective, like a dazzling coloured snow crystal overhead, creates a strange, joyous impression, as though the Florentine Renaissance, that glorious Nativity, had been announced to the backward oriental city in the epiphany of a star in the sky.

The series of long panels called 'The Rout of San Romano', which used to be framed together as a single extended scene in the bedroom of Lorenzo de' Medici, in Cosimo's palace on Via Cavour, and which is now divided – one part being in the Uffizi, one in the National Gallery of London, and one in the Louvre – has often been compared to a child's fantasy of a chivalric battle, in which the horses are rocking horses and the visored knights are dolls. It is also rather like one of those modern science fantasies in which warriors from outer space, dressed in space suits, like weird deep-sea divers, for their interplanetary travel, invade the unsuspecting earth.

This battle, which takes place in a magical forest of perpendiculars made by lances, spears, trumpets, cross-bows, halberds, waving plumes, has a curious wooden quality: a static effect is achieved in the midst of hyperactivity, and this calls into question the meaning of so

much panache and slaughter. The fallen horses appear as hobbyhorses, dethroned and broken, or as beribboned, bejewelled stuffed chargers with the sawdust about to run out of them. A fallen knight in the London panel is only a small empty suit of armour lying, junked, on the ground. In the Uffizi panel, which shows the battle at its height, the knights are blind, armoured figures, plumed in black and red; piped on by puffing boy trumpeters, they go into combat looking like unseeing robots in their plating of steel. A pink horse is kicking furiously in the foreground, and a radiant white horse in brilliant blue trappings is rearing as its rider tumbles, speared by the long, horizontal thrust of a lance; behind the rearing horse is seen the intent, pale profile of a foot soldier. In contrast to the vivid colour of the horses, the fallen weapons on the ground make a lifeless lattice-pattern of crossed poles and staves. The foot soldiers, except for the pale one in profile, with their crossbows have loutish expressions painted on their dunce faces; the trumpeters blow themselves cross-eyed. Only the round eyes of the toy horses start with living fear. On a distant hill, which seems another world patterned with green hedgerows, rabbits, deer, and greyhounds are frisking about, and a hunt is evidently in progress, while, on the left, the trumpeters are stepping out of an arcadian grove of orange trees. These panels seem less like paintings than like cartoons for a tapestry of war.

In the Duomo, painted by Uccello in trompe l'œil perspective, is the feigned equestrian statue of Sir John

Hawkwood, the famous English condottiere, leader of the White Company, who fought in the service of the Republic. The story of this fresco is usually cited as an example of Florentine avarice: the Florentines, they say, having promised Hawkwood a monument, diddled him after his death by ordering a mere painted imitation of a solid tomb. More likely it is an example of that Florentine hatred of private glory which grudged, so long as the Republic lasted, the marble symbol of an enduring fame to an individual citizen or foreign employee of the state. In any case, the original memorial, which was done by Agnolo Gaddi, a late Gothic painter of the school that followed Giotto, must have been in some way unsatisfactory, and Uccello was ordered to do a new one, which was at least intended to create the illusion of a three-dimensional tomb. Uccello, with his perspective obsession, gave more attention in this monument to imitating the effects of sculpture than to making a portrait of the dead knight, who appears as a sort of ghostly chessman, greenish pale and melancholy, on his greenish pale horse (which was copied, it is thought, from the great bronze horses of the Hellenistic period that the painter had seen on St Mark's balcony in Venice). This too is a cartoon.

From Vasari's account, Uccello would certainly seem to have been a zoophile, living in reclusion from men, absorbed in arcane studies, and surrounded by a litter of painted animals, like some crazy hermit – 'out of touch with reality', as modern cant would phrase it. This might

account for the queer, brilliant puppetry of 'The Rout of San Romano', the work for which he is best known outside Florence, and for the ghostly chessman on the wall of the Duomo. Yet the fact is that the battles of the Renaissance, as Machiavelli complained, were precisely sham battles between companies of mercenary troops, in which only the horses, panicking, suffered heavy casualties. The Historie Fiorentine of Machiavelli gives a close description of the battle of Anghiari, against Niccolò Piccinino and the Milanese (this was the battle in which the Florentines are recorded as carrying statuary and which Leonardo painted in an unfinished fresco, long ago ruined and frescoed over by Vasari, for the Palazzo della Signoria); in that 'famous victory', fighting lasted four hours and raged back and forth across a bridge near Borgo San Sepolcro, yet only one man was killed, 'and he, not from wounds inflicted by hostile weapons or any honourable means, but, having fallen from his horse, was trampled to death'. The chief gain was in the capture of horses, banners, and carriages. Nor was this battle exceptional. 'Combatants,' says Machiavelli, 'then engaged with little danger, being nearly all mounted, covered with armour and preserved from death whenever they chose to surrender. There was no need for risking their lives. While they continued to fight, their armour defended them, and when they could resist no longer, they surrendered and were safe."

In Dante's day, when armies were made up of citizens, battles were real. After the battle of Campaldino, 1,700

Ghibelline soldiers, it is said, 'lay bleeding in the green woods and valleys of the Casentino', very near where Uccello was born. Dante, who was twenty-four years old, fought, along with Corso Donati and Vieri de' Cerchi, later chiefs of the Black and the White factions; he experienced, so he wrote, 'much fear and then, at the end, tremendous happiness'. By Uccello's time, mercenary foreign soldiers were fighting toy battles for which they could be paid by their employers without fear or risk. It was only the countryside and the villages that bled. When out of work, these bands of mercenaries hovered in the neighbourhood of the city that had been paying them and laid waste everything in sight. Such companies as the White Company must have appeared to the country people indeed as carapaced invaders from outer space or as a recurrent plague of beetles devouring the crops. The father of Cosimo I, Giovanni delle Bande Nere, was called that because his bands of fearsome mercenaries went into black armour in mourning for his death; a Sforza on his mother's side, he was one of the few captains of the period who actually died from wounds.

Thus the statistics of Machiavelli, who was urging on the state the idea of a citizen army, paint the same picture, though without colour, as that given by the recluse-artist—a picture of unreal battles that were animated cartoons of war, bizarre and brilliant in their trappings, enacted against a backdrop of rural placidity. It was Machiavelli's originality as a historian that he saw things 'in perspective'.

The civil life of Florence was never much affected by

external wars, until the great siege of 1530, which the citizens, finally united, withstood with great bravery but which ended with the entry of the Spaniards and the fall of the Republic. Slightly earlier, in 1494, the French king, Charles VIII, had marched into the city with his victorious troops and had withdrawn in fear when he saw the disposition of the people. A single succinct sentence, pronounced by a leading citizen, Piero Capponi, decided the king's departure. 'Then we shall sound our trumpets!' the king had cried out, threatening, when the Florentine deputy refused the ultimatum presented to the defeated city. 'If you sound your trumpets, we shall ring our bells,' Capponi replied. Charles, who had seen Florence and the Florentines - the sombre rocky palaces, like fortresses, and the people, like tinder, who were already stoning his soldiers - knew what this meant: a general rush into the piazzas. Afraid of street fighting in those streets that had seen so much of it, he capitulated, and Capponi's iron sentence still tolls, a warning, to invaders of republican communes - the bell answering the trumpet, the call to popular assembly retorting to the military clarion. When the Medici dynasty finally seized power, they had the bell of popular assembly destroyed.

No external defeat made as much impression on the Florentines as their civic disasters. From early times, the life of the city had been rendered precarious by its situation, at a confluence of rivers, between the Mugnone and the Mensola, where they flow into the Arno. It is hard to believe today, when the Arno itself, in summer, is not

much more than a dry stony bed, over the middle of which a sluggish low current of muddy green water barely moves, but Florence, from the time of Tiberius, was repeatedly threatened by destruction in the form of terrible floods. The great flood of 1333 described by Villani was only one of many recorded by him. Floods, in fact, were virtually constant throughout the thirteenth century; in 1269, both the Carraia and the Trinita bridges went, and it appears no wonder that Villani, in telling the story of the city, traces its origin to Noah. These floods, naturally, were looked upon by many as a punishment for sin; the swollen river was God's answer to the puffed-up pride of the turbulent citizens. The great flood of 1178, already mentioned, had been attended by two devastating fires and a famine, which was general throughout Tuscany. Earlier in that century, a Florentine bishop, Ranieri, had been preaching the end of the world; he based his prediction on a comet. The cataclysms of Nature, throughout the Middle Ages, were apocalyptic visions, for the Florentines, of what lay in store; prophecy was rampant.

In the year 1304 occurred a spectacular event which, again, was regarded as a 'judgment'. A representation of hell had been advertised, to take place at the Carraia bridge, in a theatre that was set up on boats in the river; there were flames, naked souls shrieking for mercy, master demons, devils with pitchforks. Overloaded with spectators who had crowded to see the performance, the bridge collapsed, and all, supposedly, were drowned, so

that it was said afterward in Florence that those who had gone to see hell got what they were looking for.

Nearly two hundred years later, Savonarola, preaching in the Duomo, terrified his audiences with a series of realistic sermons on Noah's Ark. Pico della Mirandola, the Platonic philosopher and poet, described the sermon on the Deluge, which he heard September 21, 1494. It began with the text: 'And behold I, even I, do bring a flood of waters upon the earth.' Savonarola cried this aloud in a terrible voice, like a thunderclap, as soon as he mounted the pulpit, while a cold shiver ran through Pico's bones and the yellow hairs of his head stood on end. The same day, like a dark saying made lucid, the news reached Florence that a flood of foreign troops had inundated Italy. These were the troops of the French king, Charles VIII.

The subject of Uccello's greatest work, which was done for the Green Cloister of Santa Maria Novella, is the Universal Deluge. In this extraordinary fresco, recently restored and put on show at the old Fort of the Belvedere, on the hill of San Giorgio, Uccello's fantasy grips the mind like some graphic sermon, with examples drawn from common experience, and a Biblical event, belonging to remote times, is given the immediate, telling impact of a prophecy. Here is one of those great visions of judgment which the Florentines alone, from Dante to Michelangelo, were capable of seeing – visions which gain their clair-voyance from a unitary passion, the love of a city or a nation, like that of the ancient Hebrews, and from a 'documentary' or scientific wealth of description, Dante's

account of hell, for example, being the more alarming for the painstaking geography and geology of its reporting. Dante 'explored' hell and found it full of Florentines; when a prelate criticized the nude figures in 'The Last Judgment', Michelangelo at once added him to the fresco, showing him in hell, wearing horns, with a serpent twisted around his loins, and when the prelate complained to the pope (Paul III), the pope replied: 'Had the painter sent you to Purgatory, I would have used my best efforts to get you released, but I exercise no influence in hell; ubi nulla est redemptio.' For these decisive Florentines, hell was as near as the Bargello. In the same way, Uccello's 'Deluge' is a naturalistic picture, based, no doubt, on Florentine experience, of a Bible myth.

It is constructed in two parts, with the wooden ark, shown twice, in perspective, on either side of the picture, walling in the frenzied scene. On the left, the ark is floating on the waters, with desperate figures clinging to its side; on the right, it has turned and come to rest, the waters having started to recede. Both sections seem to have a common vanishing point, and there is no clear line of division between the two episodes, that is, between the 'Before' and the 'After'. The compression of time, which blends the long months of the flood into a single, simultaneous event, adds to the sense of claustrophobia given by the converging walls of the two arks. God is absent from the spectacle, over which a lurid light plays, and man, hemmed in, shut out from salvation (which is the same word as 'safety', symbolized by the ark), reveals

his damned nature, not once, but for all eternity. In the narrow space between the two arks, the water is clogged with a log jam of dead bodies, which impede the movement of the living. On the right, a crow is pecking out the eyes of a drowned boy, while, on the left, a naked man on a swimming horse (like a centaur) is raising his sword against a beautiful fair-haired youth with a club, around whose neck a mazzocchio, like a black-and-white coiled snake, has fallen. A brute, heavy-muscled oaf, in his pelt, has got hold of a barrel, through which he pulls himself up, wearing a stupid, sidelong leer; a naked figure on a raft is fighting off a bear with a club. Farther off, an oak tree is being struck by lightning, and fallen branches are smashed against the ark. In the left foreground, a man in drenched clothes, clinging to the boards of the ark, against which he has flattened himself, looks sideways, surreptitiously, like a person in hiding, at his fellow-creatures struggling in the water below.

Apart, on a small island of dry land, stands a majestic, clean-shaven, aristocratic figure, with a hand raised in dignified prayer; from the ample folds of his dress and the noble, rugged seams of his brow, there flows an elemental security. He appears a grey rock, a cliff, against which the flood laps, effecting no erosion of his massive, sculptured calm. Out of the water, a pair of hands extends clasping his ankles, and the lout in the barrel watches him, transfixed, but the austere man does not transfer his fearless eagle gaze from the point in space he is contemplating, the Light he sees which seems to fall on him,

so that he appears almost phosphorescent, while above him (a part of the next scene), the outstretched hand of the bearded patriarch Noah, who is poking his head out of the ark to test the weather, suggests a blessing descending.

No one knows, for certain, who this mysterious central figure is. Most critics think that he is Noah, in the prime of manhood, preparing to embark on the ark; others object that he does not resemble the bearded Noah looking out the ark window or the bearded Noah of the other frescoes in the cycle. Yet if he is not Noah, who is he? One of the sons of Noah? But he does not look like any of the sons in the 'Drunkenness of Noah' fresco, and his commanding dignity excludes the idea that he is anything less than the signorial first citizen of a great people. It would seem that he must be Noah, the legendary ancestor of the Italian people, who is sculptured in relief on Giotto's bell tower. The bearded Noah might represent the patriarch, aged and wasted and sanctified by confinement in the ark, while the man on the dry island could be Noah at the height of his virility, one of the giants in the earth spoken of in the sixth chapter of Genesis, begotten by the sons of God on the daughters of men. The eye and the magnificent beaked nose are common to both figures. In any case, he is a Florentine, a quintessential Florentine 'che discese di Fiesole ab antico e tiene ancor del monte e del macigno' (Inferno, xv, 62), 'who came down from Fiesole in the old time and still smacks of the mountain and the hard rock'.

Uccello did a whole series of frescoes for the Green Cloister (called that because of the terra verde, or greenish

grisaille, that was his favourite medium for fresco). There were a 'Creation of Man', and a 'Creation of the Animals', a 'Creation of Eve', a 'Fall', the 'Deluge', a 'Sacrifice of Noah', and the 'Drunkenness of Noah'. The others, unfortunately, are more damaged than the 'Universal Deluge', so that only certain portraits - the sons of Noah, the Lamia or Female Serpent, blonde and pink - and one startling effect of foreshortening - God the Father flying head downward - are clearly visible. In Florence, there can also be seen the beautiful clock, surrounded by heads of prophets, that Paolo painted on the interior façade wall of the Duomo. Rows of prophets (Habakkuk, Jeremiah, Obadiah, Moses, et al.) by Paolo's friend Donatello and others once stood in niches on the Bell Tower, like weathered criers, and in Uccello's clock science and prophecy, the telling of time and foretelling, combine as though in a heraldic emblem of the Florentine character and genius.

With a sonorous poetic reverberation, Milton, in Paradise Lost, another cosmic myth, the only one that approaches the great myths that sprang from the Florentines twice invokes Florence and the surrounding hills and valleys for his famous description of Satan. He compares Satan's shield to the moon, 'whose orb through optic glass the Tuscan artist views / At evening from the top of Fesole [Fiesole], / Or in Valdarno, to descry new lands, / Rivers, or mountains in her spotty globe.' And a little further on, he speaks of Satan's 'legions, angel forms, who lay entranced / Thick as autumnal leaves that strow the

brooks / In Vallombrosa, where the Etrurian shades / High overarched embower. . . '. Vallombrosa (Shady Vale), near the Consuma Pass, is a cool forest of beeches, oaks, chestnuts, and firs high in the mountains, where Florentines now go for the summer, to play canasta in the hotels, but which was once a retreat favoured by hermits; it was here that Saint Giovanni Gualberto founded the Vallombrosan order. Valdarno is the Arno valley, and 'the Tuscan artist' is Galileo. For Milton, in the seventeenth century. the astronomer with his glass was still an artist. An odd fact, too, not without relevance, is that Copernicus, a Pole, was trained as a painter. Fra Ignazio Danti, the Dominican from Perugia who was Cosimo I's court astronomer and who made the gnomon and the astrolabe on Santa Maria Novella, was a painter too; fifty-three charming coloured geographical maps painted by him and another friar are in Palazzo Vecchio.

Science, magic, art, 'inspiration' were curiously bound together in the Florentine Renaissance. A 'break-through' occurred here, on all fronts simultaneously, which did not have a parallel for five centuries, when the French Impressionists, with their scientific theories of light, started a new revolution that quickly went beyond them and kept pace with, even anticipated, the new spatial discoveries in physics and mathematics and a new concept of time. The experiments of Cézanne and, following him, of the cubists again were based on geometry and again had an aspect of danger, as the visible world was broken down and reassembled on a floor plan of mathematics,

of spheres, perpendiculars, orthogonals, cubes, and cones. Picasso's later efforts to achieve, by juxtaposition, a simultaneous view of a face or form from all angles (that is, to compress time and space into a single Einsteinian dimension) are a dramatic repetition of the efforts of Uccello and Piero della Francesca to show complex forms, with all their facets, in the round. The violins, cups, bottles, fragments of newspaper that appear over and over in the cubist works of Juan Gris, Braque, and Picasso are the equivalents of the *mazzocchi*, ribbons, armour, and lances that mesmerized Uccello. In the geometric dance of such artifacts, a kind of alienation, in both cases, is depicted, and the materials of daily life are seen as a curio collection. Surrealism takes this a step further – into magic and hallucination.

Space, with its dimension of depth, was a grave matter for the analytic Florentines. For the Venetians, trompe l'œil, which they learned from the Florentine pioneers, was a game – a game they continued to play for centuries, never tiring of the deception of feigned marble, feigned brocade, fictive doors and windows, false vistas. Their city of masks was itself a painted toyland, a gay counterfeit of 'real life'. In Florence, after the Hawkwood monument, three others were commissioned – one by Andrea del Castagno, in honour of Nicolò da Tolentino, another mercenary, which stands next to the Uccello in the Duomo, and two of less interest which stand across the church, on the other wall. This was the end of perspective jests and trompe l'œil (trumpery), as far as the Renaissance

Florentines were concerned. Their civic halls, churches, and dwellings were too real for games of make-believe.

A state based on paintings, to quote a modern historian, would be a flimsy affair, and state painting, as such, did not enter Florentine history until after the fall of the Republic, when Vasari, a poor hack, became the official artist to Cosimo I. In the last days of the Republic, Leonardo and Michelangelo, it is true, were called upon to fresco battle scenes in the big hall of Palazzo Vecchio, yet neither of these frescoes was ever finished, and the very cartoons for them perished. Michelangelo's are thought to have been destroyed by the Medici soldiers quartered in the room in 1512. Up to this time, sculpture and architecture had been relied on by the Florentines to affirm the strength of the Republic. That is why the Uffizi, beautiful as many of its paintings are, is only a picture gallery, while the Bargello and the Museum of the Works of the Duomo are Florence. Secular painting, as it developed here in the Renaissance, under the influence of the collector, became more and more private, even enigmatic and riddling, while religious painting, starting with Fra Filippo Lippi and continuing with Ghirlandaio and his workshop, became more and more a species of genre - that is, a study of interiors, manners, dress, furniture, local customs. The painters who resisted this tendency towards genre (and these were, on the whole, the best) began to treat their art as a secretive pursuit, like alchemy, half immersed in science and half in magic. A picture, a painted likeness, has by its very nature something of sorcery attached to it, Unlike the statue, which grew out of a column or massy tree trunk, the picture was a mere figment, a deceptive thin image of the real. Florentine painting was, from early times, conscious of a need for stability; hence you find the pillar placed in the centre of so many Florentine 'Annunciations', between the Angel Gabriel and the Virgin, as though it were holding the picture up.

The early wonder-working ikons of the Madonna (many of them supposedly painted by Saint Luke) are usually kept veiled in Italian churches, being shown only on a special feast day; this seems to be an acknowledgment of the strong magic they are believed to possess. The miraculous fresco of the Annunciation in Santissima Annunziata in Florence, which is renowned throughout Italy for its curative powers, is housed in a little marble temple designed by Michelozzo; it is shut off by a silver screen and hidden by a curtain of rich stuff that is raised once a year, on the Feast of the Annunciation. Like most of the wonder-working ikons, this is fancied to have been the work of a supernatural agency or Magic Helper: a thirteenth-century monk, entrusted with painting the fresco, had finished everything but the head of the Madonna; he then fell into a deep sleep, and while he slept an angel painted the head. No earthly power, in other words, could have caught the likeness, and the shrouding of the image (if it were a question of protecting it, glass would have done as well) implies a taboo. Similarly, the painted cross in Santa Trinita that nodded its head to Saint Giovanni Gualberto is kept covered by a

modern painting telling the story of the legend and is shown only on Good Friday.

Painted images, being a species of conjuration, were often used in exorcism. A banner painted with the figure of Saint Agatha, now in the Museum of the Works of the Duomo, was carried through the streets on her feast day to ensure a year's protection against fire. Those colossal images of Saint Christopher that are frescoed on the walls of so many early Italian churches were supposed to ward off danger; anyone who looked at Saint Christopher was safe in his travels, and the saint, being a giant, was painted very big, so that no one could miss seeing him. A two-way relation between the painting, especially the portrait painting, and the spectator is often felt to exist: the spectator is looking at the painting, and the painting, he begins to think, is looking at him, boring into him, in fact, with its unwavering gaze. A gallery of portraits becomes a gallery of eyes. Certain paintings have eyes that are supposed to move, following the spectator about. The spectator can walk around a piece of sculpture (indeed, he is expected to do so), but a painting holds him arrested in its grip. The idea of a painting as an inescapable nemesis is behind Oscar Wilde's The Picture of Dorian Gray - a story of a diabolical pact; and speaking in this same vein, a Florentine recently remarked that the pictures in the Uffizi had grown ugly from looking at the people who looked at them.

Painting, with its trickery, could master a class of subject that was forbidden ground to the sculptor; that

is to say, dreams and visions - reality in its hallucinated and impalpable aspect. This class of subject had its greatest popularity in Florence and Tuscany, where the great fresco cycles of the fourteenth and fifteenth centuries drew chiefly on the Golden Legend of Jacopo della Voragine and the life of Saint Francis for dreams and visions that had 'made history': the Dream of Constantine, the Dream of Pope Sylvester, the Dream of the Emperor Heraclius, the Dream of Pope Honorius III, Saint Francis Receiving the Stigmata (in which the Saviour appears as a winged creature or small half-human bird in the air), the Vision of Brother Augustine, and, from the Bible, the Dream of Joachim, the Vision of Saint John on Patmos. On the walls of Santa Croce's chapels, in the upper church at Assisi, in the Arena Chapel at Padua, in the choir of San Francesco in Arezzo, the Florentine school of fresco painters, from Giotto through Taddeo and Agnolo Gaddi and Maso di Banco down to Piero della Francesca. had traced on walls and distempered the ghostly night visitants and daytime apparitions that flitted across the portals of consciousness with messages from the future and signs from the beyond. The Franciscan religious revival, with its inspirational character and its gospel of unearthly joy, was the power behind these cycles, which are found, almost exclusively, in Franciscan churches. Many of the most beautiful works of Tuscan fresco are these curiously moving 'Dreams', with their pathos of naturalness (such touches as the pope composed for sleep wearing his mitre and cope - Giotto; the soldier watching

outside the tent while the Emperor sleeps – Piero) that makes them resemble Shakespearean night scenes (Brutus in his tent, Desdemona preparing for bed), in which a premonition or phantasm troubles the curtained stillness of the night.

Fra Angelico came out of the religious reform movement in Tuscany, and he was held, by Vasari, to have been divinely inspired, painting as an angel would, without recourse to the adroit deceptions of art. When not directly inspired by God, a painted image was often felt to be akin to deviltry. Machiavelli tells a horrible story of a certain Zanobi del Pino, governor of Galatea, who surrendered the fortress to the enemy without offering any resistance. The enemy commander (Agnolo della Pergola) turned him over to his attendants, who demonstrated their contempt by feeding him on a diet of paper painted with snakes. These snakes, they said, taunting, would turn him from a Guelph into a Ghibelline. 'And thus fasting,' concludes Machiavelli, 'he died in a few days.' The dissimulation practised by the traitor was here cruelly parodied by the snaky dissimulation felt to be inherent in a painted surface.

The habit of painting likenesses of condemned criminals on the walls of a prison, like posters, has already been mentioned. After the Pazzi Conspiracy, says Vasari, Andrea del Castagno was hired, at the public expense, to depict the conspirators on the walls of the Bargello; he showed them hanging by the feet 'in the strangest attitudes, which were infinitely varied and exceedingly fine'.

The work was pronounced 'a perfect wonder' and met with everyone's approval for its artistic and lifelike qualities, so that Andrea, ever after, was called Andrea degli Impiccati (of the Hanged Men). On the other hand, three life-size figures of the intended victim, Lorenzo de' Medici, were ordered sculpted in wax, to be put in various churches of Florence as votive offerings. This work was done by the great wax-modeller Orsini, in collaboration with the sculptor Verrocchio.

The notion of the painter as a sort of boon companion to the hangman is carried on by Leonardo, who was fond of attending executions, perhaps to study the muscular contortions of the hanged. Actually, Vasari's story is partly wrong. It was Botticelli who painted the Pazzi conspirators on the Bargello wall, submitting them to a final punishment; the body of Jacopo de' Pazzi, a relatively innocent party, had already been dragged naked through the streets, thrust into a hole, dug up again, and finally flung, wearing its halter, into the Arno, as though the earth refused it grave room. Andrea del Castagno was dead by this time, but he had painted some other hanged persons, members of the Albizzi faction, in honour of the return of Cosimo, Father of his Country, from exile.

The eerie verisimilitude, amounting sometimes to malignity, of Andrea del Castagno's work caused him to be regarded, at least after his death, as a devil. He had painted a wonderful speaking likeness of Judas in the dramatic 'Last Supper' of the Cenacolo of Sant' Apollonia,

and Vasari says that he resembled Judas, both in appearance and in his power of dissimulation. According to Vasari, he murdered his fellow-painter Domenico Veneziano, from whom he had learned the oil process, out of envy of his sweeter skill. This story cannot be true either, since Domenico Veneziano outlived Andrea by four years, but the important thing is that Vasari and his readers found it credible, so credible, in fact, that the authorities in Santissima Annunziata, following Vasari's revelation, whitewashed over some of Andrea's frescoes, in retributive justice, nearly a hundred years after his death. Andrea was a peasant, from a remote village in the mountains, and there is something wild and coarse in his work, a beetling, swarthy, almost brutal vitality that does indeed suggest a capacity for crime of the peasant sort - for the vendetta, long brooded on, or the sly murder for gain, for the possession of a secret treasure.

In any case, the idea of a secret, such as the oil process, which men would murder for, seems to connect painting even more closely with witchcraft. Conflicting accounts are still given of how the oil process came to Italy and was disseminated. Naïve authors write about it as if it were some magic concoction or philtre guaranteed to give charm or, better, fascination to a painting. Painters were enrolled in the guild of the Speziali, or Pharmacists; this was because, like the druggists, they compounded pigments or powders, according to secret formulas, out of imported 'spices'. With the discovery of perspective, itself a wizard science of numbers, painting, especially in

Florence, where everything was pushed to extremes, became more and more a black art. Geniuses like Uccello and Piero della Francesca, who abandoned themselves to perspective studies, neglected their work for the sake of this fata morgana. Piero, who was trained in Florence under Domenico Veneziano, gave the later years of his life to writing mathematical treatises. Like Uccello, he died obscure and neglected - in the little town of Borgo San Sepolcro, where he was born. He, too, had been bewitched by mazzocchi, by chalices, cups, and cones. A mystery attaches to one of his most striking works, the Urbino 'Whipping of Christ', like the mystery surrounding the man on dry land in Uccello's 'Deluge'. In the background of the picture and, as it were, far, far away and very small, Christ is being scourged by some soldiers before a still High Priest, in a frame of classic architecture, while in the front of the canvas, on the street, three figures in contemporary dress - a bearded man, a youth, and a bald man-stand conversing, with their backs turned towards the scene of the whipping. Christ is remote and unreal; they are very near, large, and almost dangerously real. The question arises: Who are they and what are they meant to signify? No one knows. Some say they are the Duke Oddantonio of Urbino, who was murdered in 1444, and his treacherous ministers; if so, this would be another memorial of infamy, like the hanged figures painted on the Bargello or the painted snakes. But there are other theories, and none is altogether satisfactory. Painting was becoming a secret language.

What happened during the fifteenth century, the age of discovery, in Florentine painting had the character sometimes of a Promethean, sometimes of a Faustian myth. Since the ancient Greeks, no people had been as speculative as the Florentines, and the price of this speculation was heavy. Continual experiments in politics had caused a breakdown of government, as in Athens, and artistic experiment had begun to unhinge the artists. 'Ah, Paolo,' Donatello is supposed to have remonstrated, 'this perspective of yours is making you abandon the certain for the uncertain.' The advances in knowledge gave rise to an increase in doubt. By a cunning legerdemain, it was found, a flat surface could be made to appear round; at the same time, paradoxically, the earth itself, which appears to be flat, was being shown to be round by scientific argument. The whole relation between appearance and reality was unsettled. 'Doubting Thomas', usually shown (by the Venetians, for instance) as a middle-aged person, became for the Florentines a beautiful, entrancing youth - the most charming of all the disciples, as he sits with his lovely chin tilted back on his hand in Andrea del Castagno's 'Last Supper' or as he stands, with graceful curls, and his fair, sandalled foot extended in Verrocchio's sculpture on Orsanmichele.

A peculiar tale of this period called 'Il Grasso Legnaiuolo' gives the flavour of Florentine intellectualism. It is a story of a beffa or jest – a trick played by Brunelleschi and his friends on the fat woodworker of the title, who had offended them by not coming to supper one night

when they were expecting him. They decide to persuade the woodworker that he does not exist, that is, to strip him of his identity, first, by not recognizing him and, second, by assuring him through an elaborate series of manœuvres that there is indeed a 'Grasso', whom he claims to be, but that he is not that person. He is, instead, they convince him by their sleights, no one, nothing, a mere confused flux of consciousness that thinks it is a fat woodworker. The climax of the tale is reached when the quivering fat man is afraid to go home, to his own house, for fear that 'He' - that is, himself - will be there, 'If he is there,' he says to himself, in a mixture of cunning and panic, 'what will I do?' This picture of self-alienation, which is more terrifying and cleverer than anything in Pirandello, is told as a true incident, well known in its own time, which befell a certain Manetti degli Ammannatini, who, unable to live down his experience, went off to Hungary, where he ended his days. The susceptible woodworker, in fact, must have been one of those 'workers in intarsia' - mentioned disparagingly by Donatello - who specialized in illusionist perspective effects, of mazzocchi, spheres, points, and so on, artfully wrought in wood inlays. The genius of Brunelleschi is the real hero of the tale; this genius, which found the way to calculate the vanishing point, could make a bulky man vanish or seem to himself to vanish, like a ball juggled by a conjurer, while still in plain sight.

The strain of eccentricity, of queer, secretive habits, among Florentine painters crops up again in Piero di Cosimo, who was well known for his paintings of dragons and other hideous monsters in the time of Savonarola. Vasari says that Piero lived more like a beast than a man, not letting his rooms be swept or his gardens and vine-yard be hoed or pruned. Unkempt and savage, he wished to see everything revert, like himself, to a wild state of Nature, and he had a passion for all Nature's oddities and 'mistakes'. He looked for the marvellous everywhere and could descry faces in the clouds and battles in filthy walls, where people had spat. One of his peculiarities was that he would not let anyone see him at work.

Leonardo had much in common with Piero di Cosimo and more with Uccello. Here were the same collections of birds and beasts: the same interest in freaks and aberrations: the same scientific and mathematical bent; the same perpetual experimentation, which made his studio resemble an alchemist's laboratory, full of the new media he was trying out, often with unfortunate results, for the colours did not last always and a beautiful work, it is said, would turn brown and shrivelled, like an ugly old woman. In Leonardo, all the genius of the Florentine people - the genius for science, engineering, mapmaking, painting, architecture, sculpture - seemed to concentrate, and he was handsome to look at as well. Of all the gifts bestowed on him, it was painting he cared most for, unlike Michelangelo, who, almost equally gifted, despised all painting, except fresco, as childish work, unfit for a man. Yet Leonardo, too, like Uccello, was fascinated by mathematical puzzles to the point where he neglected his art. A monk who was acting as Isabella d'Este's agent wrote her, to report on Leonardo's progress: 'In sum, his mathematical experiments have so distracted him from painting that he cannot abide the brush.'

With Leonardo, the element of sorcery in his favourite art declared itself finally without equivocation. The supposed self-portrait that he did when old shows him as a kind of ancient Merlin or druid mage, with long white hair, beard, and eyebrows - all the accessories of the Enchanter. The bluish caves and grottoes, the stalagmites and stalactites, the mirror pools and shadowy rivers of his easel-painting beckon the viewer into a sly realm of sinister magic. The curving smiles of his Madonnas and Saint Annes are a serpentine temptation; Saint John the Baptist with his soft womanly breasts and white plump arm like a cocotte's turns into a Bacchus, with a crown of grape leaves and a panther's skin. Everything is in a state of slow metamorphosis or creeping transformation, and the subject of his most celebrated painting, the Mona Lisa, smiling her enigmatic smile, is certainly a witch. That is why people are tempted to slash her, to draw moustaches on her, to steal her; she is the most famous painting in the world, because all the deceptions and mystifications of painting are summed up in her, to produce a kind of fear.

Chapter Five

Florentine history, in its great period, is a history of innovations. The Florentines wrote the first important work in the vulgar tongue (the Divina Commedia); they raised the first massive dome since antiquity; they discovered perspective; they made the first nude of the Renaissance; they composed the first opera (Jacopo Peri's Dafne). It is a question whether they or the Venetians were the first to collect statistics. The first humanist, Petrarch, was the son of Florentine Ghibellines, fuorusciti who had taken refuge in Arezzo at the time of his birth. Literary criticism, in the modern sense, was inaugurated by Boccaccio, who lectured in a little church next to the Badia on the Divine Comedy in the year 1373, the signory having decreed that 'the work of the poet vulgarly called Dante' should be read aloud to the public. Boccaccio's clinical account of the plague symptoms in the Decameron was a pioneer contribution to descriptive medicine. Machiavelli is generally called the father of political science, and he was the first to study the mechanism of power in politics and government. The first modern art criticism was written by L. B. Alberti.

The first chair of Greek was set up here, in the fourteenth century. The first public library was founded by Cosimo

il Vecchio in the convent of San Marco. The Italian literary language is exclusively the creation of the Tuscans, who formed it on their dialect as spoken in the city of Florence; Manzoni, the author of *I Promessi Sposi*, came here in the nineteenth century from Milan to 'rinse his linen', as he said, 'in the water of the Arno'; Leopardi came from the Marche. Tuscany is the one province in Italy that does not have a dialect, the Tuscan dialect being, precisely, Italian – what is sometimes called Tuscan dialect (the substitution of 'h' for hard 'c', for example, 'hasa' for 'casa' among the poor people, is only a difference in pronunciation). In the same way, Italian painting spoke in the Tuscan idiom from the time of Giotto to the death of Michelangelo, that is, for nearly three centuries.

The Florentines, in fact, invented the Renaissance, which is the same as saying that they invented the modern world – not, of course, an unmixed good. Florence was a turning-point, and this is what often troubles the reflective sort of visitor today – the feeling that a terrible mistake was committed here, at some point between Giotto and Michelangelo, a mistake that had to do with power and megalomania, or gigantism of the human ego. You can see, if you wish, the handwriting on the walls of Palazzo Pitti or Palazzo Strozzi, those formidable creations in bristling prepotent stone, or in the cold, vain stare of Michelangelo's 'David', in love with his own strength and beauty. This feeling that Florence was the scene of the original crime or error was hard to avoid just after

the last World War, when power and technology had reduced so much to rubble. 'You were responsible for this,' chided a Florentine sadly, looking around the Michelangelo room of the Bargello after it was finally reopened. In contrast, Giotto's bell tower appeared an innocent party.

But the invention of the modern world could not be halted, at Giotto's bell tower or Donatello's 'San Giorgio' or the Pazzi Chapel or Masaccio's 'Trinity'. The Florentines introduced dynamism into the arts, and this meant a continuous process of acceleration, a speed-up, which created obsolescence around it, as new methods do in industry. The last word, throughout the Renaissance. always came from Florence. When Cosimo il Vecchio, in 1433, arrived at Venice, an exile, with his architect. Michelozzo, and his court of painters and learned men. and was lodged, like a great prince, on the island of San Giorgio in the lagoon, the Venetians were amazed by these advanced persons, just as they were amazed, later, in Giorgione's time, by the arrival of Leonardo. The Romans, seeing the two young Florentines, Brunelleschi and Donatello, directing workmen to dig among the ruins of the old temples and baths, assumed that they were looking for buried treasure, gold and precious stones, and the measurements the two shabby young men were taking seemed to confirm this; it was thought that they must be practising geomancy or the art of divination by lines and figures, to find where the treasure lay hidden. A century later, the Romans themselves, having caught on

to the lesson of the 'treasure-hunters', were digging up the Laocoon.

Wherever the Florentines went, they acted as disturbers, agents of the new. They congregated in Ferrara, as exiles, and the Duke's own local court painting took on a fevered brilliance that reached a climax of almost sinister beauty in the frescoes of Palazzo Schifanoia ('Chase Away Care'), allegories of the Seasons and the Signs of the Zodiac, done for the marriage of the young Borso d'Este to replace frescoes by Piero della Francesca that had been damaged by fire. The Florentines came to Urbino, to Rimini, to Mantua and left behind them in these petty duchies exquisite masterpieces of painting, architecture, sculpture, like dropped handkerchiefs of marvellous workmanship, to astonish the local schools. Giotto had worked in Padua, in the Arena Chapel, and the influence of his monumental style radiated throughout the Veneto; the great frescoes in Treviso, by Tomaso da Modena, and the Altichiero cycles in Verona proclaim, like colonies planted, the parenthood of Florence. More than a hundred years later, it was Padua, again, that felt the shock of a new revolution in Florence, when Donatello came and set up the huge equestrian statue of Gattamelata in the public square to stand as a fresh wonder in the world and inspire the young Mantegna and, in turn, through him, the Venetians, who had already been unsettled by Masolino, Uccello, and that wild mountaineer from the Tuscan Alps, Andrea del Castagno. (The Gattamelata monument is usually spoken of as 'the first equestrian statue since

antiquity', though in fact many preceded it - the monument to Can Grande, Dante's protector, in nearby Verona, for example. The effect of Donatello's arrogant mounted condottiere was to make those who looked at it forget all the others and regard it as the parent of a species. Similarly, Donatello's 'David' is not really 'the first nude since antiquity'; it is the first free-standing nude.) During the next century, Leonardo's travels again spread disquiet: in Venice, where he troubled Giorgione and the young Titian; in Milan, where a Milanese school hastily formed itself in his image. Shortly after this, Florentine tombsculptors carried the Renaissance, already declining, like a sick person, to Tudor England; Pietro Torrigiani carved the tomb of Henry VII in Westminster Abbey, and sculptors from the hills around Florence, from Maiano and Rovezzano, worked for Cardinal Wolsey. It is odd to think that Michelangelo, who you might think was a contemporary of Beethoven, died the year Shakespeare was born; this conjunction of dates measures the distance between Florence and the rest of the world. Even in Rome, many of the most astounding works (the Sistine Chapel, the tomb of Pope Julius II, the tomb of Innocent VIII, the dome of St Peter's, the Masolino frescoes in San Clemente) are by Florentines.

The Florentines abroad, when they were not political exiles, conspiring among themselves, backbiting and trying to promote wars that would bring them home, were provokers of a different kind of disturbance, upsetting preconceptions of the mind and eye. Abroad and

at home, they were independent, difficult to get on with, patronizing, quick in retort. 'So this is the little person,' said Pope Eugenius IV, sizing up Brunelleschi, 'who would be brave enough to turn the world over on its axis.' Just give me a point, Your Holiness, where I can fix my lever, and I'll show you what I can do.' The little architect's prompt reply summed up the Archimedean attitude of the Florentines: 'Give me a place to stand, and I will move the universe.' The story of Giotto and the circle, which gave rise to the expression 'as round as Giotto's O', shows the same succinctness and confidence. Asked by the agent of an earlier pope for a sample of his work, Giotto simply drew a perfect circle, free hand, in red pencil, and sent it on to the vicar of Christ, who understood the point: the man who could do this had no need, like ordinary artists, to submit drawings.

On Giotto's bell tower, there is a little relief of Daedalus, the hawk-man of antiquity, whose name means 'cunning craftsman'. He is shown, all feathered, with the wings he fashioned on his back, after a design that may perhaps have been Giotto's, and it can hardly be doubted that he, the great artificer and mechanic, who built Minos's labyrinth and was a famous sculptor as well, was the real patron and mythic prototype of the Florentine builders and artisans; nor does it seem an accident that the flying machine was invented by the Florentine Leonardo, who tried, so they say, to fly off Mount Ceceri, the great cliff of Fiesole, where Milton locates Galileo with his 'optic glass' and where the Etruscan priest-astrologers used to

study the skies. The ambition to move mountains, literally, was inherent in these hill dwellers. Leonardo, according to Vasari, not only conceived of boring tunnels through mountains but speculated on the possibility of moving mountains themselves from place to place.

Most of the great Florentine architects and sculptors were engineers as well. Brunelleschi tried to contrive the defeat of Lucca for the Florentines by an ingenious scheme for turning the course of the River Serchio and flooding the surroundings of the enemy city – a plan that miscarried, however. During the great siege of 1529–30, Michelangelo was invited to supervise the city's defence, and, before he ran away, he built the walls that can still be seen near San Miniato as fortifications for the Republic. Leonardo's engineering projects for the Duke of Milan are well known. The Florentine sculptorarchitects, when not working for the Republic, were much in demand with neighbouring tyrants for the construction of public works: canals, arsenals, and chains of fortifications.

The tyrant's concern with power made a natural kinship between him and the Florentine engineers, who were also interested in power – the master-power of man over Nature. Michelangelo's close relations with four different popes, starting with Julius II, the fighting Della Rovere, and the story that Leonardo died in the arms of Francis I of France testify to something deeper than patronage; these were cases of elective affinities. Pope Clement VII (Giulio de' Medici) confessed that whenever Michelangelo

came to see him, he, the pope, made haste to sit down and to invite the sculptor to do likewise, because, if he were not quick about it, Michelangelo would take a seat anyway, without asking permission.

This lack of deference to the pope did not proceed from insolence. Like most Florentines, today and in the past, Michelangelo had no 'side'. The habit of equality with princes came out of a certain simplicity and rough, outspoken address, fostered by public assemblies, by commerce, and by the absence of a court. There was something of Benjamin Franklin in Michelangelo at the papal audiences. The boundless conceit and ambition of the Florentines was based on a feeling of 'natural' superiority, which required no outer polish, and Michelangelo, who liked to leave some roughness on a finished statue, to show the mark of the sharp tools he had used on it, in the same way left some roughness on his speech and manners, to show the mark of Nature, which had formed him in a certain mould. When Clement VII was still a cardinal, Michelangelo wrote him, dryly: 'Now if the Pope is issuing Briefs licensing people to steal I beg your Most Reverend Lordship to get one for me, since I am more in need of it than they are.' 'They' was the Chapter of the Duomo, a group of clerics with whom Michelangelo was dickering for some land.

The Florentine attitude towards antiquity was the same as towards popes and princes. The Florentines felt themselves to be the equals of the ancients and were on democratic terms with them – that is, on terms of rivalry and

competition. When Brunelleschi and Donatello took measurements in Rome of ancient temples and statuary, this was not for the purpose of copying them but to learn how the old artists had done it, what their principles had been. Imitation of the antique, such as Alberti proposed, was inconsonant with this kind of curiosity, as of one craftsman watching another to observe his method. In literature the Florentines, e.g., Poliziano, succumbed quite early to the classicizing rage, but in art and architecture Florence, though intensely classical in its own way, never showed the reverence for antiquity that was felt elsewhere; that was why Alberti had such small success with his 'orders'.

The position of frank rivalry and competition taken by the Florentines towards the ancient world was established remarkably early. When the Duomo was ordered, in 1296, from Arnolfo di Cambio, to replace the old church of Santa Reparata, a proclamation explained the citizens' requirements. 'The Florentine Republic, soaring ever above the conception of the most competent judges, desires that an edifice shall be constructed so magnificent in its height and beauty that it shall surpass anything of its kind produced in the times of their greatest power by the Greeks and the Romans.' The intention of surpassing standards held to be fixed and eternal amounted almost to blasphemy or hubris; to modern ears, this very tall order has an 'American' twang: so a millionaire might command his architect to build him something bigger and better than the Parthenon.

The Florentine spirit was averse to any notion of a fixed hierarchy, whether imposed by pope or emperor or by force of habit. Even Dante had his own seating arrangements, so to speak, worked out for the next world. whereby, for instance, he put his old grammar teacher, Donato, in paradise, and he shows himself to be conscious. also, of the notion of progress and its corollary, obsolescence, in the arts. 'Cimabue thought he had the field to himself,' he says in the Purgatorio, 'but now the word is Giotto, who has put him in the shade.' Each artist set himself to compete not only with his immediate rivals but with all previous standards of excellence. An absolute equality and simultaneity was presumed to exist, as it were, at the starting line, between the dead and the living. and no standard could impose itself except the standard revealed in each work as it unfolded its nature. None of the great artists of Florence, except the first Della Robbias and the two Lippis and Ghirlandaio, if he is considered great, belonged to one of those family firms like Bellini & Sons, the Vivarini Brothers, the Tintorettos, the Da Pontes from Bassano, which were common in Venice and the Veneto. In Florence, each man strove, if he had genius, to stand alone. Something of the same sort happened in fashion. In the fourteenth century, says Burckhardt, the Florentines stopped following the mode, and every man dressed to suit himself.

Arnolfo's Duomo does not surpass the Parthenon; nevertheless, it is a very remarkable building. Bigness has always been one of the forms that beauty can take, and the Renaissance was more simply conscious of this than sophisticated people are today. 'Let me tell you how beautiful the Duomo is,' writes Vasari, and what follows is an account of its measurements. The scale of an effort was the measure of its sublimity; the public, running its eye over the sum of measurements, contemplated a feat of daring. In daring, the Florentines excelled; that is why their architecture and their sculpture and much of their

painting have such a virile character.

The Duomo, outside, still astonishes by its bulk, which is altogether out of proportion with the narrow streets that lead up to it. It sits in the centre of Florence like a great hump of a snowy mountain deposited by some natural force, and it is, in fact, a kind of man-made mountain rising from the plain of the city and vying with the mountain of Fiesole, which can be seen in the distance. Unlike St Peter's in Rome, which is cleverly prepared for by colonnades, fountains, and an obelisk, the Duomo of Florence is stumbled on like an irreducible fact in the midst of shops, pasticcerie, and a wild cat's cradle of motor traffic. It startles by its size and also by its gaiety - the spread of its flouncing apse and tribune in their Tuscan marble dress, dark green from Prato, pure white from Carrara, pink from the Maremma. It is like a mountain but it is also like a bellying circus tent or festive marquee. Together with the Baptistery and Giotto's pretty bell tower, it constitutes a joyous surprise in the severe, dun, civic city, and indeed, throughout Tuscany there is always that characteristic contrast between the stone

dread of politics and the marbled gaiety of churches. Inside, Arnolfo's Duomo is very noble - sturdy, tall, grave, with great stone pillars rising like oaks from the floor to uphold massive arches so full they can hardly be called pointed. This splendid stone hall does not soar, like a Gothic cathedral; the upward thrust is broken by a strict, narrow iron gallery running around the whole interior, outlining the form. A few memorial busts; Uccello's clock; the two caparisoned knights on horseback in trompe l'œil; round, deep eyes of windows, set with large-paned stained glass, high in the thick walls; a small, sculptured bishop, blessing; a few faded images on gold backgrounds; a worn fresco of Dante; two statues of the prophet Isaiah; a holy-water stoup - that is almost all there is in this quiet, long room until it swells out into the vast octagonal tribune, surrounded by dim, almost dark chapels and topped by Brunelleschi's dome. There is nothing here but the essentials of shelter and support and the essentials of worship: pillars, arches, ribbing, walls, light, holy water, remembrance of the dead, a clock that still tells time.

The daring of Arnolfo, who was the first of the great Florentine master builders, lay not only in the scale of his undertaking but in the resolute stressing of essentials – what the Italians call the *membratura*, or frame of the building, a term that is drawn from anatomy (*i.e.*, from the human frame). Michelangelo, the last of the great builders in Arnolfo's tradition, considered architecture to be related to anatomy, and the Florentine Duomo, with

its pronounced membratura, is like a building in the nude, showing its muscles and sinews and the structure of bone underneath. On the outside, it is a dazzling mountain, cased in the native marbles of Tuscany, and, inside, it is a man, erect. Arnolfo was a sculptor, too, and the sculptures he made for the old façade (now replaced by a Victorian façade) and interior of the Cathedral (they can be seen in the Museum of the Works of the Duomo) have an odd family resemblance to the interior of the Duomo itself, as though saints, Madonnas, bishops, and building were all one breed of frontiersman – tall, sturdy, impassive.

Arnolfo had got as far as the tribune, as far, some think, as the drum of the cupola, when he died. In the magnitude of his ambition, he left a problem for those who followed him that remained insoluble for more than a hundred years. The problem was how to put a roof over the enormous expanse of the tribune. No precedent existed, for no dome of comparable size had been raised since ancient times and the methods used by the ancients were a mystery. Experts were invited to contribute ideas. Someone proposed that a great mound of earth stuffed with small coins (quattrini) should be piled up in the tribune; the dome could be constructed on this base. When it was finished, the people of Florence should be called in to hunt for the quattrini in the mound of earth, which in this way would be quickly demolished, leaving the dome standing. The principal merit of this bizarre plan was that it promised a supply of almost free labour - ant labour, one might say. The Republic, ever soaring but ever mindful of expenses, had got round the problem of paying Arnolfo by the expedient of simply remitting his taxes in return for his work.

In the year 1418 a competition for the dome was announced to which masters from all over Italy were invited. Such competitions for public works were a regular feature of Florentine life, and the young Filippo Brunelleschi, not long before, had lost a competition in sculpture to Lorenzo Ghiberti, whose model for the second set of bronze Baptistery doors had been accepted over his. Disappointed - so the story is told - he had gone off to Rome, with Donatello, and made himself an architect, knowing that in this field he could surpass everyone. He remained there several years, earning his living as a goldsmith, while he examined Roman buildings, with particular attention to the Pantheon and its dome. When the competition was announced, he came back to Florence, announcing that he had found a way of raising the dome of Santa Maria del Fiore without centring - a thing everyone believed to be impossible.

Faced, like Columbus, with an assembly of doubters, he anticipated Columbus with the egg trick. 'He proposed,' says Vasari's version, 'to all the masters, foreigners and compatriots, that he who could make an egg stand upright on a piece of smooth marble should be appointed to build the cupola, since, in doing that, his genius would be made manifest. They took an egg accordingly, and all those masters did their best to make it stand upright, but none discovered the method of doing so. Wherefore,

Filippo, being told that he might make it stand himself, took it daintily into his hand, gave the end of it a blow on the plane of marble and made it stand upright.' He vaulted the huge tribune by means of a double cupola, one shell resting on another inside it and thus distributing the weight – an idea he had probably got from the Pantheon.

This dome of Brunelleschi's, besides being a wonder, was extremely practical in all its details. It had gutters for rain, little ducts or openings to reduce wind pressure, iron hooks inside for scaffolding so that frescoes could be painted if they were ever wanted, light in the ballatoio, or gallery, that goes up to the top so that no one would stumble in the dark, and iron treads to give a footing in the steeper parts of the climb. While it was being built, it even had temporary restaurants and wineshops provided by Brunelleschi for the masons, so that they could work all day without having to make the long trip down and up again at lunch time. Brunelleschi had thought of everything.

In short, the dome was a marvel in every respect, and Michelangelo, when he was called on to do the dome of St Peter's, paid his respects to Brunelleschi's in a rhyming couplet:

> 'Io farò la sorella, Già più gran ma non più bella.' ('I am going to make its sister, Bigger, yes, but not more beautiful.')

Vasari said that it dared competition with the heavens. 'This structure rears itself to such an elevation that the hills around Florence do not appear to equal it.' Lightning frequently struck it, and this was taken as a sign that the heavens were envious. When the people of Florence learned that a lantern, on Brunelleschi's design though not begun until after his death, was about to be loaded onto the cupola, they took alarm and called this 'tempting God'.

Michelangelo was right, when he said that the dome of St Peter's would not be more beautiful. Brunelleschi's, moreover, was the first. Michelangelo could be blunt and sarcastic about his fellow-architects and sculptors. He dismissed Baccio d'Agnolo's model for the façade of San Lorenzo as 'a child's plaything', and of the same architect's outside gallery on the Duomo he said that it was 'a cage for crickets' (crickets in little cages, like the ones he meant, are still sold in the Cascine on Ascension Day, a spring festival corresponding to the old Roman Calends of May and called in Florence the 'Cricket's Feast'). But he was very much aware of real greatness (he called Ghiberti's second set of Baptistery doors the 'Gates of Paradise', and to Donatello's 'San Giorgio' he said 'March!'), and his architecture is always conscious of Brunelleschi, long dead before he was born, whom he could not surpass but only exceed: bigger, yes, but not more beautiful. The portentous staging of the Medici Tombs, the staircase of the Laurentian Library, the dome of St Peter's are Brunelleschi, only more so. The heavy consoles and corbels of

the Laurentian Library vestibule and staircase, with their strong, deep indentations, contrast of light and shade, their pietra serena and white plaster, are Brunelleschi, underscored or played fortissimo. Brunelleschi, like Arnolfo, had stressed the membratura of a building; in Michelangelo, there appears a false membratura, a fictive ensemble of windows, supporting pillars, brackets, and so on – in

short, a display of muscle.

In Brunelleschi himself, the Florentine tradition reached its highest point. Here - in Santo Spirito, for instance, or the Pazzi Chapel or the Old Sacristy of San Lorenzo or the Badia at San Domenico di Fiesole - are the grave purity, simplicity, and peacefulness of the early Florentine churches. The germ of Brunelleschi can be found not in classical Rome but in the little church of Santi Apostoli that legend attributes to Charlemagne. All grey and white, the dark-grey stone that is called justly 'serene' against white intonaco; three long aisles, one of which forms a nave; two processions of pillars with lovely Corinthian capitals marching down the church and upholding a rhythmic train of round arches; vaults interlacing like fans opening and closing; decorative motifs, always in dark-grey stone, of leaves, egg-and-dart pattern, scallop shells, and sun rays - these, generally speaking, are the elements of Tuscan classicism that are found, over and over, in the great Brunelleschi churches, sometimes with friezes and roundels added in the more frivolous parts, like the sacristy, by Donatello or Desiderio or Luca della Robbia: cherubs with rays like flower petals round their necks or with crossed wings like starchy bibs, the four Evangelists, or scenes from the life of Saint John.

The big churches of Brunelleschi, particularly San Lorenzo, which was the parish church of the Medici family, have been somewhat botched by later additions. The Pazzi Chapel, which was built for the Pazzi family as a kind of private oratory just outside the Franciscan church of Santa Croce, has not been tampered with, however, since the fifteenth century, and here you find the quintessential Brunelleschi. It is a small, square, yellowish, discreet temple, with projecting eaves, almost like a little mausoleum, from the outside, or like one of those little brown Etruscan funeral urns in the shape of a house, one of which can be seen in the Archaeological Museum - the 'aedes tuscanica'. It has an atrium or pronaos supported by slender Corinthian columns, above which runs a frieze of cherubs' heads in little medallions, done by Desiderio. Under the eaves is an attic and above them a cupola with a very delicate tall lantern. A tondo in glazed terracotta by Luca della Robbia of Saint Andrew (the chapel was done for Andrea de' Pazzi) stands over the door.

The interior is a simple rectangle with four high narrow windows and bare white walls and at the end a small apse. In the four corners tall closed arches are drawn in dark-grey pietra serena on the white walls, like the memory of windows. Fluted pilasters with Corinthian capitals, also in pietra serena, are spaced along the walls, marking the points of support, and in the same way, the lunettes and supporting arches of the chapel are outlined in dark ribbons of stone

against the white plaster, and the binding arches have stone rosettes enclosed in rectangles drawn on the white background. Arch repeats arch; curve repeats curve; rosette repeats rosette. The rectangles of the lower section are topped by the semi-circles of the lunettes and arches, which, in turn, are topped by the hemisphere of the cupola. The continual play of these basic forms and their variations – of square against round, deep against flat – is like the greatest music: the music of the universe heard in a small space.

The twelve Apostles, by Luca della Robbia, in dark-blueand-white roundels framed in pietra serena, are seated about the walls, just below a frieze of cherubs' heads and lambs, in alternate blue-and-faded-pink terracotta. In the pendentives of the apse are wonderful immense grey scallop shells, and in the pendentives of the room itself, outranking the Apostles, sit the four Evangelists, cast in glazed terracotta by Luca della Robbia on Brunelleschi's designs, each with his attendant symbol and companion: Saint Luke with the Bull, Saint Mark with the Lion, Saint John with the Bird, and Saint Matthew with the Angel in the form of a Man. The colours of the terracotta glazes are clear and intensely beautiful in the severe grey-and-white room. The Bird is raven-black, the Lion chocolate, the Bull brown; the robes of the Evangelists are glittering, glassy white or yellow or translucent green; and these four great Teachers with their books are placed in wavy blue backgrounds, as though they were sitting comfortably at the bottom of the sea. In the blue cupoletta, above the little apse, with its plain altar, like a table, there is a Creation of Man and the Animals. The chapel is not large, but it seems to hold the four corners of the earth and all the winds securely in its binding of *pietra serena*. No more exquisite microcosm than the Pazzi Chapel could be imagined, for everything is here, in just proportion and in order, as on the Seventh Day of Creation, when God rested from His labours, having found them good.

The strong drama of Florentine life seems to have resulted, with Brunelleschi, in an art of perfect balance. The terrible struggles that took place in this city and in which the Pazzi family, a little later, took such a part had their reward in equilibrium - a reconciliation of forms. This same sabbath stillness can be felt in the hillside Abbey church of San Domenico di Fiesole, done for the old Cosimo on Brunelleschi's designs and in the Old Sacristy of San Lorenzo, where Brunelleschi had Donatello for his collaborator - a square white room with four great lunettes marked in pietra serena, a hemispheric cupola with a lantern or 'eye', a dainty frieze of cherubs, four tablets in painted stucco of the life of Saint John the Evangelist, and four big roundels in coloured terracotta showing the four Evangelists deep in study at four classical desks. Above the altar in the tiny chapel at the back rises another cupola or playful cupoletta, painted a dark sky-blue in imitation of the heavens and sprinkled with the constellations in gilt, like a little planetarium. Santo Spirito, the Holy Ghost church in the big market square beyond the Arno, is grander in its orchestration of interior space, with its long lines of

mighty grey pillars topped by Corinthian foliage treading down the church in solemn perspective recession like a vast forest (Birnam wood) on the move, but here, too, there is an elemental harmony and tranquil measure, as of an agon resolved. Michelangelo's agitation proceeds from the stillness of Brunelleschi.

Brunelleschi was a very down-to-earth person – simple, short, bald, plain. He disliked imbalance and exaggeration, and the story is told that when his friend Donatello showed him the wooden Crucifix, of a peasant-like, harshly suffering Christ, he had made for Santa Croce, Brunelleschi said to him sharply: 'You have put a clown on the Cross.' Donatello then asked him whether he thought he could do better, and Brunelleschi made no reply but went away and secretly made a wooden crucifix of his own (it is in a chapel of Santa Maria Novella) which so astonished Donatello by its beauty, when he finally saw it in his friend's studio, that he dropped some eggs he was carrying, in an apron, for their lunch.

The homely lives led by these artists, in which aprons and eggs figure as in the daily lives of ordinary workmen, are reflected in the character of their art, which is an art of essentials, of the bread-and-wine staples of the human construct. The big Brunelleschi churches – San Lorenzo and Santo Spirito – are almost free of tourists, as has been said; they belong, appropriately, to the people, and just outside them are the main Florentine markets, where the poor come to buy. Around Santo Spirito are the fruit and vegetable sellers of the Oltrarno quarter and old beg-

gars, lame and halt, who sit in the sun, while across from San Lorenzo (the big covered market is just beyond) are the peddlers of cheap shoes, chiefly for men, hundreds and hundreds of rows of them, and displays of workmen's aprons and coveralls, hanging from clothes-hangers, like votive offerings, in brown, blue, and white—the colours of Saint Francis and the Madonna. Work and rest, weekday and Sunday, pietra forte and pietra serena make up the Florentine chiaroscuro, and the sense of their interplay, as of sphere and square, explains the unique ability of the Florentines to create cosmic myths in the space of a small chapel or a long poem. The unitary genius of the Florentines, that power of binding expressed in Brunelleschi's virile membratura, is evidently the product of a small world held in common and full of 'common' referents.

The lack of ceremony in Florentine intercourse was and still is apparent in all classes. Noblemen can still be seen in the markets, with shopping baskets, picking out vegetables for their lunch or trading some peaches from their property for oranges from Sicily; in this bachelor city, it seems to have been quite customary for the men to do the shopping. During the eighteenth century, the Grand Dukes sold wine in *fiaschi* from the back door of the Pitti Palace, and there are people alive now who remember how many of the palaces used to retail butter, from their ground-floor storerooms, that had been churned on their country estates. Some of the most charming poems of Lorenzo de' Medici are unself-conscious country poems dealing with farm life. The typical Florentine villa was

simply a farm, with olive trees and grapevines running straight up to the terrace on which the farmhouse stood. An idea of the useful still governs Florentine landscape architecture: the lemon trees in earthen tubs that flank the villas and then go into the limonaia, or lemon house, for the winter, the long lines of cypresses, which act as windbreaks, the pleached walks for shade. Big pots of bright geraniums and daisies, bunches of zinnias and dahlias - the quick-growing flowers of the poor and the peasants - are the chiefflowers of the Tuscan villas. Cut-and-come-again; how to make a little go a long way: the best Florentine dishes are recipes for using leftovers. By a seeming paradox, a plain Florentine cook makes a 'béchamel', which would be considered a chef's accomplishment in most Italian towns, to stretch the remains of a chicken into a chicken soufflé.

Simplicity of life Florence shared with Athens, and the great Florentines of the quattrocento, Donatello and Brunelleschi, lived like barefoot philosophers. Socrates traced his descent from Daedalus, the cunning craftsman, whom Brunelleschi, too, might have claimed as a mythic ancestor. Brunelleschi's architecture, moreover, is a species of wisdom, like Socratic and Platonic philosophy, in which forms are realized in their absolute integrity and essence; the squareness of square, the slenderness of slender, the roundness of round. A window, say, cut out by Brunelleschi is, if that can be conceived, a Platonic idea of a window: not any particular window or the sum of existing windows in the aggregate but the eternal model

itself. This is something different from the so-called 'ideal forms' of Michelangelo's sculptures, where 'ideal' means 'mental', 'imaginary', 'not true to life', or, in other words, 'idealized', like the dukes on the Medici Tombs. Brunelleschi's windows are not idealized in this sense at all: they are a plain statement of the notion 'window', cut out of a wall with a terse finality that makes other windows appear haphazard accidents or bellicose rhetoric in comparison. These framed openings in space recall in their uncompromising depth the remark of Leonardo, which is both profound and simple, that the eyes are the windows of the body's prison. Florentine architecture became deep with Brunelleschi, deep in both senses; each object and kind of thing - corbels, capitals, arches, shafts, vaulting is so intensely itself, so immersed in its own being, that it gives a sort of pain along with its joy, as though this being-itself were a memory stirring of something other, of the lost realm of perfect, changeless shapes. No better illustration of the old doctrine of universals and particulars and their mysterious consanguinity can be found than in the Pazzi Chapel or the Second Cloister of Santa Croce, with its poignant slender columns and its cruelly incised decorations of urns, wreaths, scallop shells, and strigil moulding.

Italian critics speak of the 'sincerity' of Brunelleschi's architecture; 'schietto', or 'frank', he is always called. 'Truthful' might be better, for he has the philosopher's love of eternal, elemental truths. Brunelleschi's dome compels a curious kind of slow, surprised recognition; it is

the way a dome 'ought' to be, just as love, for a young person, is at once a surprise and the way he knew it should

be, from books and hearsay.

All great Florentine art, from Giotto through the quattrocento, has the faculty of amazing with its unexpected and absolute truthfulness. This faculty was once called beauty. The immediate effect of a great Giotto or a Masaccio is to strike the beholder dumb. Coming into the first room of the Uffizi or the Brancacci Chapel of the Carmine, he is conscious of a sensation he may not even associate with what is today called beauty (a voluptuary's compound of allure and strangeness): the inadequacy of words to deal with what is in front of him. What is there to say? This art cannot be likened to anything but itself, and in this sense it resembles architecture - a solid fact obtruded into the world. It is easy enough to talk about a lovely Giorgione, a Titian, a Giovanni Bellini, even a Piero della Francesca; these paintings are, as it were, already coated with legend and literature so that they play on the fancy like fairy-tales. If there is nothing to say before a Giotto or a Masaccio, this, of course, is the sign that it continues to be a revelation, an event still so untoward and brusque that it results in a loss of speech, like the announcement of the conception of the Baptist to the old priest Zachary that deprived him of the use of his tongue.

It was Masolino who began the fresco series in the Carmine; the young Masaccio continued them, and they were finished by Filippino Lippi nearly sixty years after Masaccio's early death. The Masolino sections are full of

lissom grace and charm, and the Filippino Lippi sections show a skilful shrewdness in portraiture. But the Masaccio sections almost instantly distinguished themselves from the rest by their spatial immensity, deep, massive volumes, and implacable candour of vision, which sweeps across the panels in aerial perspective like the searching ray of a lighthouse. No matter how many times they have been seen, these 'Stories of Saint Peter and Original Sin', they produce in the beholder a kind of consternation. This is partly due, no doubt, to the realism of such details as that of the shivering naked boy about to be baptized or the hooded, world-sick eye of Saint Peter as he extends his old hand to give alms or the crouching figure of the cripple (who might come out of Les Misérables) or the stumpy body and gaping mouth of Eve as she is driven, howling, from the Garden - all the horror and deformity of the human condition. But this clinical realism is only an aspect of a universal truthfulness that shows the whole expanse of the world, fair and foul alike, as if in a flash of lightning or at the rending of the veil of the Temple, when Christ's death shook the earth. In the stature and dignity of the figures, always arrested in a momentous tableau, is implicit a kind of recognition scene, the benign climax of the great drama of the Redemption.

In the same way, the whole fearsome scheme of the universe is shown within a frame of Brunelleschian architecture in Masaccio's wonderful fresco of the Trinity in Santa Maria Novella. Standing in a fictive arched chapel upheld by Tuscan pillars, God the Father, Himself a stern

pillar of justice, upholds the Cross on which the Son is hanging with wide-outstretched arms; below are the kneeling Virgin and the young Saint John, and below, on a still-lower level, outside the arched chapel, and beneath two immense fictive Corinthian pilasters, kneel the two donors, husband and cheery, plump wife. The Virgin, a mature woman with a worldly face, like an abbess's, turns towards the spectator and makes a peculiar gesture, almost like a shrug, with her extended palm, while the young Saint John, in a robe as pink as his cheeks, prays in profile, his face set harshly, like a Crusader knight's. Here, as in the Pazzi Chapel, there can be no doubt that this is the great ordered plan of Nature embraced in a single design - in this case, of Justice and Redemption whose scaffolding is the Cross. This fresco, with its terrible logic, is like a proof in philosophy or mathematics: an equilateral triangle is inscribed within an arched figure which is inscribed within a rectangle; and the centre, the apex of the triangle, and the summit of all things is the head of God the Father, the Padre Eterno, with His grey beard and unrelenting grey eyes. In His midnight-blue cloak, He is the axiom, the self-evident central Proposition, from which everything else irrevocably follows and Who holds everything in its place and at its distance.

Socrates had a woman adviser, Diotima, a kind of seer, whom he consulted on difficult questions, such as the nature of love. Florence had a number of such wise women. A certain Sister Domenica, during the siege of 1530, had great influence with the Republic, which con-

sulted her at every turn of events; she believed that the Medici were 'fated' to return and hence advised making peace with Pope Clement (since it was futile to oppose fate). During the time of the Medici Grand Dukes, there was a famous wise woman, Donna Maria Ciliego, who lived in the portico of Santissima Annunziata, which was a great resort for odd 'characters' of all descriptions, either because the wonder-working Madonna in the church attracted motley pilgrims or because the portico offered a certain amount of shelter from the weather. Like Diogenes, this female Philosopher, who came from the people, lived in the street, sleeping under a loggia or a portico; she received charity without begging, because she spoke in marvellous apothegms and enunciated dogmas of her own. She was extremely clean; she carried a broom with her to sweep out her 'quarters' (i.e., the pavement she slept on). In her basket, she had a change of linen and a brush for her clothes; she toted a washtub about with her, for her laundry, and a little caldanotte, or stove, to do her cooking. Under her skirt, she kept saucepans and plates in sacks and whatever leftovers she had with her. When she wanted to change her clothes, she would go to the house she had once owned, where her sisters and nephew lived, but she would never consent to sleep there. Nihil nimis: at the end of the week what she had left from the alms that had been given her she would distribute to poor nuns.

This remarkable person evidently had reduced bodily life to its essentials without compromising her standards of propriety and decorum. She was a sage of the antique stamp, conducting her little affairs according to the tidy principles of reason, unlike the filthy anchorites of the Christian tradition. Even beauty received its due allowance; her clothes were full of patches, which were sewed on prettily, like ornaments.

Women of high and sometimes virile character played a considerable part in Florentine history, from the time of the Countess Matilda of Tuscany, who brought the Emperor Henry IV to his knees in penance at Canossa, her castle. There was Dante's 'good Guadralda', with her sweet Tuscan speech, who was married to Guido Guerra and softened his native fierceness; she came away from the mirror, said the poet, without paint on her face. Lucrezia Tornabuoni, Lorenzo de' Medici's mother, was a model of rational virtue, like Cornelia, mother of the Gracchi; such matrons gave lessons in government to their sons starting with self-government, the control of the passions, which is where philosophy's lesson, in the old school, begins. It is women like these that we see in the white busts of Mino, Desiderio, and Verrocchio, busts that are sometimes said to be copied from the antique manner, though more likely this was true of the sitter.

If Brunelleschi and Donatello (who lived with his mother) had managed their lives plainly and frugally according to what was thought to be Nature's plan, Michelangelo defied Nature and men as well in his personal habits, which Symonds calls 'repulsive'. His father had instructed him never to wash ('Have yourself rubbed down but don't wash'), and he seems to have overheeded

this advice. He used to wear his long goatskin gaiters or boots to bed, never changing them from day to day, so that when he finally came to remove them, his skin tore off with his boots. He must have smelled horribly, and his parsimonious ways doubtless affected his health. While he was working, he would eat only a crust of bread. Dry and short-spoken, he wrote curtly to his relations of money transactions. Though he was outdoors a great deal, opening new quarries in the mountains, riding back and forth on horseback from one project to another, he cared nothing for the country – only for real estate. As Symonds puts it, he had an 'absolute insensibility' to decorative details, to jewels, stuffs, natural objects, flowers, trees, landscape. Yet his indifference to pleasure did not make him, like the old Stoics, indifferent to pain.

He was intensely jealous of other artists, particularly of Leonardo, Raphael, and Bramante, and he blamed all his troubles with Pope Julius II on the machinations of his competitors, who had come, he thought, between him and the pope to prevent him from finishing the famous tomb. 'All the dissensions between Pope Julius and me,' he wrote in a letter, 'arose from the envy of Bramante and Raffaello da Urbino; and this was the cause of my not finishing the tomb in his lifetime. They wanted to ruin me. Raffaello indeed had good reason, for all he had of art, he had from me.'

It is possible that he was right. This proud, outspoken man must have been much hated by his rivals and inferiors. Nevertheless, jealousy and irritable suspicion poisoned his life, which, from his own point of view, was nothing but a series of failures and botched attempts. They put breeches on his nudes in 'The Last Judgment'; they put a gilded fig leaf on his 'David'; they prevented him from finishing Pope Julius's tomb; they (Bramante) spoiled St Peter's; they melted down the colossal statue of Pope Julius that he had made in Bologna for the façade of San Petronio; they obstructed him in his quarrying at Pietrasanta and Serravezza; they stopped him from doing the façade of San Lorenzo, of which he had boasted, 'Well then, I feel myself capable of carrying out this façade ... in such a way that it will be a mirror for architecture and sculpture for all Italy.' And 'they' comprised not only Bramante and Raphael but popes, workmen, prelates, apprentices, the people of Bologna, the governors of Florence, Titian's friend Aretino - in short, everyone, the whole world of others, which, unlike the inert matter of bronze and marble, would not obey his will. And it was all true, more or less; he was persecuted not only by the 'natural' inferiority of others but by relentless bad luck, which was only the personification of disobedient matter. The accidents that happened to his work (the arm of the 'David' was broken in 1527 during a tumult in the Piazza della Signoria when stones thrown in an assault on the Palazzo Vecchio hit the statue in the square) do indeed seem purposive, as if Nature itself, working through the passions of men, were showing its resistance to the tyranny of Michelangelo's genius.

The Florentine passion for greatness, for being first, went

beyond all human limits in Michelangelo, and his sufferings, on this account, were terrible. Among living competitors, he would accept only God for his rival, and his late, lumbering, unfinished works are all metaphors for the primal act of bringing shape out of chaos. Such a contest was really unequal; everything (i.e., all creation) was against Michelangelo – the mountains, from which he tried to draw marble like a dentist savagely pulling a tooth, the rivers, human beings. This is why so many of his works, like Leonardo's, are unfinished: no particular work could satisfy the magnitude of his ambition. Perfection can be achieved if a limit is accepted; without such a boundary line, the end is never in sight. Desiderio, say, or Mino could finish; Michelangelo could only stop.

As a boy in Ghirlandaio's workshop, he had his nose broken by the sculptor Pietro Torrigiani in a fist fight that had started with an insult flung by Michelangelo. This disfigurement was a kind of portent – the mark of Cain. His likenesses show him looking like a broken statue. Almost the first thing we know of him is the story of this fist fight, and one of the last glimpses completes the circle. As a solitary old man in his bare house in Rome, he had fallen into the habit of working at night, wearing a kind of nightcap with a candle attached to it which Symonds compares to the candle stuck in the belly of a corpse during an anatomy lesson. By the light of this candle, he was engaged in making a *Pietà*, to serve, like Titian's, for his own tomb. Before it was finished, he grew dissatisfied with it, and instead of simply abandoning work on it, as

he had done with so many of his commissions, this time he took a hammer and began to smash it to pieces. It is this *Pietà* that, having been repaired, stands in a chapel of the tribune of the Duomo, near the dial of Toscanelli's great gnomon (now covered with a bronze plaque) that used to mark the sun's rays on the floor. The right arm of the Virgin is fractured, and her hand is cracked across; one of the dead Christ's nipples has been mended, but His left arm is still badly scarred by the hammer blows. The figure of Nicodemus, an old man in a cowl who is supposed to represent Michelangelo, is barely sketched into the stone.

Here again the Florentines were first. This tragic, fractured group is the first known example of an artist's vandalism directed against his own work. Other sculptures have been defaced by time or barbarian invasions or revolution or war, but here is a work slain, so to speak, by the author's own hand, as though God, in one of His fits of irascibility, had elected to destroy the created world. Only a Florentine could have done this. Titian's *Pietà* is unfinished because he died of the plague while working

on it.

Chapter Six

The palette of the great Florentine innovators is decidedly autumnal or frostbitten. The brown robes of Franciscan friars, the grey beards of patriarch saints, the ashy flesh of the hanging Christ, grey slabs of rock and desert-brown desolation of hermits penetrate the trecento with a chill that can still be felt in the rusts, greys, and sepias of Masaccio, the purply browns of Andrea del Castagno, the tawny oranges and russets of Michelangelo, just as, even in midsummer, the thick stone walls of the fortress-palaces remain, on certain narrow streets where the sun does not strike them, cold and damp to the touch. Iron and iron rust entered the souls of these masters; Masaccio's shivering boy, waiting by the riverbank to be baptized; Adam and Eve, driven naked and howling from the Garden into the cold world, epitomize the forlorn exposed human creature, bare as a stripped tree. Fallen leaves, bare boughs, burnt sedge are evoked by all these masters' tonality. Uccello's favourite medium, terra verde, suggests greenish fields coated with rime. Leonardo's brown-skinned witchwomen sit in blue-green, northern grottoes, and the strong hues of the Pollaiuoli have a darkish, raisiny cast.

'Pollaiuolo', observed a Florentine, pointing to a dish of the small green shrunken second-crop figs that appear on local tables towards the end of September, and Pollaiuolo, too, are the last velvet pom-pom dahlias, in yellow, wine-red, and purple, that come into the florists' shops, a fall harvest, just before the *vendemmia*, when the turning grapes are picked. 'Yellow and black and pale and hectic red, pestilence-striken multitudes' – Shelley composed his 'Ode to the West Wind' in the Cascine, with the autumn leaves blowing sombrely about. Late September is the most beautiful time in Florence. San Miniato flashes the green and gold of its mosaic into the setting sun; deep-blue distance is framed sharply in the three honey-coloured arches of Ponte Vecchio. The compact dun and ochre city seems gold as an apple of the Hesperides against the cypresses and olives of its bowl of hills, and the tourists are leaving, like migratory birds.

May, too, is a favourite time, but uncertain; it may rain in May for days without stopping. A nasty wind blows, and winter clothes that have been put away are brought out again, often smelling of naphtha. May, nonetheless, is the classic Florentine 'month'. To spend May in Florence is the foreigner's dream; framed reproductions of Botticelli's 'Birth of Venus' and 'La Primavera' compete, along the Arno, with linen and leather goods, for the foreign trade. The city co-operates with a 'Maggio musicale' – a season of concerts and opera which, in fact, continues into June and July. Flower shows are held, and the Thursday flower market in the arcades along the Piazza della Repubblica brightens that depressed area with potted plants for window boxes and gardens: begonias, gloxinias,

gardenias, geraniums, and hydrangea. Azaleas are blooming in tubs outside the doors of villas, and nightingales sing in Fiesole and Settignano. Bagpipers appear from the Abruzzi at Porta San Niccolò, and mules from the Abruzzi come with their muleteers to work the timber in the Mugello.

This Maytime Florence had its set of painters: Bernardo Daddi, Fra Angelico, Fra Filippo Lippi, Benozzo Gozzoli, Verrocchio, Botticelli - the flowery painters beloved by the Victorians. The popular idea of Florence, which, like most popular conceptions, derives from the Victorians, is based on their work. Nor is this idea altogether wrong. In Florentine painting, there were two distinct strains, just as there were Guelphs and Ghibellines, Blacks and Whites, in politics. One is stern, majestic, autumnal, sometimes harsh or livid - the Guelphish painting, you might say, that started with Giotto and continued with Orcagna, Masaccio, Uccello, Andrea del Castagno, Antonio Pollaiuolo, Leonardo, Michelangelo; the other is sweet, flowery, springlike - Ghibelline painting that seeded in from Siena and blossomed first in Bernardo Daddi, then in Fra Angelico and the little masters who followed him, next in Fra Filippo, Verrocchio, and, finally, Botticelli.

Or you might say that Florentine painting, largely austere, impassive, and frugal, had a sweet tooth. Or that Florentine painting oscillated between two images, set at opposite poles: one, the Crucifixion and the clay-coloured body of Christ, and the other, the Annunciation. It is true that Fra Angelico painted Crucifixions, very moving

ones, and that Leonardo painted Annunciations, that Giotto's colour, with its silvery pinks, gold yellows, and radiant, glistening whites, glows more freshly and sweetly than the irons and rusts of his great successors, that Uccello is a mixed case (take his chivalric fantasy of 'St George and the Dragon' in the Musée Jacquemart-André in Paris as an example of quaint 'Ghibelline' conceits), that Piero della Francesca (who did not, however, paint in Florence after his apprenticeship) cannot be accommodated to these categories at all. Still, all exceptions made, the contrast is palpable. A split runs through Florentine painting that grows wider throughout the quattrocento till it becomes a great fissure or cloven hoof. Nor is this a question of schools. Michelangelo, a stern painter, studied in the workshop of Ghirlandaio, a dulcet master of genre; Andrea del Castagno, who imposed a certain fashionable swagger on the brute, swarthy, primal matter of his figures, influenced Botticelli at one period; Fra Angelico learned from Masaccio.

The Guelphish works resemble the stony city of Florence, while the Ghibelline works resemble the country-side in May. Here is a perpetual dewy meadow of grasses and multicoloured flowers or an enclosed garden with rosebushes and orange trees and cypresses or a loggia with pink pillars and Easter lilies and the glimpse of a bordered walk behind. In the garden, or the meadow, sits a maiden—the Madonna with the Heavenly Child on her lap. The tiled loggia is the scene of an Annunciation brought by a glorious angel with snowy fire-tipped wings. The loggia

may become a charming bedroom, furnished with books and a *prie-dieu* or lectern, potted plants, and a canopied bed with bolsters, and the maiden in the meadow may become a nymph or a newborn goddess. With the Blessed Angelico, the setting may shift to Paradise, where the maiden is being crowned by the Saviour and angels toot on gold trumpets. But the translation to Paradise is effected without a jar or a bump, for it was an earthly paradise the maiden dwelt in, and Heaven itself, with its angel choirs and oriental carpets, could not be brighter than the Tuscan spring.

Most of Tuscany today is cultivated and clipped; the spring countryside is laid out in delicate swatches of green: yellow-green of young corn and wheat, blue-green of rye, across which march, as if in spring manœuvres, files of silver-green olive trees, yellow-green figs, bluegreen copper-sulphate-sprayed grapevines, wheeling, fanning in and out, deploying, while the blackish-green cypresses and parasol pines, always seen in profile, silhouetted along a hilltop or on a slope, stand at attention, a windbreak, against the pale-blue sky. But flowery meadows still exist, high in the uplands, in the Mugello and the Casentino, in the Chianti, near Arezzo, along back roads that pass through forests of oaks, beech, and chestnuts, and are lined with stacks of firewood, like logging trails in some pioneer country. These incredible meadows, in early May, are very much what the quattrocento painters represented them to be - thick carpets of grasses and wild flowers: red poppy and blue iris (a

garden stray), deep-pink wild gladioli, pink and lavender anemones, hairy grape hyacinth, daisies, cornflowers, flax, primroses, columbines and harebells, the wild pink or carnation called Ragged Robin, strawberry flowers, wild orchids, the pretty green-white wild garlic. In early May, at any rate, the plough has not touched them: there is no one to be seen in this country and no sound but the call of the swallow and the distant crashing of waterfalls. The woodcutters have gone away. It is as if these teeming meadows were blooming for their own sake, remote from mankind, like the stars in the sky. Indeed, the effect is of a starry firmament spilled out onto the earth, as in Botticelli's 'Primavera', where Flora walks scattering blossoms, or in 'The Birth of Venus', where flowers resembling pink powder puffs are sifting down through the air onto a cat-tail-bordered seashore.

This world, then, of the Maytime painters, is not a fairy-tale world. It is perfectly real, but useless, and therefore fragile, always imperilled, fugitive, transitory. To use it, you would have to destroy it – turn in cattle to pasture or cut the flowery carpet with the plough. The useful Tuscan farmland, with its disciplined pattern of hedgerows, crops, conical hills, white roads, and milk-pale rivers, belongs to Piero and to Baldovinetti, surveyors and commanders of space; and in its greener, more velvety passages, with rich folds of valley and still glass of rivers, to Pollaiuolo and to Leonardo, who grew up in the corn country, near Empoli, on the way to Pisa. Fra Angelico, too, who knew felicity in all its aspects,

furnished glimpses, on an exquisite dollhouse scale, of the order and solid geometry of Tuscan husbandry; Fra Angelico's world, like any good monastery, is not all rapt devotion – on its borders are kitchen gardens and a stable domestic economy. Botticelli, who loved motion, was the master of the evanescent forest meadows, into which he turned a troop of nymphs, goddesses, winds, breezes, Graces – half-allegorical pagan spirits who were the quintessence of sweet uselessness since nobody believed in them any more.

'Exiles', Pater called them, these non-terrestrial creatures who always have the air of just debarking, of having just been deposited, and a modern critic speaks of figures isolated from true space in the 'closed garden' of Botticellian sentiment. The Tuscan villa, which was basically a fortified farmhouse, was becoming - briefly - a bower of bliss, a place of voluntary exile from the iron and stone of the counting house and the piazza, especially for rich, aggressive members of the middle class, the 'fat popolani', to whose estates succeeded, hundreds of years later, a new set of well-to-do refugees, the foreigners of the villas around Fiesole. The 'Primavera' and 'The Birth of Venus' were both painted for Lorenzo di Pierfrancesco de' Medici (the Medicis were not noble, being descended from pharmacists, and the balls on their shield were called 'pills' by their enemies) in his pleasure villa at Castello.

An abundant use of gold characterizes all the springtime painters, as though the florin had been melted into a

ductile substance that could be looped in heavy coils and arabesques by Botticelli for the coiffures of his Madonnas and goddesses or spun into fine wire for the tresses of Fra Angelico's maidens. Blond colours are predominant pinks, mauves, pale greens, lavender, violet, and carmine, scented colours, one might say, flowery distillates. Fra Angelico's palette, sharper than most and less odoriferous, sometimes suggests a field of yellow wheat mixed with poppies and cornflowers, and sometimes, as in the frescoes he painted for the monks' cells in San Marco, it reverts, in its whites and browns, to the grave tonality of Giotto, There are few brunettes in the May realm of the Madonna. and the heavy underslung Tuscan jaw of early sculpture and painting, which survives in some Giotto Madonnas and angels, disappears, like a mark of peasant origin. Skin tones are pink and ivory - wonderfully transparent. In Bernardo Daddi's Madonnas, still wearing the black robes of the trecento over their pink dresses, a vivid throbbing and pulsing of the blood imparts a juicy look to the full, plump neck and face; the cheeks are warmly flushed, and the long limpid eyes are brimming with moisture, like the sap of a young plant. Round spots of carmine, disks of excitement, stand out on the cheeks of Fra Angelico's little Virgins, making them resemble pert rouged flappers of the twenties.

After Fra Angelico and Gozzoli, the blood ceases to course so actively, and as the *quattrocento* continues, the blond Virgins grow paler and paler, as if from exhaustion, till Botticelli's young Madonnas appear positively

greensick. Their flower heads, pallid and heavy, encumbered with veils, droop on the long stems of their necks. The 'Madonna with the Pomegranate' in the Uffizi looks like a wan Persephone needing a spring tonic after the winter in Hades. This pallor or greensickness, however, belongs to the springtime of life, which in those days was a particularly dangerous and susceptible period. Lorenzo de' Medici was writing his 'Quant' è bella giovinezza, Che si fugge tuttavia...,' and many beautiful girls

were dying young.

Youth and love are the themes of these painters, whether it is celestial love in Fra Angelico or carnal love in Fra Filippo Lippi, the scabrous monk who finally, after many escapades, capped it all by running away with a nun, the black-eyed sensual Madonna whom he found in a convent at Prato. Throughout the quattrocento, the central pillar of the Annunciation figures almost as a Maypole, around which ribbons might be wound by dancing youths and maidens in flower-spangled brocades. Botticelli's figures, in whatever context, sacred or profane, are arranged two by two in a zigzag, interlacing pattern, as though they were meeting each other in the steps of a country dance. The flowing movement of thin drapery bellying about a bare, luscious form, was first shown by Fra Filippo in his tremendous fresco of 'Herod's Banquet' in the choir of the Duomo at Prato, where Salome is doing her veiled dance, ingenuously, almost modestly, before a gigantic dark tetrarch and his tall, ominous soldiery, while the head of the Baptist is being brought in on

a huge gleaming platter, like an ogre's pièce de résistance.

The three dancing Graces in Botticelli's 'Primavera' repeat the dance of Salome in a forest meadow; sheer veils, caressing as breezes, play over rounded nude buttocks and slender waists and legs. But here, in the open air, on the flowery carpet, all is innocence; the shadow of the deed, the pressure of an interior, where passions are enclosed in space, cannot touch the Graces, and the veils that embrace them, transparent and clinging, are of the same immaculate fabric as the thin underveil of the Madonna. Sheer chiffon veils, sometimes drooping over the soft cheek of a Virgin, sometimes rippling across a dimpling naked body, became in the late quattrocento almost a signature of the Florentine school. They are often seen in low relief, particularly in the work of Agostino di Duccio, that most voluptuous of Florentine sculptors, who botched the block of marble known as 'The Giant', which Michelangelo, later, made into the 'David'. His finest workmanship (in which marble seems to yield to the onrush of a strong wind) belongs not to Florence but to Urbino and Rimini, where cultivated tyrants had him embellish a palace and a private temple of worship.

The most wanton and luxurious expressions of Florentine art are found, for the most part, outside the city's three tight circles of walls, though some, like the 'Primavera' and 'The Birth of Venus', have been removed from their natural setting. Fra Filippo's masterpiece is in Prato, the prosperous, somewhat coarse and materialistic wool

town where he was born. And there is nothing quite so rich in Florence as the pergamo of dancing putti that was made by Michelozzo and Donatello together for the Prato Duomo. This pergamo is a covered pulpit affixed to an outside corner of the black-and-white-striped Cathedral; from it, on certain feast days, a girdle, said to be the Madonna's, is shown to the people in the piazza below. The story of how the girdle came to Prato is told in fresco inside the Duomo in a reliquary chapel painted by Agnolo Gaddi, one of the Gothic painters of the trecento. The Madonna, at the time of her Assumption, threw her girdle to Saint Thomas, who was standing, with the other Apostles, watching her disappear into the sky. The Apostle, when his time came, entrusted it to an old priest, whose daughter, Maria, fell in love with a Pratese, Michael Dagomari, who had come to the Holy Land as a crusader and remained as a merchant. After a fortunate sea voyage, the pair arrived in Prato, bringing the girdle as the girl's dowry, locked in a little hamper of rushes. Michelozzo's and Donatello's balcony, constructed for the exposition of this relic, is an almost oriental fantasy; the tall nutmeg-coloured baldaquin, carved as if in supple leather, is sustained by a single central column, so that it looks like a graceful umbrella raised over some khan or shah; below is a marble frieze of revelling children, which, by contrast, seems a page from a classic epithalamium. This pure Renaissance work, by the very profusion and order of its details - pilasters, cornice, corbels, single bronze capital - harmonizes in an extraordinary

way with the rich, half-oriental Pisan Romanesque of the façade and long-striped flank of the Cathedral, and harmonizes, too, with the fabulous tale of the girdle, the Prato trader in the Holy Land, and the Eastern priest's daughter. The Florentines themselves, Burckhardt noted, were rather indifferent to relics; this no doubt was due less to scepticism than to a dislike of the atmosphere of costly ostentation that always surrounds the cult of old bones and bits of material. Nevertheless, in 1312, a Pratese had the idea of stealing the sacred girdle and selling it to the Florentines; he was put to death, and a reliquary chapel was built to protect it.

This is one of the rare Church legends that centres around a love story, in fact, around an elopement (for the pair ran away from the old priest, who disapproved of their love), and the cult of the Holy Girdle, perhaps for this reason, is very popular in Tuscany. The Tuscan ballads, or stornelli (refrains; those of the Pistoiese hills are said to be the most haunting), unlike other folk songs, contain no references to epic events - wars, invasions, generals, and rulers. This is a telling fact, especially when one considers how often the place names in the remote contado awaken the memory of battles (Montelungo, Montaperti, Altopascio, Campaldino, Gavinina, Montecatini Alto), and a wine made at Brolio, the last bastion of the Florentines against the Sienese, is named Arbia after the river which, as Dante said, turned red with blood on the terrible day of Montaperti, when a traitor in the ranks hacked the hands off the Florentine standard-

bearer and 10,000 Florentines were slaughtered by Manfred's German knights with their Ghibelline allies the fuorusciti, the Sienese, the Luccans, and the men from Cortona. There is hardly a mountain pass, a hill, or a stream that does not evoke, at the very least, a siege or some act of treachery, yet none of this horror and infamy, which has not been forgotten, has passed into the plaintive songs of the peasants, as did the wars of Louis Quatorze, for example, into a love song like 'Auprès de ma blonde' or the Crusades into 'Malbrouck'. Or if it did, it has been expunged, leaving fewer traces than the castles and walls of the nobles that were demolished in the wars of pacification. The accent of the stornelli is entirely personal, solitary, and passionate. A lover sings to his girl, and she replies from her window. Or he goes away, and she watches, pining. These simple refrains that deal only with poor people and with the simple elements of love meeting, leave-taking, waiting, longing - contain nothing rustic or low. They are as pure and elegant, as dignified in feeling, as the Baptistery of Florence.

In the city of Florence, the preoccupation with politics did not exclude the passion of love; if anything, it seems to have quickened it, as can be seen from that unique work *The Divine Comedy*, where the poet's ardour for the Lady, for Paradise and the ideal city, is fed by indignation, sternness, and sorrow, and the progress upward is accompanied by maledictions and political curses cast backward at the actual city and all its neighbours. The only parallel to this curious omnium-gatherum of love,

theology, and political pamphleteering is War and Peace, and Tolstoy, the passionate, puritan peasant count, would have made a good Florentine. 'Donne ch'avete intelleto d'amore' – Dante in the Vita Nuova and Petrarch in his sonnets to Laura, these burning Florentines set a fashion in love poetry that lasted in Europe up through the sixteenth century. The grosser kind of love, in fecund variety, is found in Boccaccio, who again set a model – for light, licentious tales framed in an elaborate ensemble, almost like opera arias, with contralto, bass, soprano, and so on. Between Dante and Boccaccio, between Fra Angelico and Fra Filippo, love, like a high-tension wire, is stretched to its uttermost span. The Florentine experience left no form of the erotic untried.

This hypersensitized people, whose emotions were constantly being recharged by the oratory of the piazza and the sermon, was very strongly sexed. Here is the surprise that Florence holds behind the austere surface of its buildings and that begins to explain the mystery of the Florentines: their political fickleness, their proneness to conversion, their alternation between rationality and superstition, and, finally, most of all, those 'tactile values' Berenson discovered in Florentine painting and made the basis of his aesthetic. What distinguishes Florentine art is its extreme plasticity, and this is evidently the leading trait of Florence as a body politic, just as it was of Athens, plastic, too, ductile, malleable. In these two great, impressionable, disaster-prone cities, Eros was everywhere, or, to put it in the modern style, everything

was erogenized, that is, it had assumed a shape that spoke directly to the body.

Florentine religious outbursts often had an Orphic character. Savonarola's puritan mobs were not always bent on arson and image-breaking; sometimes they were carried away by joy. After one of the Frate's sermons, the crowds would pour out into the squares, yelling 'Viva Cristo!' and singing hymns. In the squares, they would join hands to make a circle and dance, a citizen alternating with a friar. A favourite hymn for these occasions was written by one of Savonarola's close followers. 'Crazy for Jesus', it might be called.

Non fu mai'l più bel solazzo, Più giocondo ne maggiore, Che per zelo e per amore Di Gesù, diventar pazzo. Ognun' gridi com' io grido, Sempre pazzo, pazzo, pazzo.

This is hard to translate because of a shift in vocabulary that takes place in the middle, from the language of courtly love ('Never was there greater solace, / Fairer or more jocund') to the tone of the Bible meeting ('Than from zeal and love / Of Jesus to go crazy. / Everybody shout with me, / Always crazy, crazy, crazy'). Savonarola himself had been brought to God after a severe disappointment in love. He was not a Florentine, the great Prior of San Marco, and Florence twice rejected him. As

a young medical student in his native Ferrara, he fell in love with a Strozzi girl, whose family, like so many Florentine expatriates, was living there under the protection of Duke Borso d'Este. The Strozzis, from pride, forbade the marriage. It took him two years, they say, to get over his passion. The second rejection was more terrible. Florence, which had loved him, suddenly turned cold, under pressure of the Borgia pope, Alexander VI. Savonarola was challenged to an ordeal by fire by the Franciscans of Santa Croce. First he accepted, then refused. This vacillation made a bad impression. More than four hundred years before, in 1068, a humble Vallombrosan monk, San Pietro Igneo, encouraged by that other great reformer Saint Giovanni Gualberto had walked unscathed through the fire, before a huge crowd, to prove that his opponents were simonists. The signory, on papal instructions, seized Savonarola and tortured him to get a confession; one day, he was put to the rack fourteen times. The orders from the pope were 'to put Savonarola to death were he even another John the Baptist'. These orders were carried out. Together with two of his disciples, he was hanged and then burned on the Piazza della Signoria, just where the false hair and profane pictures and lewd books had gone up in the Bonfire of Vanities.

Savonarola had written *canzoni*, not all of a pious nature, to be sung to the tunes of the ribald carnival songs. Earlier, during the fourteenth century, the Franciscan religious movement had filled the town with music.

The mendicant friars sang in the streets and squares, like the itinerant minstrels and jugglers who collected in Pian de' Giullari, or Merry Andrews' Heights, just outside the city. In the Franciscan church of Santa Croce, there was a great music school, which also gave lessons in rhetoric, fencing, and dancing; both secular and sacred music were taught. Across the city, in Santa Maria Novella, the Dominicans had a rival school offering the same curriculum. The word note (nota) in music had been coined by Guido, a Florentine monk, in the eleventh century. The amorous songs of the Tuscans - canzoni, ballate, catches, and villanelles - which derived from the troubadour songs of Provence and from the minstrelsy of Frederick II's Swabian court in Sicily, were condemned, as ars nuova, in a papal bull issued by John XXII in 1322. The most celebrated composer of ars nuova was the blind Florentine Francesco Landino, whom the Venetians crowned with laurel when he came to their city to play on his little hand organ with its eight gilded pipes. Lorenzo de' Medici, at carnival time, used to go through the streets at the head of a throng of dancers, singing the licentious ballads he had written. And as early as 1283, a prosperous year for Florence, the Rossi family gave an entertainment for 1,000 people, all dressed in white, that lasted two months. The young Medicis, Giuliano and Lorenzo, gave famous jousts in Piazza Santa Croce.

According to Machiavelli, the youth, in Lorenzo's period, spent its whole time on gambling and women,

their principal aim being how to appear splendid in apparel and attain a crafty shrewdness in discourse'. Such a giovanotto, though already thirty-two years old, must have seemed Francesco de' Pazzi, one of the main figures in the Pazzi Conspiracy, still unmarried, a dandy, vain, supercilious, jealous, and passionate. The story of the conspiracy, or, rather, of Francesco's odd behaviour, gives a glimpse of the ambivalent, almost amorous savagery that lay beneath a surface of studied craft. The plan was to murder the two young Medicis, Lorenzo and his brother, the beautiful Giuliano, one Sunday at high mass in the Duomo; the signal for the assassins to strike was to be the priest's taking the Host. To make sure that Giuliano, who had not been feeling well, would go to mass that morning, Francesco de' Pazzi and a fellow-conspirator went to the Medici Palace to get him, just as, today, two young Florentines, on their way to the Duomo, might stop to pick up a friend. Giuliano came along willingly, and all the way to the Cathedral, the two murderers, to allay any possible suspicion of them, diverted him with a flow of jokes and lively talk. Francesco kept pressing him to himself and fondling him. so as to be certain that he was not wearing a cuirass under his clothes. These endearments seem to have been rather excessive, since they were remarked on afterward. Then in the Duomo the plan went askew. The Pazzis and their friends succeeded in killing Giuliano, but Lorenzo they only wounded, and he fought his way to the Old Sacristy, on the right of the altar, where he secured himself behind barred doors. Meanwhile, the Pazzis left the Duomo and found that the city had turned against them. The others fled in all directions, but Francesco, instead, simply went home and was found lying on his bed, naked and bleeding from a deep wound in the leg that he had given himself in the Duomo, stabbing this way and that in a murderous ecstasy. Just as he was, stark naked, they took him to Palazzo Vecchio and hanged him. He could not be induced to speak a syllable, says Machiavelli, 'but regarding those around him with a steady look, he silently sighed'. The Pazzis, adds Machiavelli, were notorious for

their pride.

The conduct of Lorenzino ('Brutus') de' Medici towards Alessandro, the distant cousin he assassinated, was also very queer. He had been the young duke's companion in every kind of debauchery and viciousness. They had gone to whorehouses together and invaded convents; Lorenzino had acted as a procurer of respectable married women for Alessandro. They were often seen riding two on a horse through the streets of Florence. The Florentines, in fact, looked on them as two of a kind - two degenerate thugs. When the deed was finally committed, Lorenzino was obliged to leave a note, in Latin, on the tyrant's corpse, to explain that the crime had had a political motive. 'Vincit amor patriae', the note said, but there were many who, knowing Lorenzino, could not be got to believe it. Dissimulation may have carried Lorenzino to bizarre extremes - dissimulation as an art in itself, a flamboyant theatrical mimicry beyond the call of necessity.

Here again the Florentine plasticity seems evident. For an artistic people, feigning is a perilous business; the actor loses himself or, worse, finds himself in the part he assumes.

Dissembling, however, was a general Renaissance accomplishment and not particularly characteristic of Florence, where the native temperament was blunt and tersely outspoken: 'Cosa fatta, capo ha.' 'A thing once done has an end' – so Mosca de' Lamberti, met by Dante in the eighth circle of hell among the Sowers of Discord, called for the murder of young Buondelmonte de' Buondelmonti at the foot of Mars' statue. Craft (astuzia) was highly valued, but this was closer to the financier's astuteness or the merchant's shrewdness than to the diplomat's guile. With one exception (Lorenzo de' Medici), the Florentines were never strong on diplomacy.

What is manifest in these two strange stories is a profound nervous instability. Judith and Holofernes was a favourite subject for Florentine art, but tyrannicide in practice, plainly, gave rise to mixed emotions. In this oligarchical society, where democracy used to break out, like the plague, every hundred years or so, the shifts in attitude towards public men, tyrants or benefactors, were like the sudden shifts of the wind during a great forest fire. Dante's image for the Florentine body politic and its incessant changes is that of a sick man moving his position in bed. The mutability of opinion could drive a sensitive official to madness. In the time of Cosimo il Vecchio, a gonfalonier of justice was so much ridiculed by his

colleagues for an unpopular proposal that he lost his mind and had to resign. It was not only the masses that veered back and forth. The individual person was liable to shifts of passion or lapses into barbarism, as though he constituted a mob in himself. All this is related to the phenomenon of conversion, which was so common in Florence as to suggest a local pathology, like the prevalence of goitre among mountain people. Intellectuals and artists were particularly susceptible. Savonarola's converts included Pico della Mirandola, Fra Bartolomeo, and Lorenzo di Credi, who contributed their works to the Bonfire of Vanities, and, according to legend, Lorenzo de' Medici himself.

Botticelli, some writers think, became a 'Weeper' ('Piagnone' was the hostile name applied to a follower of the Frate), though not till Savonarola had been martyred. In the London National Gallery, there is a 'mystery picture' of Botticelli's known as 'The Mystic Adoration', which can be interpreted as an enigmatic allusion to the martyrdom and prophecies of the monk. Savonarola's prophecies, incidentally, were, so to speak, rediscovered during the Siege of Florence; not only Sister Domenica, the wise woman, but various friars were employed by the signory to draw auguries from the Frate's dark utterances. 'Gigli con gigli dover fiorire' - this saying of his, suddenly recalled, was taken to mean that the French alliance must be clung to (lilies to lilies), a very poor idea, when the terror of the Spanish power had already showed itself in the Sack of Rome. The signory and the people also kept reminding themselves that he had said that

Florence would lose everything and yet be saved. In the light of this utterance, every catastrophe was looked on as a portent of final victory – the loss of Empoli, for instance. Having burned the friar, the Republic put all its reliance on him. They proclaimed Jesus Christ king of the Florentines, and the people really believed that the Sacred City, which had been called by Pope Boniface VIII 'the fifth element' and by Cardinal Peter Damien 'a new Bethlehem', would be saved by angels, arriving in armed bands from the sky.

Whether or not Botticelli, like Fra Bartolomeo and Lorenzo di Credi, actually became a Piagnone and repented, as Ammannati did later, his pagan nudes, the atmosphere of his late works is tense with revulsion. An interior struggle of some kind, typically Florentine, must have taken place in the soul of this artist, who was evidently, in any case, a man of vast contradictions, since his workshop, from which so many languid, dreamy Virgins issued, was a famous centre for rough practical jokes and horseplay - the burle and beffe fiorentine. After the 'Primavera' and 'The Birth of Venus', a nervous, harsh, dry realism begins to tense his forms, still at first glance lissom and sweetly, voluptuously pensive in the Botticellian mode: the supple gold coils grow heavy and the drapery becomes burdensome, as though in a tedious charade. In 1480, for the church of Ognissanti, he painted a big angular fresco, in queer yellows and greys, of 'St Augustine in His Study', which reveals a dramatic sympathy with that proto-Calvinist saint. By the time

of the little picture called 'Calumny' (1494; Savonarola was not burned till 1498), the metamorphosis is complete. A malign, cold ugliness stares out of the figures in this neo-classic composition, where an Unjust Judge, with ass's ears, seated on a throne, is being advised by Ignorance and Suspicion, while Hatred leads on Calumny, who is bearing the torch of Truth and dragging along Innocence, a half-naked young man, by the hairs of his head. Calumny is attended by Fraud and Envy, who are twining roses in her brazen hair. Behind them comes Remorse, an old crone in black, and the Naked Truth, with long unbound fair locks, who, statue-like, raises her right hand, pointing to Heaven, in a gesture of faith. In the background, through the arches of a heavy frame of classic architecture, is seen a pale-green sea, recalling, like the figure of Truth, 'The Birth of Venus'. This back reference is like a vindictive recoil on the earlier, arcadian Botticelli; 'Calumny' is Arcadia turned violent and paranoid.

This, in all its details, is the puritan picture par excellence – cold, declamatory, programmatic, without any of the fantasy of the northern 'temptations' of Bosch, for example, where the devil, at least, is fertile. Botticelli was the pet painter of the Medici, a family in whose character puritanism combined or alternated with animal sensuality and coldness with geniality. Cosimo il Vecchio was cold, crafty, and ascetic; he knew how to wait, and this feline quality reappears in Cosimo I and the young Catherine de' Medici, the power-stalkers of the family. Old Cosimo's son, Giovanni, on the other

hand, was a sybarite who lived for the moment and died of overeating. Lorenzo the Magnificent was 'incredibly devoted to the indulgence of an amorous passion', as Roscoe, his eighteenth-century biographer, puts it; his sexuality was uncontrollable, a perpetual bullish rut. Three Medici were attractive physically: the beautiful Giuliano and his son, handsome Pope Clement, and Cardinal Ippolito, who was painted by Titian in Hungarian dress. Lorenzo, with his straight black hair, long thin upper lip, hawk nose, and swarthy complexion, is a curious physical specimen, like some Sioux chief, even in his portraits, which are said to flatter him. He had very weak myopic eyes, a harsh unpleasant voice, and no sense of smell; like all the Medici, he suffered from gout. His father, called Piero the Gouty, was crippled all his life by the disease. Lorenzo, Duke of Urbino, the father of Catherine de' Medici, died of syphilis.

Gout, a long pawky upper lip, and a talent for arts and letters ran in the family. Lorenzo, Giuliano, Piero di Lorenzo, and Cardinal Ippolito all wrote verses. Ippolito did a translation of the second book of the Aeneid that went through several editions. Pope Leo X was a connoisseur and a patron of letters. Lorenzo was more than a dilettante. His love poems disclose a true poet, and his bucolics, already mentioned, have a note of exquisite freshness and delicate pathos that recalls Propertius and Tibullus. His poem on autumn, for example, describes a late bird hiding in the cypress of some sunny hill, where the olive tree shows now green, now white, according to

the wind; and he goes on to picture, with that characteristic Florentine tenderness which smiles a little at what it sees, a pair of migratory birds travelling south, with their tired family - the parents pointing out Nereids, Tritons, and other monsters in the sea below to entertain the children on the long trip to Africa. The family remains the basic unit for the Florentines, who are a large family themselves, with many poor relations nesting in humble quarters. Lorenzo's son, Piero, who was ignominiously chased out of the city, wrote a touching patriotic sonnet to Florence, in which he likens himself, a homesick exile, to a bird born with a native flight and call. This was poor Piero's only achievement; his lack of political capacity is aptly symbolized by his ordering a statue made of snow from Michelangelo during one of the rare Florentine snowfalls. The melting snowman, as Roscoe notices, might have stood for the dissolving Medici power.

But Cosimo I, who restored the dynasty in its cadet branch after the fall of the Republic and the murder of Alessandro, had the coldness and catlike craft of the tribe. His father, Giovanni of the Black Bands, to judge by Bandinelli's ugly statue outside San Lorenzo, resembled a blinking wildcat or mountain lion. Cosimo took after him physically but inherited none of his bravery and gallant rashness. A tame, cruel house-mouser (when he wanted to poison Piero Strozzi, he had the poisons tried out on the prisoners in the Bargello and he had Lorenzino murdered by his agents in Venice with a poisoned dagger), he was a relentless taxer and ferocious puritan. During his

gloomy reign, harsh laws against sodomy and bestiality were passed; he insisted on a chaste court, setting himself up as an example by his chronic fidelity to his consort, Eleanor of Toledo. He did not trust the Florentines and relied on his wife's Spanish train - her uncle, brother of the Viceroy of Naples, and various churchmen - for the backstairs work of administration. The historian Segni (not a Medici partisan) wrote of him: 'It must be said of this prince, that though he was a great lover of Divine worship and temperate in the pleasures of Venus, to tell the truth, he was still more temperate in giving audiences and showing himself human and pleasant to any Florentine.' He spent unparalleled sums, Segni continues, on 'colonels, spies, Spaniards, and women to serve Madame'. And he kept increasing the number of guards on himself and spies on others.

It was this chaste and cautious ruler, nonetheless, who formed the collection of suggestive sculpture by Cellini and Bandinelli, now to be found on the third floor of the Bargello: a Leda, two Ganymedes, a Narcissus, and a Hyacinth. And a fearful story is told of a scene witnessed by the court painter Vasari, in a room in Palazzo Vecchio, which the Grand Duke had commissioned him to fresco. One hot summer day, Vasari was standing on a scaffold, painting the ceiling, when he saw Cosimo's daughter, Isabella, come into the room, lie down on the bed, and finally go to sleep. While the girl was sleeping, Duke Cosimo suddenly entered the room, and, in a moment, Vasari heard a terrible cry come from the bed. After that,

as the story puts it, 'he looked no more', but he was obliged to stay concealed on the scaffold, 'feeling no more

inclination to paint that day'.

This tale, which is recorded by a later diarist and may possibly be an invention, has the ring of truth in its very succinctness. The Florentine heat, the oppressive atmosphere of Palazzo Vecchio, with its stifling upper rooms and yards of dull fresco, the cry piercing the stillness of the after-lunch stupor, carry absolute conviction, especially to anyone familiar with the Florentine summers, and the final sentence echoes, in a morbid *cinquecento* way, the greatline of Dante, telling of Paolo and Francesca and their fleshly sin: 'Quel giorno più non vi leggemmo avante' ('That day we read no more') – in the Book of Lancelot.

The spoor of the Grand Duke Cosimo can still be followed down the passageway that was made for him, possibly by Vasari, from the hot rooms and corridors of the Uffizi, across the top part of Ponte Vecchio, over the church of Santa Felicita and the housetops of Via Guicciardini, to Palazzo Pitti, which he bought and had enlarged for his wife, who disliked the Old Palace. This aerial version of an underground corridor (making it possible for Cosimo to go from his offices, the Uffizi, to Palazzo Pitti without descending into the streets) preserves a claustral image of the man and his reign – spies and Spaniards, secrecy, a catlike tread. It is in fact what we would call a cat-walk, royally roofed over.

Cosimo's laws against sodomy and bestiality, so oddly violated, at least in spirit, by his sculpture collection, were

aimed to correct a Florentine habit against which Savonarola had thundered. Homosexuality or bisexuality has always been very common in Florence. It seems to have run, like the gout, in the Medici family; the effeminacy of the last Medicis, in fact, their uncontrollable aversion to women, caused the extinction of the line; heirs grew fewer and weaker till finally none at all could be got from fat Gian Gastone. In France, it cropped out in Catherine's son, Henry III, who appeared at the fête at Chenonceaux, in honour of his accession, dressed in women's clothes. The locus classicus, however, was Lorenzo the Magnificent's table, where the young Michelangelo met Poliziano and which was known for its 'Greek' tendencies: the love of boys must have been taken as much for granted there, in Palazzo Medici, as it was in the 'Symposium'.

This proclivity was found everywhere in the Renaissance, but in Florence it was deeply ingrown and far from 'unnatural'. The medieval hermits in the Casentino battled with flail and psalter against the 'impure spirits' that tempted them, in the shape of boys. As an old man, Saint Romualdo, founder of the white-robed Camaldolese order, had to do penance for sodomy at Styria, near Fonte Avellana, and, in the next generation, Saint Giovanni Gualberto was contending against the same sin in the Vallombrosan forest. These two virile reformers, Baptists of the forests and the mountain streams, were the local epic heroes. Saint Romualdo actually came from the Romagna, but he perched his hermitage high in the

dark, thick beech woods of the Tuscan Apennines. The hermitage and the great Camaldolese monastery, which was once the seat of the Academy started by Lorenzo de' Medici, Leon Battista Alberti, and Cristoforo Landino for Platonic philosophical discussions, are still pilgrimage centres, and near the hermitage is a chapel with a stone block inside that bears the imprint, so they say, of the saint's body – the devil had given the saint a tremendous push, to cast him into a ravine, but the vigorous Romualdo

had saved himself by clinging to the massy rock.

'Michelangelo non avrebbe potuto peccare di più col cesello,' remarked a Florentine, thoughtfully, contemplating the loose, soft white curves of the 'Bacchus' in the Bargello. 'Michelangelo could not have sinned more with the chisel.' In any virile society, boys become objects of desire, and the passionate, intellectual Florentines were nearly as susceptible as the Athenians. The 'sin' is found not only in Michelangelo and Leonardo, the most publicized instances, but in Donatello, too, and Verrocchio, not to mention Pontormo and the Mannerists. No scandal attaches to Donatello's life (though a Freudian might find it suspicious that he lived with his mother), and his fearless San Giorgio is the acme of manly virtue. His 'David', on the other hand, wearing nothing but a pair of fancy polished tall boots and a girlish bonnet, is a transvestite's and fetishist's dream of alluring ambiguity. This brazen statue, indeed, is more enticing than anything conceived by Michelangelo or Leonardo, for this is not an androgyne, plump and flabby, but a provocative coquette of a boy. There is something of the same allure in Verrocchio's bronze 'David', with its ambiguous, Leonardoesque smile.

In the Florentine quattrocento, the well-turned, sturdy male leg and buttock cased in the tight hose of the day is always painted with a flourish; this leg is seen from all angles, in profile, in demi-profile, full on, and, perhaps most often, from the rear or slightly turned, so that the beauty of the calf can be shown. Standing at rest, idly, or striding across a piazza, these elastic, boyish pairs of legs, from Masolino to Botticelli, are among the chief vaunts of Florentine painting; they belong, almost always, to bystanders, who pause conversing in the street while a sacred scene is being enacted, or to casual passers-by who cross the stage of a miracle, unknowing, with a quick, preoccupied step. All the springy vitality of the terrestrial is implicit in these buoyant legs; Mercury, god of travel and business, has them, bare and wonderfully drawn, in the 'Primavera'. The beauty of the hands in Florentine painting has often been remarked on; these lovely hands are generally feminine. The legs are the resilient male principle of action.

The boy of fashion was glorified here in Florence as nowhere else in the world, and for the ordinary, mundane Florentine, lust might light as well on a lovely boy as on a young woman. A businessman to whom Michelangelo complained of a servant he had sent him replied that, in Michelangelo's place, he would at least have taken the boy to bed with him, since he was good-looking, if not

good for anything else. The businessman was simply being practical. In the same common-sense way, Segni tells the story of Filippo Strozzi, the anti-Medicean banker, who was sent by the Republic to Pisa to stand guard over the two young Medici bastards, Ippolito and Alessandro, prisoners or hostages in the signory's custody. Instead of doing his duty, Filippo Strozzi went off alone with Ippolito to a fort near Leghorn, and before long the two boys escaped. He was blamed, as Segni tells it, for showing too much indulgence to Ippolito, 'some said out of a licentious love for him, who was beautiful to look at and in the bloom of youth'. But the censure was not severe, for the weakness was regarded as natural. Later, defeated by Cosimo I and imprisoned in the Fortezza da Basso (which he had been obliged to pay for building), the banker showed great firmness under torture; it was he who reminded himself of Cato's example and committed suicide.

A very different type was the waspish, jealous Poliziano, tutor to Lorenzo's children and resident humanist in the Medici household, who died, according to his enemies, of a fit of amorous fever while playing a love song on the lute in praise of one of his pupils. The humanists of this period, however, in Florence and elsewhere, were a special category of persons, whose disagreeable traits were due, no doubt, to the parasitic position they occupied in the households of the great and to the fact, also, that they were continually defending themselves against the attacks of the clergy. Backbiting and quarrelling were their main

occupation; many, or most, were effete, and all were charged with being so. Poliziano was intensely jealous of Lorenzo's wife, Clarice Orsini, whom he complained of over and over by letter to Lorenzo, saying that she interfered between him and his pupils; he finally left the house in a huff. The humanists of this generation, talented, envious, easily wounded, had something in them of the modern interior decorator; taste was their special province, and they were bent on doing over the whole house of Italian civilization from top to bottom in a uniform classic style. Poliziano was a real scholar and, from time to time, a poet, but the eternal 'hic est's and 'ut visum est's and 'tandem's of his correspondence are ludicrous, and the sterility of his attitudes can be seen in his ecstasies over a popular preacher; he was enthralled by the 'artistic grace' of his gestures, the 'music of his voice', the 'elegance of his diction', and so on. He wrote a poem, in Italian, on Giuliano's tournament in Santa Croce, and a Latin commentary on the Pazzi Conspiracy.

The youth and beauty of Florence were better served by Benozzo Gozzoli, the common workman-painter from San Gimignano, a lazy sort of fellow when not put on his mettle, who had studied with Fra Angelico and did some of his liveliest work for the chapel in Palazzo Medici. The pageant picture was very rare in Florence, and this series of frescoes by Benozzo is one of the few celebrations of an historical spectacle. Called 'The Journey of the Magi to Bethlehem', it represents the visit of the Emperor John Paleologus VII in 1439, on the occasion of the Council

of Florence, which was the last attempt to heal the schism between the Eastern and the Western churches. This East-West summit meeting is converted by Benozzo into a species of delightful wallpaper, with a background pattern of Benozzo's famous cypresses, palms, and parasol pines. Winding down the Apennines, on horses and mules, the Eastern cortège has arrived on a pleasant plain, where the tall stone-grey tree trunks, with their plumed or tufted tops, are standing like erect spears or flagstaffs on a parade ground to honour the potentates' approach; meanwhile, the Medici have ridden out to meet them with a vast train of celebrities.

The painter has put everyone in, everyone who was or might in fancy have been present on the great occasion pages and servants and dependents and animals, people who were not yet born or were already dead. The emperor, in a gold-figured dark surcoat, mounted on a beautiful white caparisoned horse, is a dark-browed, bearded, handsome, grave prince in a crown that has the look of a turban; facially, he has a strong resemblance to the King of Kings, as the Italian painters represented Him, and this evokes, though no doubt accidentally, quite another and more 'popular' scene: the entry of Jesus into Jerusalem on Palm Sunday, riding an ass. Set apart from the rest of the train, in demi-profile, motionless, he strikes a note of absolute gravity in the pretty cavalcade. The Patriarch of Constantinople, who died in Florence during the Council and was buried in Santa Maria Novella, is not so conspicuous - almost a background

figure, with a white wavy beard and a gold crown in points, looking like some old necromancer.

Among the Italians are Piero the Gouty, with the device of the diamond ring and the motto 'Semper' on his horse's trappings; the three Medici girls, dressed as pages with feathers in their caps and mounted on prancing horses; Lorenzo, blond, winsome, and girlish in the costume he wore at the tilt of 1459; the 'bel Giuliano' with a leopard; Giangaleazzo Sforza of Milan, with a star in his horse's forehead; Sigismondo Malatesta, tyrant of Rimini; Gozzoli himself, wearing a cap on which he has painted 'opus Benotii'; and his teacher, the Blessed Angelico. Others supposedly present are Pico della Mirandola. Poliziano, members of the Tornabuoni family, Nicolò da Uzzano, the Filippo Strozzi who began the Strozzi Palace, and Castruccio Castracane (died 1328). Birds are flying about, among them a beautiful long-necked pheasant; some ducks can be seen in a stream. In the procession, there are a number of dogs, two leopards in all, and a monkey. In the distance, a greyhound is chasing a deer across mountain rocks. Farther along in the sequence, worshipping angels with peacock-feather wings are shown in 'Paradise', which is simply a bit of Florentine landscape, of needle-like cypresses, palm trees with heads like compact feather dusters, a village, and distant mountains which seem to be Monte Morello and Monte Ceceri.

Throughout the fashionable scene there appear the wonderfully turned, strong, sturdy legs of the young

Florentines, dressed as pages and holding spears; the youth, pink-cheeked boys and girls alike, wear gold curls in neat rows that still have a damp look, as though the whole party of them had just come from the hairdresser. And the crowd of middle-aged men in red caps who are lined up behind the celebrities all have an intensely shaven look that again is peculiar to the Florentines. These sharp, shrewd, materialistic male faces, fat and jowly, or thin and lean-jawed, smelling almost of the barbershop, keep showing up, in a dense, serried group, at miracles and holy incidents, and the realism of these faces, intruding on a sacred event or, as here, on a fairytale pageant, produces a queer effect. In Masolino, Masaccio, Piero, Ghirlandaio, Gozzoli, Filippino Lippi, the same greyish faces reappear, like an eternal recurrence of prose. These faces belong to citizens who seem to have edged their way into the picture and stand craning their necks to be seen, as if in a modern newspaper photograph, where a head of state or a screen star is snapped in the midst of a pushing crowd. They wanted to go down into history, evidently, these serried Florentines, and this. in fact, they have done, though, being for the most part no longer identifiable, they represent for us the anonymous, everyday, banal part of history - the part that is always the same. And the truth is that it is these faces that, literally, have survived. The beautiful boys and girls, the dancing Graces, and the Madonna have disappeared from real life. In the streets of modern Florence, you will never see a living Donatello - a San Giorgio or a David - but

middle-aged Gozzolis and Ghirlandaios are everywhere.

The citizens who appear on the periphery of quattrocento painting sometimes brought along their wives - pinchfaced, sharp-nosed dames in white coifs and severe black dresses who can be seen in the frescoes of Gozzoli and Ghirlandaio. The entry of these women, trenchant onlookers, signifies that painting has taken, here in Florence, the step into genre, which from then on becomes the alternative to the magic or sorcery of the brush. With Fra Filippo, Gozzoli, and Ghirlandaio, beds, pots and pans, pitchers and basins, chairs, tables, platters begin to tumble into stories of sacred history as if dumped by a firm of house-movers. A holy birth, for Ghirlandaio, becomes a lying-in, with maidservants and lady callers. Genre was implicit, no doubt, in Florentine painting from the time of Giotto, who liked to show a sleeper in bed with his effects neatly arranged about him, but the shower of household articles into a well-delineated. polished interior does not really commence until the painters of youth, love, springtime, dancing, and splendid entertainments moved on, by a logical necessity, into ordinary clock time. 'Quant' è bella giovinezza, Che si fugge tuttavia.' Pots and pans, pitchers and basins are the sequitur to love and dancing.

Chapter Seven

In 1786, Goethe, who was then thirty-seven, realized his wish of seeing Italy. In Florence, after 'running rapidly over the city, the cathedral, the baptistery, and the Boboli Gardens', he summed up his impressions: 'In the city we see the proof of the prosperity of the generations that built it; the conviction is at once forced upon us that they must have enjoyed a long succession of wise rulers.' Hearing that assured German pronouncement, the angels could have wept. Still, the poet's perception, if not his inference, was right. Anyone coming to Florence and knowing nothing of its actual history would jump to the same conclusion. Only its intemperate climate betrays its inward character; on its 'good' days, in spring and throughout the autumn, it appears the spit and image of the ideally governed city, an architectural representation of justice, equity, proportion, order, and balance. One of the chief tasks of an ancient hero, like Theseus, was to be a citybuilder, and Florence has the air of having been constructed by an ancient hero and lawgiver, to be the home of virtue and civil peace. Seen from a distance, in a bird's eye view, the city, drawn up for inspection in parallel ranks on either side of its green river, radiates a sense of 'good government' in its orderly distribution of verticals

and horizontals, in the planification of its surrounding hills and slopes, marked off by dark cypresses, measured by yellow villas, while Florentine painting, in its government of space, makes every masterpiece a little polis. On the Campanile, as Goethe must have noted, are small bas-reliefs, by Andrea da Pontedera, and others, of Agriculture, Metallurgy, Weaving, Law, Mechanics, and so on – an incised, exemplary system of political economy. Every aspect of Florence, from the largest to the most minute, affirms the immanence of law.

The Grand Duke Cosimo I, who was not a feeling man, burst into tears when he saw his beautiful city all buried in mud after the dreadful flood of 1557, the worst in two hundred years, which had swept away the old Trinita bridge and covered parts of the town seventeen feet deep in water. Up in the Mugello valley, the Sieve, suddenly rising, had broken into the Arno, which had been badly shored up by Cosimo's engineers; taken by surprise, everyone on the Trinita bridge was drowned, except for two children, who were left standing on an isolated pier in the middle of the raging river and who were fed for two days by means of a cord sent out from the roof of Palazzo Strozzi carrying bread and wine to them. The pair of marooned children, fed from on high as if in a miracle, and the weeping tyrant compose together a touching picture of Florence, like some incident in an early fresco - a picture more imbued with the local pieties than the honorific 'Victories' that Cosimo had Vasari paint for the Salone dei Cinquecento, the great

hall in Palazzo Vecchio, where, in Savonarola's time of triumph, the General Council of the People had met. The tyrant's grief as he confronts the spectacle left by the receding waters comports well with the resourceful civic-rescue action, and this, in turn, evokes still another image, classically, tenderly Florentine: of the Spedale degli Innocenti, the first architectural work of the Renaissance, that exquisite asylum designed by Brunelleschi for the city's foundlings, with ten glazed terracotta roundels, by Andrea della Robbia, of babies, swaddled, each in a different position, aligned, as if in a nursery, over the graceful pale-yellow portico.

What the German poet saw in his rapid course over the city was the Republic, compact in public buildings, squares, churches, and statuary - that is, an ideal republic made of pietra dura, pietra forte, rough bosses, and geometric marbles. This republic never existed as a political fact but only as a longing, a poignant nostalgia for good government that broke out in poems and histories, architecture, painting, and sculpture. That view of a pink towered city in the background of early Florentine fresco (it soon became a white Renaissance city with classic architecture and sculpture) is the same as Dante's vision and Machiavelli's, the vision of an ideal city washed in the pure light of reason, even though Dante and Machiavelli, both moved by despair, looked to a Redeemer from above (an emperor or a prince) to come as a Messiah to save the actual city, just as Savonarola looked to Jesus and to a constitution modelled on that of Venice and the

poor people of Florence looked to the angels. The evidence of wise rule that Goethe thought he perceived was the wise ruling of space - the only kind of government the Florentines ever mastered but one that was passed on to later generations, like a Magna Carta, by the great builders of the Republic. By 1786, the Florentines had been enduring two and a half centuries of conspicuous misrule, under the grand dukes, and the city Goethe visited was, to a considerable extent, a grand-ducal construction, but the Trinita bridge, the Uffizi, the extensions of the Pitti Palace, the Fort of the Belvedere, the strong, severe palaces of Via Maggio and Via de' Ginori and Corso delgi Albizzi, with their frowning roof projections - all done under Cosimo I and his deplorable successors - still hold firm to the 'old' way of building, the republican tradition of lucidity, order, and plainness. Cosimo I could erect a column from the Baths of Caracalla (a present from a pope) to honour his own military glory in Piazza Santa Trinita, but the city's personality was stronger than he: Florence refused to take on the aspect of a grand-ducal capital.

'The Florentine historians,' wrote Roscoe, the very intelligent Liverpool attorney who was Goethe's contemporary and Lorenzo de' Medici's biographer, 'as if unwilling to perpetuate the record of their subjugation, have almost invariably closed their labours with the fall of the republic.' This principle remains in force, imposing itself even on foreigners; the late Ferdinand Schevill of the University of Chicago closed his history of Florence

with the fall of the Republic. Some interesting special studies, like Harold Acton's *The Last Medici*, have been done of the later grand-ducal period; there are scattered works on the Risorgimento period and on the foreigners in Florence. But the story of Florence proper, by almost universal consent, ends with the extinction of its civic life; after this, there is no history (history and story are the same word in Italian) – only the gossip of diarists.

The Florentines still refer to the Siege with a capital S. The only ruins in Florence are the well-kept remains of the walls of 1300–25 that formed the 'third circle' or outermost line of defence, marked today by boulevards, and the remains of the fortifications built by Michelangelo along San Miniato's mountain at the time of the Siege, which are described by Charles de Tolnay as having looked originally like crustaceans, with long claws, mandibles, and antennae stretching out to ward off the approach of the enemy to the city's ring of walls. 'Il nemico', having been the Sienese, the Pisans, the Luccans, the Milanese, became, during the eleven-month encirclement, finally and for all time the Spaniards.

Florence, as has been said, is not a town to prompt sentimental reflections, but on a summer night, looking out across the Arno from a terrace on the Lungarno Acciaiuoli or the Lungarno Vespucci, one can imagine, very easily, the troops of Charles V massed in the shadows on the other side of the river. 'Son le truppe di Carlo Quinto.' The time is August, 1530; Francesco Ferrucci, the Republic's great commander, has just been taken prisoner

and killed at Gavinina, in the fateful Pistoiese hills, during a last brilliant action against immensely superior forces -'You are killing a dead man,' he murmured as he fell. already covered with battle wounds, to the enemy commander's treacherous dagger. Inside the walls, no resource remains. The valuables have been stripped from the churches and convents to pay for the defence and the women's rings have been taken; the doors and windows have been torn from the houses during the winter for firewood. The cabbages and other vegetables that have been planted on the roof tops have been eaten. There is only three days' food left in the city. The horrible Sack of Prato, down the broad valley, by the soldiers of the Spaniard Cardona and Giovanni de' Medici (later Pope Leo X) is still fresh in Tuscan memory, not to mention the Sack of Rome, by the Catholic Emperor's Lutheran troops. The mercenary, Malatesta Baglioni from Perugia, at the head of the city's garrison, has made a secret commitment to the Spaniards, and from his headquarters at Porta Romana has suddenly turned his artillery on the city. The dream of a last desperate resistance, of putting fire to the houses, killing the women and children, and perishing in a general holocaust so that 'nothing would remain of the city but the memory of its greatness of soul, to be an immortal example to those who are born free and desire to live freely', even this dream has had to be relinquished. Next day, the city will capitulate.

This was not the first time the Republic had been imperilled by a foreign power at the gates. Only a gener-

ation before, the French king had marched in and been frightened off by Piero Capponi. After the Sack of Prato in 1512, the gonfalonier elected for life, Pier Soderini, had fled in terror, and the Medici had come in, profiting from the fear inspired by their Spanish allies. Long before, in July, 1082, Florence, the only town in Italy to remain faithful to the pope, had been besieged by the Emperor Henry IV, warring with the pope's defender, Matilda of Tuscany, and the city had been saved by its terrible heat, which caused the emperor to raise the siege after ten days. Again, in 1312, another emperor, Henry VII, had sat down to wait with his troops near the monastery of San Salvi, east of the walls, and had had to go away, disconcerted; the spot is still known as Harry's Camp (Campo di Arrigo). But now, with the Spaniards and their vindictive Medici ally, Pope Clement, the real Day of Judgment had arrived. This was the last act, the long stored-up climax of Florentine history. The last coins struck by the Republic were a beautiful gold ducat and a silver half-ducat, minted during the Siege from the gold and silver ornaments and household utensils contributed by the citizens and from the sacred vessels of the churches. Instead of the usual figure of the Baptist, the gold coin bore, on one side, the Cross of the people, and, on the other, an inscription, 'Jesus Rex Noster et Deus Noster'. They were used for soldiers' pay.

The Republic that fell to the Spaniards, who took it on behalf of Pope Clement, was not a democracy in the modern sense (the lowest class of workers had no vote

and until the final days of the Siege were not allowed to bear arms), and off and on, from the time of Cosimo il Vecchio, it had in fact been governed by the Medici, even though the forms and institutions of a free state had been maintained. When the bastard Alessandro, installed by his supposed father, the pope, in the year following the Siege, received the anomalous title of Duke of the Florentine Republic, this might have appeared to be merely a new name for the same thing. But in reality it was not so. The name announced a changed state of affairs; the power of choice no longer rested with the electorate, which had done its epic utmost in defence of its liberties, causing the whole world to marvel, and had found that this utmost counted for nothing in the cynical world-balance; everyone - the French King, the Venetians, the Duke of Ferrara, Henry VIII of England - had watched, and no one had raised a hand to help. The popular will and its caprices, which had sometimes tolerated the Medici, sometimes chased them out, broken up their statues and effaced their emblems, no longer had sovereignty. It was a sheer waste for Lorenzino, six years after Alessandro's entry, to assassinate the tyrant; no one knew how to use the opportunity, so inopportunely presented, for regaining the city's freedom. The usual mood-swing that followed on such actions did not occur. It was a deed for History, conceived as a stage in the Renaissance fashion, not a political act. This point was clearly seen by Alfred de Musset in his play Lorenzaccio, where he has Lorenzino ('accio' is a derogatory ending) say: «Une statue qui descendrait de son piédestal pour marcher parmi les hommes sur la place publique serait peut-être semblable à ce que j'étais le jour où j'ai commencé à vivre avec cette idée: il faut que je sois un Brutus.» ('A statue coming down from its pedestal to mingle on the public square might be like me the day I began living with that idea: "I must be a Brutus."') When the marble deed was done, Cosimo I, then a young man of modest demeanour, quietly accepted the post left vacant by his distant relation. He himself proceeded to strike the pose of an absolute monarch, the ruler of a nation-state like France, England, Spain, and when he had defeated Siena (no hard job), he extracted from the pope the title of Grand Duke of Tuscany. Florence as a political entity thereupon ceased to exist.

But Cosimo's conquering pose was more effective in statuary than in real life, where he must have appeared a poor player on a world stage occuped by Francis I, Henry VIII, and Charles V, whose viceroy's daughter he married and who relentlessly bled him for money. The title that meant so much to him he secured by turning over to the pope the Protestant reformer Carnesecchi, a guest under his roof and at his table, who was then beheaded and burned, over Cosimo's weak protests, on the Campo dei Fiori in Rome. By the time Cosimo took power, the real sovereignty of Tuscany and of most of the Italian peninsula had passed to foreigners. Until the unification of Italy, in 1860, the Grand Duchy was governed, not by consent of its subjects, but by consent of the rulers of Europe, who,

when the Medici had died out, conferred it on the House of Lorraine, that is, on the Austrians.

The grand dukes who succeeded Cosimo were hardly worthy of being called tyrants. They were, rather, landlords, with the occasional virtues and manifold vices of the breed; under them was a vast and wretched tenantry, who supplied an audience for their monotonous, costly, and uninspired festivities. A few of the grand dukes were enlightened, but the majority were grasping, mean, dissolute, lazy, feeble, dull-witted, provincial, bigoted, or else absentee, like Francis of Lorraine, husband of the Empress Maria Theresa. The Austrians, when they stayed in Tuscany, were the best of the lot. They drained the Maremma, the marshy coastal region extending from Pisa to Grosseto, which had been barren, wild, and malaria-stricken since Roman times; they encouraged agriculture and made economic reforms. Under the Austrians, Tuscany began to revive a little from the torporous decadence it had sunk into. Marital quarrels, pious observances (under the hypocritical Cosimo III, the shops were closed half the year because of the numerous holy days decreed by the sovereign, who was also a great persecutor of the Jews), carousing, and a series of boy 'favourites' had marked the reigns of the later Medici grand dukes, whose principal redeeming characteristic (this was finally bred out of the last members of the family) had been the promotion of natural science. One grand duke, Ferdinand II, a pupil of Galileo's, constructed a liquid thermometer, and his brother, Cardinal Leopold, also

Galileo's pupil, founded the Accademia del Cimento – which means 'test', 'trial', 'risk', in short, experiment – the first academy in Europe for research in experimental physics. Its collection, originally in Palazzo Pitti but now housed in the Museum of the History of Science, contains, not only Galileo's telescope and the lens through which he first saw the planets of Jupiter – the 'Medici planets' – but also, in a glass urn, the third finger of his right hand.

The late Medici taste ran to such curios. Their architects had remained true to the old way of building, so that even a fort like the Belvedere, a brown-and-cream sentry box with a clock set in its head and strongly accented windows, monitors the city in the style of a plain fortified farmhouse; but interiors and gardens reflected the real predilections of their owners and the grand-ducal society around them - predilections for the bizarre, the extravagant, coy monstrosities of Nature, metamorphoses, for colossal white statues resembling the huge cut-out milk bottles and ice-cream cones of American billboard display or the Michelin tyre man, for hideous fantasies in rocaille, simulated sea shells, and tortured topiary work, for life-size house dogs in stone set out on walls or patches of lawn, anticipating the Victorian stag, for grottoes and caverns with imitation stalagmites and stalactites, for 'specimen' trees and malachite, porphyry, alabaster, chalcedony. Eighteenthcentury English travellers, like Addison and John Evelyn, were impressed by the grand-ducal zoos (there seem to have been two or possibly three, one near the 'Belfry',

one near Palazzo Strozzi, and perhaps another near Santissima Annunziata), and the gardens of the grand dukes and their circle often had a zoomorphic character, rhinocerine or hippopotamus-like. The famous Orti Oricellari, for example, where the Platonic Academy had been transferred and where Machiavelli, it is said, read aloud his Discorsi, have a statue of the Cyclops. Polyphemus, nearly two hundred and fifty feet high, the one-eyed giant's cave with a whole cyclops family and feigned stalactites, an enormous mock-Pantheon with imitation classic tombs of the Academicians, and an imitation necropolis. Laboured imitations of Nature's curiosities, as well as abstract personifications, were introduced into the Tuscan hills: the Medici Villa della Petraia at Castello has in its garden a bronze fountain representing Florence, who is squeezing water out of her hair with her hands, while the Villa di Castello, another Medici property next door, has a grotto with stalactites, bronze animals, and a fishpond with a giant statue that used to be known as 'The Apennine'. In the Accademia del Cimento's collection, there are clinical thermometers made in the shape of turtles.

In the Villa Ambrogiana, near Empoli, Cosimo III, according to another traveller's report, had a special art collection painted for him by 'one of the best artists in Florence' that contained lifelike likenesses of one hundred rare animal specimens, 'quadruped and flying', among them two two-headed calves and a two-headed sheep, 'together with a record of when and where they were

born and how long they lived'; there were also 'portraits' ('ritratti') of fruits of unusual and monstrous size and 'portraits' of colossal trees. This collection of monstrosities, which was intended to perpetuate the grand duke's memory, seems to have disappeared, and the villa is now an asylum for the criminally insane.

The kind of vulgarity in decoration that is today thought of as middle-class seems to stem straight from Tuscany in the time of the Medici grand dukes. From the Florentine cinquecento and its highly developed craftsmanship, its skill in the inferior arts of imitation, flowed a torrent of bad taste that has not yet dried up. The interiors of the grand-ducal palaces and villas are sumptuously, stuffily ugly in a way that is hard to connect with a period that was contemporary, after all, with classic Palladio in the Veneto. By one of those peculiar time leaps so characteristic of Florence, one finds oneself, while visiting one of the grand-ducal villas, transported suddenly into the Victorian age or the time of President McKinley; if there had been Toby jugs and Swiss weather clocks available, the grand dukes would certainly have collected them.

The lifting of all restraints in the minor arts of decoration took place in the time of Cosimo I and no doubt had a political meaning – the rejection of the human scale (this was the same as refusing audiences) and the proclamation of complete license on the part of the ruling family and its sycophants. And just at this time, though not without warning, the major arts (excepting architecture) expired. The Florentine *cinquecento*, which had seemed at its begin-

ning the most audacious century of all, suddenly declined into provincialism, and a glance sideward at Venice, where Titian, Veronese, Lotto, and Tintoretto were reigning, could only provoke mournful comparisons. There were many reasons for this. The accession of Cosimo could not have been the cause but was itself a symptom of the same exhaustion that was showing itself in Florentine painting and sculpture.

During the last years of the Republic there had begun the great Diaspora of Florentine artists. It was nothing new for Florentine artists to journey about Italy, studying or executing commissions. Giotto, Uccello, Masaccio, Fra Angelico, Andrea del Castagno, Brunelleschi, Donatello, Verrocchio had all done it. Michelozzo had gone into exile with Cosimo il Vecchio; Masolino, after working in Rome and Venice, had been called to Hungary, like the Fat Woodworker. But these voyages were mere business trips, temporary absences from the centre, and the works undertaken by Florentine artists abroad were like the branches of the Florentine banks opened in France, England, Rome, Venice, Flanders; the main office was at home, in the workshops of the streets around the Duomo and the old Santa Croce quarter. Young foreign artists - Piero della Francesca from Borgo San Sepolcro in Arezzo territory, Raphael from Urbino, Jacopo Bellini, founder of the Venetian school, Perugino from Perugia came here to purchase knowledge of the Florentine 'way'. Luca Signorelli, from Cortona, leaping beyond the soft Umbrian influences that had formed him, became,

in Florence, an epic painter of massive Demeter-like women and naked heroes, like Myrmidons – a titan in the noble Florentine tradition of contest and struggle. Florence learned from itself, reinvesting: the young Michelangelo made drawings of the Giottos in Santa Croce and the Masaccios in the Carmine; Leonardo, so it is thought, was inspired by Ghirlandaio's 'Last Supper'

in the Cenacolo of Ognissanti.

Yet the first warning of something different, of a new phenomenon - the genuine migration of talent elsewhere came from Leonardo, a forerunner in this as in everything else. He appeared in Florence young, left it young, returned for a short stay, during which he painted the 'Mona Lisa', and then went off to France, to the court of the French king, who kept him in his château, a royal guest, till he died. One by one, other artists followed his example. Michelangelo went to Rome. Pietro Torrigiani and the Rovezzano sculptors went to England. Jacopo Sansovino went to Venice. The painter known as Il Rosso Fiorentino went to Fontainebleau. Abroad (and the point is stressed by Vasari in his life of Il Rosso), they lived like kings or like signori and abroad, therefore, they died. When Michelangelo quitted Florence for good in 1534, four years after the Siege, only one artist of any importance was left in the city - the crazy Jacopo Pontormo.

Vasari makes no bones about the reasons for Il Rosso's decision to leave: 'e tòrsi, come diceva egli, a una certa miseria e povertà, nella quale si stanno gli uomini che lavorano in Toscana e ne' paesi dove sono nati' ('to raise himself, as

he used to say, out of a certain wretchedness and poverty, which is the common lot of those who work in Tuscany and in their native places'). Again, the famous Tuscan avarice or grudging meanness, reluctant to give a decent living to a native painter. Just then, moreover, times were particularly hard. When Il Rosso left Italy to try his luck in France, the year was 1530. Shortly before, during the Siege, Cellini had deserted the Florentine militia and gone to Rome to work for Pope Clement; the hack Bandinelli had fled to Lucca, where the Medici refugees were, leaving an unfinished block of marble behind him. In the last years of the Republic, as the records show, the chief private commissions had been coming from the Medici and their dependents, including the Servite friars of Santissima Annunziata, Medici mouthpieces, who got their atrium frescoed by the painters then in fashion - Andrea del Sarto, Il Rosso, Pontormo, and Franciabigio - and a new porch begun by Antonio da Sangallo, with the crossed papal keys of Leo X over the entrance. (Owing to the Medici largesse, this church, with its tribune by L. B. Alberti and its baroque decoration, is so rich that it hardly looks Florentine; it is still the fashionable church of Florence, popular with the aristocracy for weddings and masses for the dead, social events to which invitations are issued.) When the Medici were driven out, for the last time, in 1527, their art patronage naturally ceased.

The years between the execution of Savonarola and the Siege were uncertain, fearful years for all the Floren-

tines - artists and citizens, popes and bankers. Leo X is supposed to have been haunted on his deathbed by the horrors of the Sack of Prato, which he himself had licensed. While the German soldiers, wild for 'Gelt', were pillaging Rome, Clement VII was a prisoner in Castel Sant'Angelo and later had to escape to Orvieto; no such indignity had befallen the papal person since the Middle Ages. At the same time, Henry VIII of England was pestering him for a divorce. The 'barbari' were loose in Italy again, and, with them, there returned another medieval scourge, the plague, which in 1527-28 took the lives of 30,000 people in Florence and its suburbs (a quarter of the population) and double that in the contado. The gonfalonier Niccolò Capponi, son of the famous Capponi, having remained steadfastly in Florence throughout the plague, when nearly all the well-to-do had fled, was shortly afterward tried for treason, on the suspicion that he had been intriguing with the pope. Despair and the recurring hope of a miracle were the natural response to this incessant mutability of public affairs and private fortunes, and the resigned philosophy of the new dark ages that seemed to be beginning was well expressed by Guicciardini, who said that when he thought of the infinite vicissitudes to which human life was subject he marvelled to see an old man or a good crop.

This fearsome twilight was a time for historians, for summings up and bitter stocktaking. The Florentine literary genius turned in these years to history, as though there were a presentiment that all past deeds would vanish, together with the social structure, if a careful record were not compiled. The histories of Guicciardini, Machiavelli, and a little later Segni and Varchi have the air, often, of being written for a time capsule or to be cast to sea in a bottle: each writer retells the story, as though he would be the last to remember it, of the deeds and sayings of the Florentines, starting, usually, from the foundation of the city.

A kind of tyrannophobia had seized the Florentines after the last expulsion of the Medici. Bands of young political purists went about questioning the loyalty of venerable elected officials and attacking works of art. It was the custom to keep wax statues of outstanding citizens, living and dead, in the church of the Annunziata, for special feast days, when they would be dressed in rich costumes and hung on the convent walls; one morning, in 1528, a masked gang of roughs went into the church and broke up the images of the two Medici popes, of Lorenzo the Magnificent and other distinguished Medici; the broken bits were then treated as though the church were a public latrine. This had happened once before, in the interregnum after the Sack of Prato. By public decree, the Medici emblems were ordered to be removed from churches and private dwellings, and it was proposed to tear down Palazzo Medici. Old Cosimo's epitaph in San Lorenzo was rewritten to say that he was not Pater Patriae but Tyrannus. Michelangelo offered to do a 'Samson Overcoming a Philistine' to stand as a republican symbol in a public square, but (a sign of the new times) he

was too busy painting a 'Leda' for the Duke of Ferrara to keep his promise. And finally, during the Siege itself, painted likenesses of hanged criminals appeared, once more, on the walls of the Mercanzia in the Piazza della Signoria, painted by Andrea del Sarto, at night because of the shame attached to the work; these public enemies were not now, alas, in the grip of the Republic but had deserted to the enemy outside the gates. Throughout the Siege, this curious punitive species of fresco, always praised for being very lifelike, was persevered in, Andrea working at night and in his pupils' names on the Bargello walls. A certain Ghiberti, descendant of the great sculptor who had done the 'Gates of Paradise', painted a placard for the military headquarters, the Golden Lion in Via Larga, showing Clement VII in his papal dress and mitre at the foot of the gallows.

Andrea del Sarto, who died in 1531, was the chief Florentine representative of the bella maniera of Raphael, that is, of an ideal 'classicism', already somewhat stereotyped and saccharine, that was being developed in Rome. His masterpiece, a 'Last Supper' in the monastery of San Salvi, near Campo di Arrigo, was spared during the Siege by a squadron of Florentine workmen sent to demolish all the buildings within a mile radius of the walls (so that they could not prove useful to the besieging enemy), spared, so it is said, from artistic sentiment that could not bear to destroy something so beautiful and so fresh from the artist's hand. The 'perfection' of Andrea, which today seems boring and academic, still retained a

saving element of Florentine naturalism, of that lifelike quality that was noted in the hanging figures on the Mercanzia and the Bargello. But just during the chaotic years preceding the Siege there began, in reaction to Andrea, the peculiar movement called Mannerism, which departed both from Nature and from ideal standards of perfection. The 'unnaturalness' of the first Mannerists – Pontormo and Il Rosso Fiorentino – was a subject for Cellini's sarcasms and for Vasari's worry. He speaks of 'bizzarrie' and funny ('stravaganti') poses, of 'certi stravolgimenti ed attitudini molto strane'. Early Florentine Mannerism might be called the first modern art, in the sense that it was incomprehensible to the artists' contemporaries, who in vain sought a rationale for what seemed a wilful violation of the accepted canons of beauty.

Up to the time of Pontormo and Il Rosso, there had been a general agreement, not restricted to connoisseurs, as to what constituted beauty and what constituted ugliness, and the judgment of the citizens of Florence was regarded as supreme. Their quick applause for the new had kept this agreement from becoming a form of philistinism – nobody complained that Giotto was not like Cimabue or that Brunelleschi had violated the plan of Arnolfo. A lively faculty of recognition was the common denominator between the artist and the public. When Michelangelo spoke of 'a cage for crickets', everyone saw what he was talking about and what Cellini was talking about when he said that Bandinelli's 'Hercules and Cacus' (made, after the Medici restoration, from the

block of marble intended for Michelangelo's 'Samson') was like a great ugly sack of melons stood up against a wall. A joke is a proof that everyone is capable of seeing with the same eyes. The Mannerists were the first to require a special vision, an act of willed understanding, on the part of the public. With Il Rosso and Pontormo, 'What can anyone see in it?' became, for the first time, a question propounded about a work of art. And even today, the visitor to the Uffizi who has not been prepared by a heavy reading course in art criticism and theory will find himself wondering, in the Mannerist rooms, what anyone ever saw or sees in this art, with its freakish figures arranged in 'funny' postures and dressed in vehemently coloured costumes.

In their personal lives, both Pontormo and Il Rosso were 'disturbed' cases, to use the psychiatric jargon of today. Pontormo was a recluse in the tradition of Uccello and Piero di Cosimo – a solitary hypochondriac who lived in a strange tall house he had had constructed for himself ('cera di casamento da uomo fantastico e solitario') with a top room, where he slept and sometimes worked, that was reached from the street by a ladder, which he would pull up after himself with a pulley, so that no one could get at him once he was safe inside. Often, he did not answer when friends knocked on the door in the street below. 'Bronzino and Daniello knocked; I don't know what they wanted.' He had no wife, and in his old age he adopted a foundling from the Innocenti with whom he had a great deal of trouble, because the youth would not

stay home with him or would shut himself in his room and refuse to eat. Pontormo's diary, kept during the last three years of his life, records his minute attention to his stomach, kidneys, and bowels, and painstakingly itemizes his lonely, abstemious meals. 'Dined on ten ounces of bread, cabbage, beet salad. 'A bunch of grapes for dinner; nothing else. 'A "fish" of eggs [a frittata made in the shape of a fish], six ounces of bread, and some dried figs.' One writer, Bocchi, relates that Pontormo was 'excessively melancholy and kept dead bodies in troughs of water to get them to swell up', in order to study them for the 'Deluge' he was painting in San Lorenzo; the smell sickened the whole neighbourhood. Vasari says, on the contrary, that he had a morbid fear of death and could not bear to have it mentioned or to see a dead body carried through the streets. During the plague, he fled to the monks in the Certosa at Galluzzo. Il Rosso (so called because of his fiery complexion) used to dig up corpses in the graveyard of Arezzo in order to study the effects of decomposition. In Florence, on Borgo dei Tintori, he lived with a baboon, which, he taught to perform services for him. According to Vasari, he committed suicide in Fontainebleau, but modern authorities deny this.

Of the two, Pontormo was decidedly the greater artist. His late-summer idyl, 'Vertumnus and Pomona', painted for the big sunny upper room of Poggio a Caiano, Lorenzo's favourite villa, is one of the most convincing and freshest bucolics ever projected by a painter; it is as light and graceful as an eighteenth-century Venetian and

as strong in its design as a Michelangelo. Above, two naked putti are riding on the central bull's-eye window, perched on laurel branches, and two more, below, are sitting astride a wall. Branches and delicate leaves spray out, suggesting, in their movement, a swing or swings. A party of handsome country girls, a naked boy, an old man with a basket, a youth in a jerkin, and a dog have stopped to rest, as though by a roadside, and have disposed themselves on two stone walls, which provide a platform or stage for the painting, transecting the half-moon of the lunette. The country girls (goddesses, really) are wearing low-necked summer dresses, with white fichus or berthas and billowing sleeves. One has pulled up her red skirt and is dangling a white bare leg over the wall she sits on. One has a pale blue cap, like a Vermeer; she is turning her head over her shoulder, again Vermeer-like, towards the room; her sleeves are rolled up, her pretty hip is raised, and her bare foot and legs are stretching out from her pale lavender dress. One, the most beautiful of the three, with a violet bow in her dark piled-up hair, is reclining, propped up on an elbow, looking intently forward; she wears an olivegreen dress with violet sleeves, and her free arm, somewhat tanned, is extended sideward, straight out, in a lovely taut gesture, as though she were maintaining her balance. On the other side of the bull's eye, the naked sunburned boy on the wall has his arm thrown back and upward, as if he were playing at ball. The old god Vertumnus sits crouched by his basket like a brown peasant or beggar. The youth next to him wears a mauve tunic

and a white shirt with full sleeves. Nothing could suggest better a warm, late-summer afternoon on a Tuscan road-side than these bare legs, white kerchiefs, slightly disarrayed gowns, tucked-up skirts and sleeves, the unself-conscious medley of dress and undress, the play of cool, precise colours against heated flesh in the semi-shade of the branching laurel. The fresco was commissioned by Pope Leo X to honour the memory of his father, Lorenzo, and from it transpires a breath of the natural farm life of the villa as described in Poliziano's letters and Latin verses: family shopping trips to Pistoia, cheese-making, mulberries, peacocks, and geese. In a quite different vein, Pontormo's 'Crucifixion' (now in the Belvedere), painted for a roadside chapel near Castello, is in its swelling volumes and austere tragic simplicity nearly as fine as a Masaccio.

From these extraordinary works, no one would be led to suspect the 'derangement' of Pontormo; nor would anyone guess that he, like Il Rosso, suffered from 'l'orrore dello spazio'. Yet a horror of space, in fact, was the phobic obsession that dictated or drove most of his compositions, and those of Il Rosso, too, to an even more marked extent. The first reaction to a typical altarpiece by Pontormo or Il Rosso is one of sheer repulsion and bewilderment. There is no depth and no dimensionality, and the figures, uprooted like the corpses in the graveyard, stare out as though they were apparitions. Space has been dismembered, and anatomy, no longer obedient to spatial discipline, reverts to a kind of Gothic abandon. Arms have grown extraordinarily long; heads have shrunk; feet

and hands have become gigantic or withered into claws; eyes are mere holes, blackened around the edges, or else they are rolling up, showing their whites, in ecstasy. Bodies are swivelled about in remarkable contortions. A screaming phantasmal colour jumps off the canvas – lurid greens and oranges, leprous whites, burning reds, and

jarring violets.

What is most disturbing, however, in this 'primo manierismo fiorentino' is the presence of a kind of prettiness a sugary, simpering prettiness which is already unpleasantly noticeable in Andrea del Sarto, whose rapt devotional groups are all too 'seraphic' often, in the style of the cheap holy cards with a prayer printed on the back that are distributed in churches. Iridescent or opaline colour, used by Andrea for religiose effects of light and shade, became the specialty of the Mannerists, who loved the two-tone effects now found chiefly in sleazy taffetas popular with home-dressmakers for an ungainly girl's first 'formal' - orange turning yellow, flame turning red, lavender turning rose. Il Rosso's colour is more garish than Pontormo's. In his 'Madonna, Saints, and Two Angels' in the Uffizi, the principal personages are all dressed in 'shot' textiles. The Madonna is wearing a two-toned pinky purple dress with peach-coloured sleeves; Saint John the Baptist has a Nile-green shoulderthrow and a mauve toga; Saint Jerome's bare ancient shoulders, shrunken neck, and ferret-like head are emerging from what is best described as an evening stole, in dark grey iridescent taffeta. The mauves, peaches, and

purples are reflected, like a stormy sunset, on the flesh of the holy group; clawlike hands have red transparent fingers as if they were being held up to the sun or to an infernal fire. A simpering, rouged, idiot Child sits on the Madonna's lap. The eyeholes of the Child, the Madonna, and the red-winged Angels are circled by blackness, like melting mascara; their reddened, purpled features are smudged and blurred; and the whole party appears intensely dissipated or lunatic - a band of late roisterers found at dawn under a street lamp. Other sacred paintings of Il Rosso, like the 'Moses Defending the Daughters of Jethro', also in the Uffizi, suggest, again, the half-carnival atmosphere of an insane asylum or of a brothel during a police raid. In other toppling constructions of Il Rosso and Pontormo, the pyramid of the Holy Family and saints calls to mind a circus tableau, of a team of brightly costumed acrobats teeteringly balanced on the strong man at the base.

The hellish, freak-show impression made by many of these altarpieces was not accidental, at least in Il Rosso's case. Vasari tells a story of how the painter was doing a picture for the superintendent of the Hospital of Santa Maria Nuova, and the superintendent, seeing the oil sketch and taking the saints for devils, drove Il Rosso off the premises. Vasari goes on to explain that Il Rosso, when making an oil sketch, had the habit of giving 'certe arie crudeli e disperate' to the figures, which he later sweetened and softened in the finished canvas. But those 'cruel and desperate airs' are not really dispelled by the

orangeade colour or by the drooling smiles of the sticky Child and angels. 'The Madonna of the Harpies', the name given to a well-known painting by Andrea del Sarto, because it shows the Madonna standing on a pedestal carved with harpy forms, might serve as the over-all title for Il Rosso's leering underworld.

Softly idealized Holy Families, flanked by ecstatic friars, were hardly the best subject for a painter who was living with a baboon, and the horrible falsity of feeling that is evident in much of the post-Raphael painting of this period seems a product of a growing clerical demand for a specifically 'Catholic' art – an art of genuflections and bead-telling and family unity. Il Rosso was great once, when he painted his Volterra 'Deposition' and his own spatial horror coincided with the disequilibrium of the event to produce a kind of shrieking surrealism: white phantom figures are seen busily moving on a crazy pattern of ladders and crosses in a spatial void.

In Pontormo's 'Deposition', in the church of Santa Felicita, the subject is treated in a totally different and even stranger fashion. Because of the darkness of the chapel he uses pale boudoir shades reminiscent of ribbon and silken coverlets; the pale soft lifeless body of Christ, carried by attendant nacreous figures, might almost be the centre of a chiffony Bacchanale. There is no sign of the Cross or of any solid object. A drift of pale-green chiffon is lying on the ground in the front of the picture, and the mourners are dressed in peppermint pink, orchid, gold-apricot, sky-blue, scarlet, pale peach, mauve-pink,

pomegranate, iridescent salmon (orange-persimmonyellow), and olive-green. All the figures are ethereally feminine, except for a tiny bearded old man whose head is seen in one corner. The two bearers of Christ's drooping, supine cadaver are wide-eyed girlish pages with pearly, satin-smooth arms, silky short gold curls, and white shapely legs; one of them is wearing a bright blue scarf or ribbon. An utter detachment from what has happened characterizes this bizarre epicene ensemble; about to shoulder their burden, the bearers turn their curly heads, as it were, to pose for the picture, and the one on the left, with Cupid's-bow lips parting, has assumed an expression of pathetic, pretty surprise. The choreographic grouping of harmonious candy tints, flowing gestures, and glistening white tempting flesh makes an eerie morbid impression, as though Cecil Beaton had done the costumes for a requiem ballet on Golgotha.

The faculty of eliciting inappropriate comparisons is always a mark of strain in art, and the early Florentine Mannerists possess this faculty to the highest degree. The detachment of their tapering figures from the action they are supposed to be performing and from any affective sentiment prompts the onlooker to associate this dissociated work with the realm of common things, and he is shocked, for example, to find that the cut of the dead Christ's beard in Pontormo's 'Deposition' reminds him of Cosimo I. The banished real world returns, in an unpleasant way, forcing itself in where it does not belong, carrying a bedraggled train of reminders and associations.

Still, it must be said for the Florentine Mannerists, that, again, they were the first – the first to feel the strain and hollowness of the *cinquecento*. Early Florentine Mannerism, is, above all, nervous painting, twitching, hag-ridden, agoraphobic, looking over its shoulder sidewise, emerging whitely from black shadows. The tics of Pontormo and Il Rosso signalled a breaking-point. The disturbance originating in Florence was eventually felt all over Italy – in Parma, Siena, Venice, and Rome. But the diverse painting and sculpture identified in art history as Mannerist – Beccafumi, Parmigianino, Michelangelo, Bronzino, Allori, Vasari, Cellini, Giambologna, Tintoretto – had only superficial similarities with the calamity-shrieking canvases of Pontormo and Il Rosso.

In Florence, under Cosimo I, the second Mannerism, cold and formal, became a semi-official style. The Florentine workshops were busier than ever, thanks to the grand duke's Renaissance vanity, which was stronger, even, than his stinginess. He wished to leave behind him imperishable monuments to his reign and allotted the task of doing this to the artists who happened to be on hand: Vasari, Allori, Bronzino, the younger Ghirlandaios, Franciabigio, Cellini (back from his travels and buying Tuscan real estate), Bandinelli, Ammannati, Giambologna. Even the old Pontormo, though he was not in fashion, received a commission, and the grand duke and duchess paid a gracious visit to San Lorenzo to see his work progressing. Ammannati enlarged the Pitti Palace, and the Boboli Garden was laid out, with grottoes, caverns,

stalactites, an artificial lake with an island on it, and avenues of ilex – all in the new foreign 'landscape' style. Sculptors and painters were employed to do likenesses of Cosimo himself, his wife, his descendants, and his remote ancestors, as well as his mother and father. He set Cellini to competing with Ammannati for the 'Neptune' on the Piazza della Signoria and let him work on his model in the Loggia dei Lanzi; unfortunately for the piazza, Ammannati won the commission because, explains Cellini, he himself was poisoned by a *scodellino* of sauce and was sick for nearly a year.

A great deal of hack work was done for Cosimo, with which he was immensely satisfied. He was not able to distinguish between the talents of his busy artists and artificers; the high value he put on Vasari seems to have been due to his speed. The perfected 'bella maniera' in which Vasari excelled could be applied, like a patent process, to any subject matter or medium, and Vasari was proud of the fact that the arts in his generation had reached a degree of efficiency or near-automation undreamed of in the past. Pain and difficulty in composition had been almost eliminated, and from the point of view of both artist and patron this appeared to be an advance of stupendous importance. The new efficiency permitted Vasari to exceed all previous norms: he frescoed the interior of Brunelleschi's dome; he remodelled Palazzo Vecchio from top to bottom and frescoed the principal rooms; he built the Uffizi and even found time, in the midst of other commissions, to spoil the interiors of Santa Maria

Novella and Santa Croce, putting in new chapels and getting rid of many old works of art.

The Panglossian optimism with which Vasari attacked these jobs was a product of the age and of the sudden parochialism of Florence, now a backwater, though it did not yet know it. Vasari believed that he was living at a zenith while in fact he and the Florentines with whom he shared Cosimo's patronage had arrived at a nadir; only Cellini, among them, was a world figure. The rest were 'School of Florence', as one might say a school of small fish.

This sad ending of the story of a great people has a curious epilogue. Florentine painting and sculpture never recovered from their collapse in the mid-sixteenth century, and it was not until the Risorgimento that Florence once again became a centre, if only a small one, of literary men, political figures, and historians, like Gino Capponi and Bettino Ricasoli of Brolio (called 'the iron baron'). liberals of ancient blood, and the Swiss G. P. Vieusseux, who founded the reading room now called the Vieusseux Library. Yet the city did not die or petrify like Mantua, Ravenna, Rimini, Siena, or turn into a dream like Venice. The Florentine crafts, out of which the arts had grown, survived the era of bad taste that was inaugurated by the grand dukes, survived, too, the Victorian cult of tooled leather and glazed terracotta; the severe tradition of elegance that goes back to Brunelleschi, Michelozzo, Donatello, Pollaiuolo has been transmitted to the shoemaker

and the seamstress, just as the wise government of space can still be found, not in Florentine modern architecture and city-planning, but in the Tuscan farmland with its enchanted economy, where every tree, every crop has its 'task', of screening, shading, supporting, upholding, and grapevines wind like friezes in a graceful rope pattern among the severed elm trunks, the figs, and silvery olives.

In Tuscan agriculture, everything not only has its task but its proper place; a garden, as Edith Wharton explains in her little book on Italian gardens, is treated in Tuscany as an outdoor 'house', which is divided into 'stanzoni' (big rooms), often on different levels: the lemon 'room', the orange 'room', the camellia 'room', and so on. In this perspicuity and distinctness, so characteristically Florentine, there is some residue, perhaps, of medieval scholasticism, something that recalls the architecture of Dante's hell, with each group of sinners in their proper bulge and circle, as chickens in Florence are found at the pollaiuolo, meat at the macellaio, vegetables at the ortolano, milk at the lattaio, cheese at the pizzicheria, bread at the panificio, a system of division that has broken down in most Italian cities and in which modern products like toilet paper find it hard to discover their proper 'house'.

Yet Florence is not backward, only extraordinarily rational. The Florentines consider themselves and are considered by other Italians the most civilized people in Italy, just as the Tuscan peasant is regarded as the most skilled and intelligent of Italian farmers. 'Questi primitivi', the Tuscan poor people say pityingly of workers im-

ported from the South and from the islands of Sicily and Sardinia, and they pity them not only for their unskilled hands but because these unfortunates, not having lived with the 'Davidde' (the Florentine pet name for the 'David' of Michelangelo) and the 'cupolone' (Brunelleschi's dome), do not understand 'le cose dell'arte'. The literacy rate in Tuscany is by far the highest in Italy, and the poorest Florentine maidservant can be found in the kitchen spelling out the crimes and 'le cose dell'arte' in the morning newspaper.

That quality called 'fiorentinità' (and Florence is the only Italian town whose name naturally turns into a substantive denoting an abstract quality) means taste and fine workmanship, as 'Paris' does in France. The world knows it in shoes, umbrellas, handbags, jewellery, trousseau linens, and the firms of Ferragamo, Gucci, Bucellati, Emilia Bellini, with their seats on Via Tornabuoni and Via della Vigna Nuova and branches in Rome, Milan, New York, awaken faint reminiscences of the old banking firms of the Peruzzi, the Bardi, the Pazzi. Fiorentinità is made by the Florentine workman in his coverall and by those firms of spinster sisters like the Sorelle Materassi of Aldo Palazzeschi's novel with their needles, scissors, and embroidery hoops and their big maid called Niobe. If it is synonymous with civilization and refinement, it cannot be separated from the poor and their way of talking, thinking, and seeing, which is always realistic and equalizing. The Florentine speech is full of diminutives; everything is turned into a 'little' something or other, which has the

curious effect of at once deprecating and dignifying it. Old-fashioned expletives ('Accidentil', which means something like 'I'll be blowed', 'Diamine!', or 'the dickens!', 'Perbacco!', or 'You don't say!') give Florentine talk a countrified flavour. 'Per cortesia', among the poor people, is the common preface to an inquiry. A 'pisolino' (somewhat humorous, meaning 'a little nod') is the common word for a nap; a drink of hot water and lemon is a 'canarino' (canary bird). Nature becomes human when the peasants look at her; around Florence they call the two kinds of cypresses, the tall male and the blowsy female, the 'man' and the 'woman'.

Florence today is a city of craftsmen, farmers, and professors, and every Florentine has something in him of each of these. In a sense, there is no class of unskilled workers, for every occupation is treated as a skill, with its own refinement, dignity, and status – even unemployment. 'What did your husband do?' 'Era un disoccupato, signora.' In the same way, upper-class idlers, such as are found in Rome and Venice, are extremely rare here, which explains the absence of night life. There is no jeunesse dorée; children of the upper classes are busy studying at the University: law, archaeology, architecture, political science.

The Florentines today are probably more like what they were in the Middle Ages and the early Renaissance than were the Florentines of any intervening period; the revival of crafts and small industries and the restoration of free institutions after Fascism may have something to do

with this. These eternal Florentines have no need to be sentimental about the past, which does not seem remote but as near and indifferently real as the clock on the tower of Palazzo Vecchio to the housewife who puts her head out the window to time her spaghetti by it. There have been many changes, of course, in these centuries, but they are like the changes a man sees in his own lifetime. The diet eaten by Pontormo in his crazy tall house is almost precisely the diet of the Florentine people today: boiled meat, a frittata of eggs, a fish from the Arno, cabbage, minestra, beet salad, capers, lettuce salad, three pennys' worth of bread, the bitter green salad called radicchio, pea soup, two cooked apples, asparagus with eggs, ricotta, artichokes, cherries, melon (popone in Tuscan), the small sour plums called susine, grapes, a young pigeon, two pennyworth of almonds, dried figs, beet greens with butter, a chicken. If he were alive now, he might have eaten, besides, white haricot beans with tuna fish from Elba, the broad beans called mangia-tutto, Tuscan ravioli (little green gnocchi made with beet greens and ricotta), rabbit, and the long string beans called serpenti.

The merit of this fare is that it is inexpensive and healthy. In Pontormo's 'Supper at Emmaus', the bill, or what appears to be the bill – a scroll of paper with figures on it – is shown lying on the floor. This sardonic touch is as characteristically Florentine as *radicchio* and *popone*. The economy of the Florentines, reprehended as avarice by Dante, is an ingrained trait, which was made even more pronounced, doubtless, by the general misery during the

Medici period. Farmers are naturally economical, and the farmer in every Florentine scrimps, saves, and stretches. When the capital was moved to Florence at the time of the unification of Italy, a Roman paper printed a cartoon showing three Florentines seated at a dinner table with a single boiled egg in the centre. 'What shall we do with the leftover?' was the caption. Such jokes are still told of the Florentines, and they tell them of themselves. At an expensive seaside resort, during a recent heat wave, all the Florentines checked out of the hotel one morning. 'They must have heard that the heat wave was over in Florence; someone sent them a penny post card,' observed a non-Florentine. A lady who lived in Fiesole was invited by a Florentine countess to drop in at her house 'any time you feel like it; if you want to do p. p. . . . 'To the countess, this invitation was the summit of hospitality.

Eggs, cigarettes, and postage stamps are still bought cautiously, one at a time, by the poorer Florentines, and a cabbage is sold by quarters. The habit of careful division, of slicing every whole into portions, is an instinct with the Tuscans that is confirmed by their very geography. Tuscany produces a 'little of everything', as the Florentines love to explain: iron, tin, copper, zinc, lead, marble, hides, oil, wheat, corn, sugar, milk, wool, flax, timber, fruit, fish, meat, fowl, and water. This little, if carefully distributed, meant self-sufficiency and independence; it was a kind of proof, from the Creator, that Tuscany was a 'natural kingdom' or completely furnished model world which could survive, as in some fairy-tale pact, so long

as a principle of limit was recognized. The idea of rightful shares has been rooted literally in the soil here since the early Middle Ages. The mezzadria system of farming (half to the peasant and half to the landlord), which introduced an even division into agriculture, emancipated the Tuscan peasant from slavery centuries in advance of the rest of Italy and Europe. This no doubt explains the superiority of the Tuscan peasant and the sharpness of his intelligence. Similarly, in the thirteenth century, a then-revolutionary code governing mining and the rights to mineral deposits was enacted in Massa Maríttima, in the Maremma. The mezzadria, incidentally, which has become the general practice throughout Italy, now no longer satisfies either the landowner or the peasant; it is not as equal as it sounds. Nevertheless, it made the peasant a free man and instilled in him those qualities of foresightedness, thrift, and neatness that are not found in slaves or serfs.

The pride of the Florentines, as proverbial as their avarice, is particularly irritating to materialistic people because it appears to be based on nothing concrete, except the past, to which the Florentines themselves seem all but indifferent or wryly jesting. What have they got to be so proud of? No money, no film stars, no big business, no 'top' writers or painters, not even an opera company. A few critics and professors – 'sharp eyes and bad tongues', which was a Renaissance summing up of the Florentines.

The professor in every Florentine is a critic, and that critical spirit is the hidden source of Florentine pride. 'O, signore, per noi tutti gli stranieri son ugualmente odiosi', said

a manicurist, bluntly, to Bernard Berenson, who was trying to enlist her against the Germans before the First World War. 'Oh, sir, for us all foreigners are equally hateful.' 'Noi fiorentini' – this phrase, so often used, grates on the nerves of many strangers, who take it to be a boast. But it is only a definition or simple statement of identity, just as the manicurist's remark was not rude but explanatory.

The manicurist was a poor girl and not ashamed of it. This is the distinction, the real originality, of the Florentines in the modern world, where poverty is a source of shame and true natural pride, as opposed to boastfulness, very rare. Florence is a town of poor people, and those who are not poor are embarrassed by the fact and try to hide it. Professors, farmers, and craftsmen have one thing in common; they are generally short of ready money. The Milanese-type industrialist with his bulging crocodile wallet and the Roman-type speculator hardly exist in Florence. The aristocracy here is a gentry preoccupied with crops and rainfall. Every Friday during the growing season, the counts and marchesi gather in Palazzo Vecchio, the seat of the agricultural administration, to trade and barter and exchange information, just as the peasants do who come in from the country with their samples to meet in the square below; on Wednesday, which is market day in Siena, the Florentine nobles who have vineyards in the Chianti or the Val d'Elsa gather there as well, in the Palazzo Comunale on the square. These men, whatever else they may be - erudite archivists, amateur

historians, collectors of scientific instruments, pious sons of the Church, automobile salesmen – are, above all, farmers, and their wives, too, who set an excellent table, spend a good deal of time in conference with the *fattore* (land agent) and the accountant, having inherited estates

themselves to manage.

On the whole, stocks and shares hold little interest for the Florentines, who care only for the land, that is, for 'real' property. Like Michelangelo and Cellini, Florentines of every station are absorbed in acquiring real estate: a little apartment that can be rented to foreigners; a farm that will supply the owner with oil, wine, fruit, and flowers for the house. Upper-class families return from a week-end on their country estates, their millecento packed with flowers wrapped in double thicknesses of damp newspaper to last the week in town, just as the poor people do who go by bus on Sunday to visit their relations in the country. The aristocracy is fond of shooting, and many a handsome old villa is furnished as a hunting lodge with a gamekeeper dressed in green; fishing in the Arno and the tributary mountain streams is a passion with the artisans and white-collar workers, whose bending rods make a Sunday pattern all along the river. Both sports rest on the same principle: taking something free from Nature.

Like the wise woman who lived in the portico of Santissima Annunziata and sewed pretty patches on her clothes, the modern Florentines are extremely gifted in repair work—mending and fixing old things to make them

last. The restoration of works of art, which is mending at its most delicate and perilous, is one of the great crafts of modern Florence; to the workshops and laboratories of the Uffizi, spread out through the old quarters of the city, come pictures and frescoes, marbles and wooden polychromes from the Florentine churches and from remote parishes in the contado to be put back into condition by Florentine specialists and professors. The Florentine 'way' of restoration, less drastic than the German method as practised in London and New York, is one of the new wonders of the art world; art scholars and historians of English and American universities, critics and curators come to watch how it is done. To them, the workmen in white smocks, like doctors, operating on frescoes that have been detached from damp churches and cloisters, revive the old Florence and the workshops around the Duomo. Climbing up ladders onto shaky scaffolds in the Bardi Chapel of Santa Croce, where the Giottos are being restored, the foreign professors marvel over the work and over the new, 'modern' Giotto who is revealed by the removal of the nineteenthcentury overpainting - a resplendent, transfigured Giotto, whom Ruskin never knew, having given nearly all his praises, it is now found, alas, to the œuvre of the nineteenthcentury restorer, Bianchi, who painted, in toto, the figure of Saint Louis of Toulouse, considered by Ruskin the essential Giotto. Saint Louis of Toulouse has vanished; the Victorian age has vanished, its only relic being an ironic Franciscan friar, the plump head of the Belle Arti

of Santa Croce, who paces up and down the trembling scaffold arguing, with Florentine pungency, that the missing figures be painted in again, 'for devotional reasons'.

These Giottos of the Bardi Chapel have been brought back, almost, from the dead, and the other innovations of modern, post-war Florence - the new Museum of the Belvedere with its wonderful collection of detached frescoes restored to life and the new Trinita bridge standing come era - appear as veritable miracles. The redemption of a work of art is a kind of Second Creation. Yet what is involved is simply painstaking repair work, not essentially different from the housewife's darning or the furniture-mending of the small workshops of the Oltrarno. Around the saving character of the Florentines, their historic vice, cluster the local virtues: the wise division of space, substantiality, simplicity, economy, and restraint. If high-flying Daedalus is their real patron, Poverty is their attendant virtue, the home-made cross of San Giovanni dei Fiorentini that guides him, the precursor, through the desert.

The two modern writers who have best caught the spirit of Florence are Aldo Palazzeschi whose Sorelle Materassi tells of two old-maid sisters who have a fine-linen and embroidery business specializing in trousseaux and hope-chests – putting away for the future – and whose own bureau drawers are stuffed with ancient trim for their own Sunday wear (tassels, fringe, scarves, veils, little collars forty or sixty years old, boleros, little jackets

with dangles, Spanish combs and tortoise hairpins), and Vasco Pratolini whose *Cronache di Poveri Amanti* tells of the poor people of the Santa Croce quarter: artisans, pushcart vendors, prostitutes, and pairs and pairs of young lovers. In the back streets of the Santa Croce quarter, the farthest remove from the smart linen shops of Via Tornabuoni, two characteristic sounds can be heard, when the traffic is momentarily silent, two sounds that *are* modern Florence: the clack-clack of a sewing machine and the tinkle of a young girl practising on an old piano.

Books by Mary McCarthy available from Harcourt, Inc. in Harvest paperback editions

Birds of America
Cannibals and Missionaries
Cast a Cold Eye
A Charmed Life
The Company She Keeps
The Group
The Groves of Academe
How I Grew
Intellectual Memoirs: New York 1936-1938
The Mask of State: Watergate Portraits
Memories of a Catholic Girlhood
The Stones of Florence
Venice Observed
The Writing on the Wall and Other Literary Essays

Hannah Arendt and Mary McCarthy

Between Friends: The Correspondence of Hannah Arendt and Mary McCarthy, 1949-1975